The Beginnings
of Japanese Art

Volume 2
THE HEIBONSHA SURVEY OF JAPANESE ART

For a list of the entire series see end of book

CONSULTING EDITORS

Katsuichiro Kamei, *art critic*
Seiichiro Takahashi, *Chairman, Japan Art Academy*
Ichimatsu Tanaka, *Chairman, Cultural Properties Protection Commission*

The Beginnings of Japanese Art

by NAMIO EGAMI

with supplementary chapters by
Teruya Esaka and Ken Amakasu

translated by John Bester

New York · WEATHERHILL/HEIBONSHA · Tokyo

This book was originally published in Japanese by Heibonsha under the title *Nihon Bijutsu no Tanjo* in the Nihon no Bijutsu Series.

First English Edition, 1973
Second Printing, 1978

Jointly published by John Weatherhill, Inc., of New York and Tokyo, with editorial offices at 7-6-13 Roppongi, Minato-ku, Tokyo 106, and Heibonsha, Tokyo. Copyright © 1969, 1973, by Heibonsha; all rights reserved. Printed in Japan.

Library of Congress Cataloging in Publication Data: Egami, Namio, 1906– / The beginnings of Japanese art. / (The Heibonsha survey of Japanese art) / Translation of Nihon bijutsu no tanjō. / 1. Pottery, Jōmon. 2. Pottery, Yayoi. 3. Terra-cottas, Japanese. I. Title. II. Series. / NK4167.E3213 / 738.3'0952 / 72-78599 / ISBN 0-8348-1006-9

Contents

The Beginnings
of Japanese Art

The Origins of Japanese Art

ANY DISCUSSION of the manner in which the arts of Japan came into being—under what cultural conditions they were created, by men of what racial stock and temperament, fired by what purposes and ambitions—must begin by examining the land and climate that nurtured them.

Thanks to its nature as a closely linked chain of islands, Japan constituted a cultural sphere in its own right from a surprisingly early age, a fact attested to by the widespread distribution of Jomon pottery. The Jomon vessels that have been unearthed not only along the whole main archipelago from Hokkaido in the north to Okinawa in the south but even on outlying islands such as Tsushima, Sado, Oki, and the Izu Islands vanish without trace once one crosses the straits to the Asian mainland. In short, by the Jomon period (roughly 3000–200 B.C.) Japan was already a single cultural unit.

Although surrounded by water Japan is not isolated. Only the La Pérouse Strait separates it, to the north, from Sakhalin, which in turn is separated from Siberia by only the narrow Tatar Strait. To the west, the Korea Strait gives access to the Korean Peninsula and to northern China. The Ryukyu Islands serve as a steppingstone to Taiwan and the south of China. In fact, its geographical location as a kind of arc stretching off the coast of the continent makes Japan almost a kind of semipeninsula. (See map on page 35.)

The four great seas that lie about the isles of Japan naturally have a close bearing on the land and climate. Warm currents such as the Kuroshio and Tsushima currents that bathe the southern and western shores of the islands give the west of Japan a warmth, moisture, and luxuriant vegetation unusual at such a northerly latitude. The Oyashio and other cold currents that wash both the Pacific and Japan Sea shores of Hokkaido and northeastern Honshu, though giving these areas lower temperatures, serve to create well-stocked fishing grounds in their coastal waters. It was the plentiful supply of food obtainable from the sea, together with the rich variety of flora and fauna on its hills and plains, that enabled Japan, despite its small size, to support a relatively large population from Jomon times on.

At the same time, Japan had neither vast plains nor outstandingly fertile areas, nor any especially remarkable natural resources; thus the land was not suitable to the development of heavy concentrations of population. As a result, no single district underwent particularly intensive development in comparison with the others, and as Japanese culture developed, it tended to spread evenly over a large part of the country.

Japan is divided by countless mountain ranges and coastal inlets into any number of small districts favorable to the growth of independent administration, and authority tended to become dispersed among the provinces. But very seldom did any great sources of regional power develop to exert

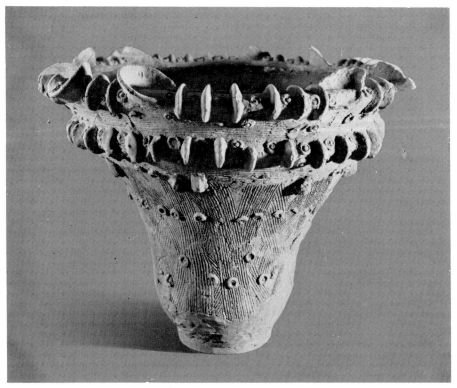

1. Deep earthenware pot decorated with shells and combed pattern. Early Jomon. Height, 34 cm. Shimojima site, Chino, Nagano Prefecture. Collection of Eiichi Fujimori.

powerful dominion over the nation as a whole. Japan had a consistency in the broadest sense that was at the same time extremely loose-knit. On the one hand, there was racial homogeneity; on the other, the natural setting promoted the development of pronounced regional characteristics.

Closer examination reveals that the north and south of the country differ considerably in the nature of their cultures. This is due in part to factors we have already considered—the nature of the climate, the natural surroundings, and contacts with the continent—yet there is one more important factor. North of the Chubu district (central Honshu) the topography forms a more or less integrated whole, with mountains running vertically down

the center and plains in the coastal areas on either side, whereas in the area stretching south from the Kinai district (the old name for the district around Kyoto) the topography falls naturally into two narrow sections, with twin mountain chains running from northeast to southwest on either side of the Inland Sea. These natural barriers affected the manner in which culture developed, was transmitted, or was borrowed from other areas, giving the two halves of the country cultures and traditions of a different character.

For this reason, it is necessary, if one is to understand Japanese art, not merely to consider the country chronologically as a single geographical unit but to survey it district by district and examine

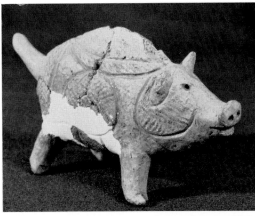

2. *Earthenware boar. Terminal Jomon. Length, 17.5 cm. Tozurazawa site, Hirosaki, Aomori Prefecture. Hirosaki Municipal Board of Education.*

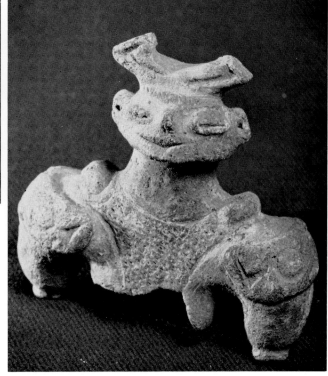

3. *Earthenware figurine with topknot. Middle Jomon. Height, 12.2 cm. Yakushi site, Iwaki, Aomori Prefecture. Hirosaki Municipal Board of Education.*

the development of the characteristics and traditions peculiar to each district.

The further one goes back in history, the closer are Japan's relations with the Asian mainland. Already in the pre-pottery period Japan was under the influence of continental culture. Despite the views of a few scholars who have claimed in recent years that pottery originated independently in Japan, the pottery vessels that constitute Japan's very first works of art and the culture with which they are associated carry elements suggesting a connection with the continent. Thus the continent and Japan remain inseparable, whether one is considering Japanese culture as a whole or the question of the birth of its various art forms.

Nonetheless, it is equally true that one can detect certain consistent and essentially Japanese cultural phenomena; from the Jomon period onward, a pottery culture developed that employed styles and techniques peculiar to Japan and extended over the whole country. Even at those times when Japanese culture underwent rapid and violent changes as the result of great influxes of continental culture, there was always a quiet undercurrent that remained undisturbed. This was particularly true of the areas that were more remote from continental influences. When, for example, a new culture from Siberia came into Japan from the north, it halted for the most part at the Kanto district (the area around present-day

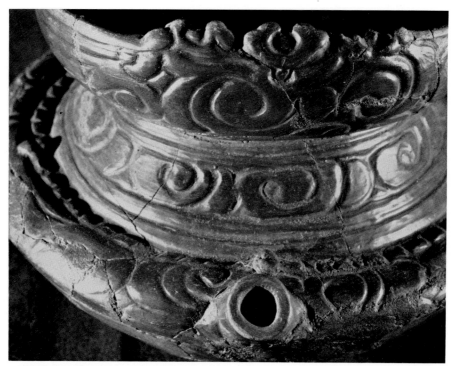

4. *Spouted earthenware vessel. Terminal Jomon. Height, 19 cm. Shitazaki site, Kindaichi, Iwate Prefecture. Collection of Mugeji Hakamada.*

Tokyo), and the Chubu and other districts farther west were subject only to a secondhand influence. Conversely, the continental culture that flowed in via Kyushu went, generally speaking, no farther than the Kanto district, its influence remaining weak in areas farther to the north.

Japan already had a large population at an early date, and there was by no means a shortage of manpower, as is quite clear from the great tombs constructed in and around the Kinai district during the Tumulus period (roughly A.D. 300–700). Yet the contents of those tombs were surprisingly unlavish in their materials. Objects such as the cylindrical *haniwa* (earthenware funerary figures), made from readily available materials and limited only by the amount of manpower available, were made in astonishingly large quantities, but strangely enough no large collection of objects in gold or silver has ever been discovered in an ancient tomb. There seems to be no doubt that this is related to the use of simple materials that is observed throughout the whole of Japanese art.

CHAPTER TWO

The Jomon Period:
A Hunting-Gathering Culture

THE DISCOVERY of the remains of what is known as the "pre-pottery culture" has confirmed beyond all doubt that men were living in Japan before the Jomon period. The artifacts of the pre-pottery culture so far discovered, which extend from Hokkaido in the north to Kyushu in the south and number several thousand, consist exclusively of sharp-edged stone implements and show no traces of any artistic elements. In this respect, the pre-pottery culture can also, perhaps, be termed a "pre-art" culture.

This does not rule out entirely the possibility that there were other artifacts of bone, horn, or wood, some of which showed features of decorative art or bore decoration of an artistic nature, or that there once existed, for example, cave paintings that have been obliterated by the damp climate or other factors. Nevertheless, it would seem likely that in this case the men who created the pre-pottery culture, skilled as they were in fashioning stone implements, would also have developed some form of art in stone—primitive stone carving, for example, or engraving on rockfaces. Generally speaking, one finds among peoples at the stage corresponding to the pre-pottery culture in Japan some who showed a striking artistic creativity and others who seemed utterly indifferent to art in any form. Examples of the former are the hunters and

fishers of western Europe in the later part of the Paleolithic era and, more recently, the Eskimos. Examples of the latter are too numerous to need citing here. Our present knowledge suggests that the pre-pottery culture of Japan belonged to the latter category. However, as we have seen, the prehistoric culture of Japan summed up in the term pre-pottery culture included in fact various different cultures, and it might be hasty to assume that none of them possessed any art. Careful investigation may yet yield results, particularly in caves and rock shelters where there is a possibility of personal ornaments of bone or horn, or of rock engravings or paintings having survived.

Little is known of what relationship, if any, existed between the pre-pottery age in Japan and the age characterized by Jomon pottery. Recent investigations of caves and other sites, however, have revealed that even before the earliest of the five eras—Archaic, Early, Middle, Late, and Terminal—into which the Jomon period is customarily divided, there was an era characterized by earthenware vessels bearing raised-line, fingernail, or cord-impression patterns. Some scholars have labeled this the Jomon "inaugural era," but it might equally well be called the Primeval Jomon era.

Generally, these earthenware pots were produced for practical purposes—as vessels for holding and

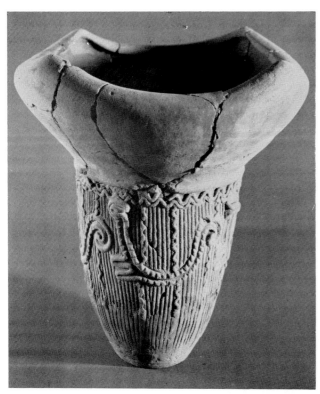

5. *Deep earthenware pot with relief design of weasel. Middle Jomon. Height, 36 cm. Tonai site, Fujimi, Nagano Prefecture. Idojiri Archaeological Museum, Fujimi.*

6 (*opposite page, left*). *Earthenware pot with snake-shaped ear. Middle Jomon. Height, 25.6 cm. Togariishi site, Chino, Nagano Prefecture. Togariishi Archaeological Museum, Chino.* ▷

7 (*opposite page, right*). *Earthenware pot decorated* ▷ *with grotesque animals (?). Middle Jomon. Height, 47 cm. Tokuri site, Fujimi, Nagano Prefecture. Togariishi Archaeological Museum, Chino. (See also Figure 95.)*

storing, or for boiling and cooking in. The material was clay, which can be modeled freely, so that man's artistic instinct inevitably came into play, thus introducing an element of decorative art. In this sense the earthenware vessels produced in Japan during the Primeval Jomon era can without mistake be seen at present as marking the birth of art in Japan.

What led to the production of the first pottery in Japan after such a long period without? Vital though this question is in its direct bearing on the birth of art in Japan, two diametrically opposed views on it still exist today.

The first is based on estimates employing the radioactive carbon-14 dating method developed since World War II. As a result of these calculations, the date of Archaic Jomon pots is estimated as around 7000 B.C. This would set the origin of

pottery in Japan long before that of anything found in other areas of East Asia, and it is claimed accordingly that earthenware must have originated independently in Japan.

The opposing view points out that the stone implements found together with earthenware vessels of the Primeval Jomon era include stone blades (*shokujin*) that were set in bone or wooden handles, as well as long, narrow, awl-like stone implements triangular in section. These peculiar implements are not found in the Archaic and succeeding eras of the Jomon period, although similar implements have been found over a wide area of northeastern China, Mongolia, and Siberia. From the dates of the latter it is concluded that the Primeval Jomon era dates from about 3000 B.C. If this is so, the earliest pottery in Japan dates back no further than this, and the view that pottery evolved independ-

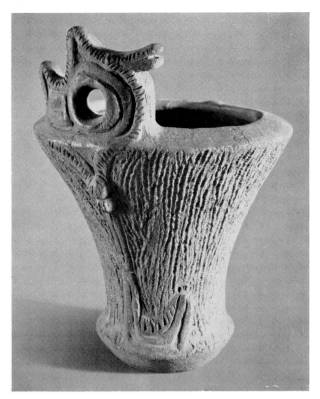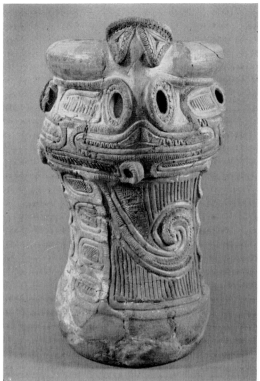

ently in Japan loses its chronological justification.

These two conflicting views hinge on the larger question of whether the origin of pottery in the world as a whole should be seen monistically or pluralistically. The monistic theory holds that pottery is not invented immediately whenever and wherever a need for storage vessels or cooking utensils makes itself felt, but only on comparatively rare occasions, when a number of different conditions have come together in a particular pattern. Such rare occasions can only occur when men have settled in one spot and begun to engage in agriculture. In both the old and the new worlds, the origin of pottery coincided with the most ancient agrarian cultures, and its spread throughout the whole world was simply a result of the gradual transmission of the method of pottery making to other areas. This theory, in short, considers that hunting,

fishing, and gathering cultures afforded no opportunity for the independent creation of pottery.

The pluralistic theory believes it possible that pottery was produced quite independently at a comparatively large number of spots throughout the world; there are such cases not merely in agrarian societies but also in hunting-gathering societies. Champions of the former theory hold that actual cases cited by proponents of the latter are—even if they in fact exist—extremely rare exceptions, and that the principle that pottery originated in primitive agrarian culture remains intact.

It is not enough to consider pottery in isolation. Pottery is only one manifestation of a culture complex whose content, nature, and antecedents must all be considered before one can determine how pottery evolved within it. Thus, where the origins of pottery in Japan are concerned, the ap-

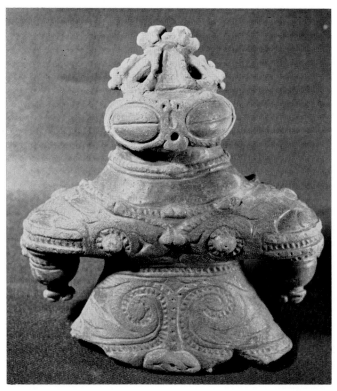

8. *Earthenware figurine with snow-goggle eyes and elaborate costume. Terminal Jomon. Height, 22.3 cm. Fujikabu site, Takanosu, Akita Prefecture. Tohoku University, Sendai.*

proach that takes into account the stone implements and other artifacts found along with the pottery, and examines them together as parts of a culture complex, is surely more valid than simple reliance on the results of carbon-14 tests.

I also believe that the pottery bearing raised-line, fingernail, and cord-impression patterns that is peculiar to the Primeval Jomon era unquestionably derives from Siberia, Mongolia, and other areas of the Asian mainland. I have frequently found pottery fragments virtually identical in style on the plateau of Inner Mongolia, while reports by Soviet scholars show that similar finds are not uncommon in Siberia and farther west into Russia. It follows that along with the stone blade and long awl-like tool that characterize the culture of this era, these types of patterned pottery also probably came to Japan, via northeastern China and the Korean Peninsula, as part of a single culture com-

plex. And if, as already suggested, the beginning of pottery also constituted the birth of art in Japan, it means that the links between the arts of Japan and the continent, and northeastern Asia in particular, were strong from the very outset.

Despite evidence suggesting that a primitive type of agriculture began in some districts around the middle of the Jomon period, it is indisputable that during the period as a whole hunting, fishing, and gathering were the principal means of livelihood. Since the period lasted at least three thousand years, it is natural to suppose that it saw a development in the hunting, fishing, and gathering way of life, as well as the emergence of well-defined local cultures in various parts of an archipelago that extends so far from north to south. The high level attained by Jomon culture—unrivaled in any other hunting and gathering culture in the world—can be attributed to a number of factors, among them

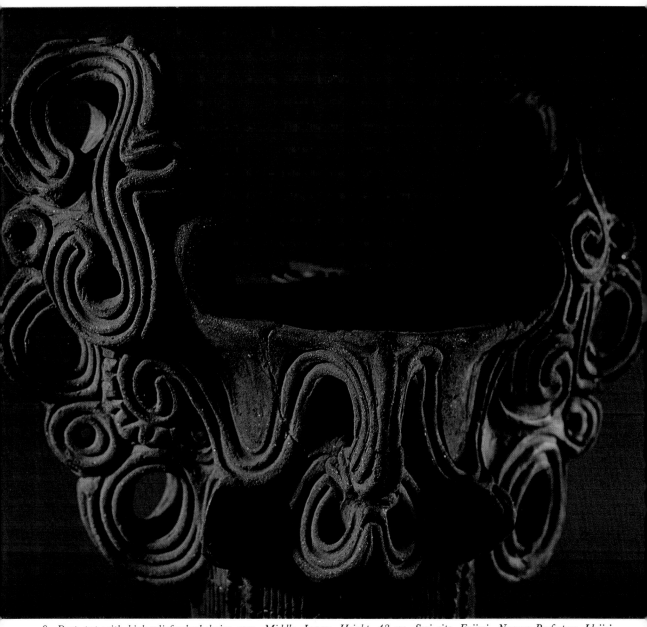

9. *Deep pot with high-relief whorl-design ears. Middle Jomon. Height, 43 cm. Sori site, Fujimi, Nagano Prefecture. Idojiri Archaeological Museum.*

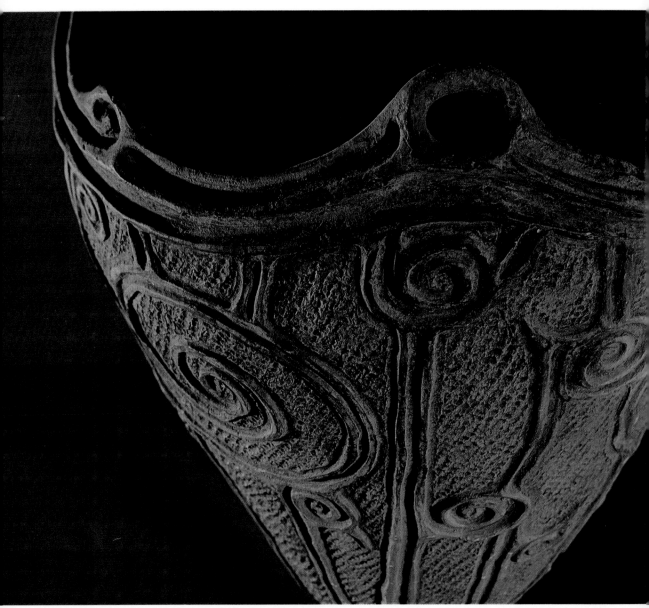

10. *Large urn with whorl design. Middle Jomon. Height, 49.8 cm. Tateichi site, Tsunagi, Morioka, Iwate Prefecture. Tsunagi Junior High School.*

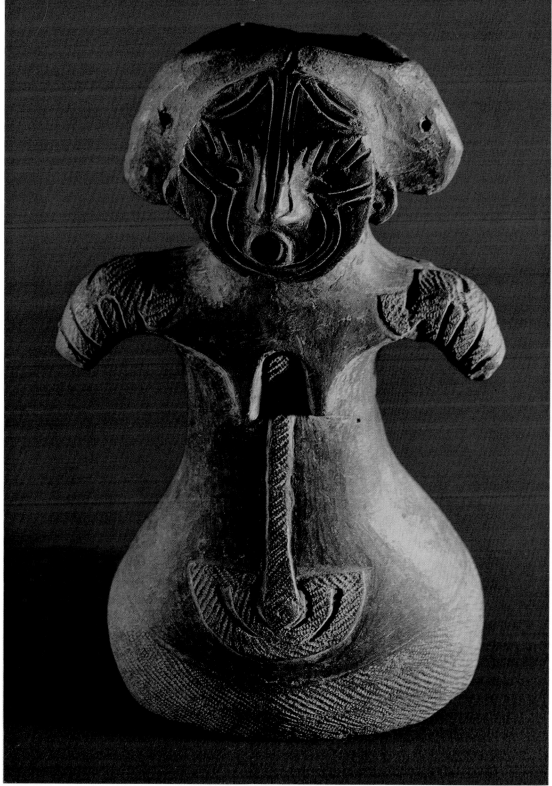

11. Hollow earthenware figurine with anchor design, used as bone container. Terminal Jomon. Height, 26.7 cm. Naka-yashiki site, Oi, Kanagawa Prefecture. Collection of Misao Komiya.

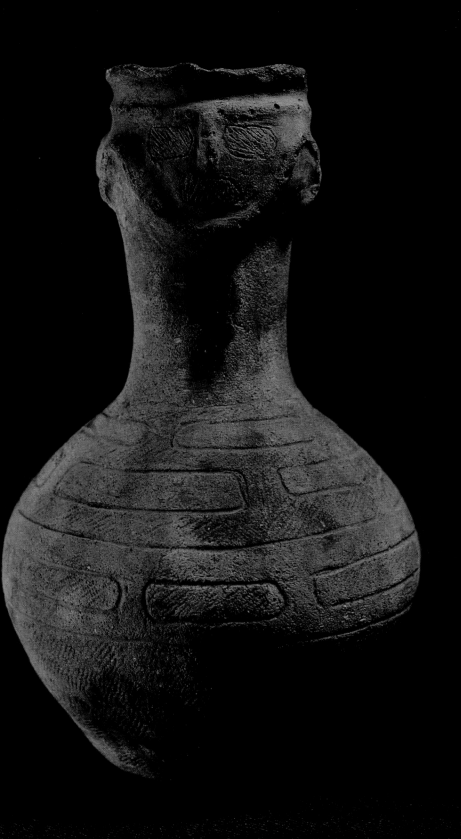

12. *Jar with faces on two sides. Middle Yayoi. Height, 25.3 cm. Takinomori site, Omotego, Fukushima Prefecture. Omotego Primary School No. 2. (See also Figure 19.)*

13. Haniwa *warrior wearing cap decorated with bells. Late Tumulus. Height, 91 cm. Kamiyasaku Tomb, Iwaki, Fukushima Prefecture. Iwaki High School.* ▷

14 *(overleaf). Design of quivers and concentric circles carved into inner wall of tomb. Late Tumulus. Width, 162 cm. Segonko Tomb, Matsuo, Kumamoto Prefecture.* ▷

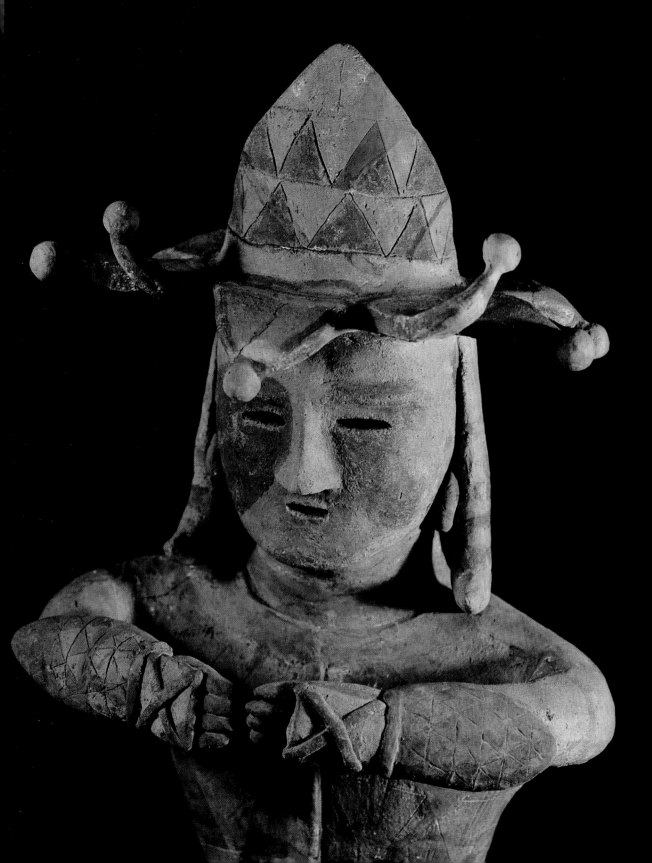

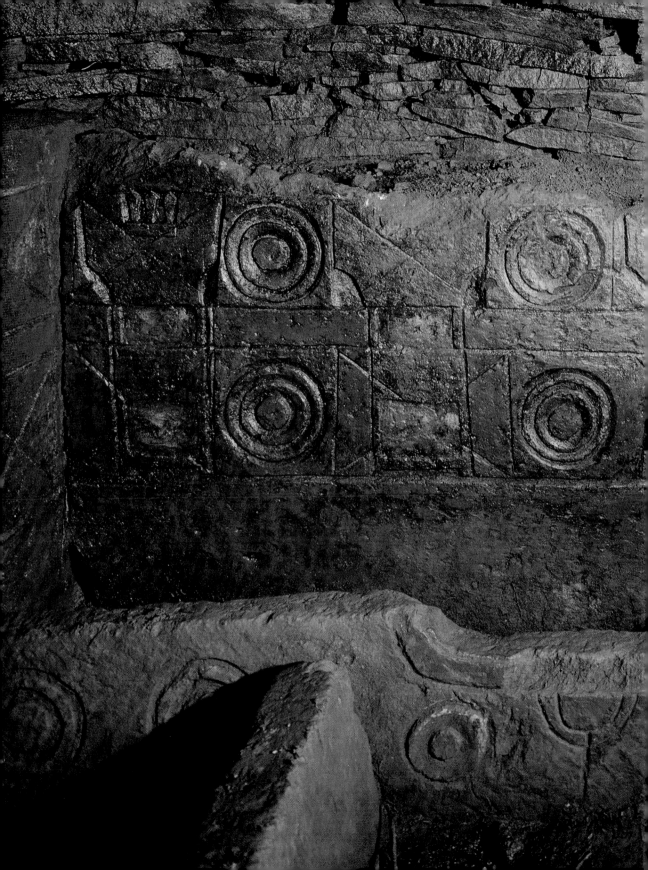

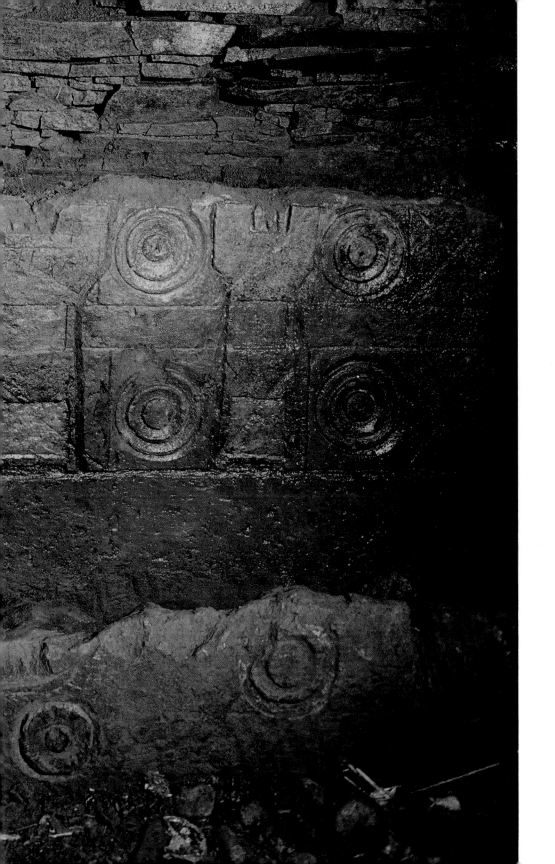

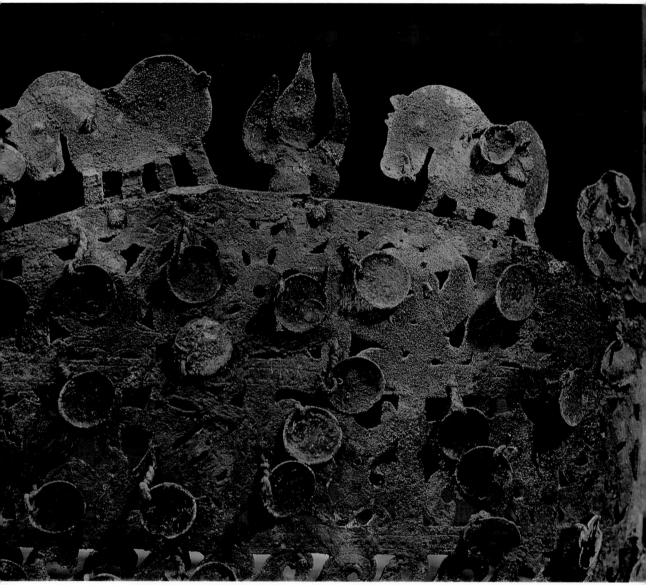

15. *Detail of bronze crown ornamented with horses. Late Tumulus. Height, 13 cm. Sammaizuka Tomb, Tamatsukuri, Ibaraki Prefecture. Ibaraki Prefectural Art Museum, Semba. (See also Figure 126.)*

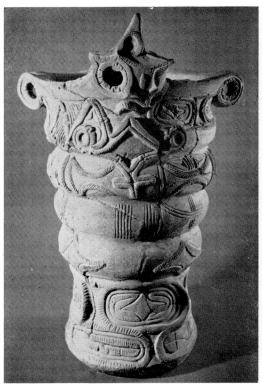

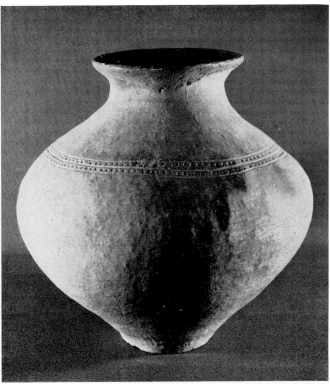

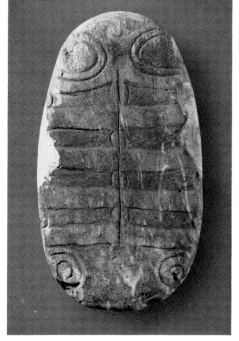

16 (above left). Richly decorated earthenware vat. Middle Jomon. Height, 57.3 cm. Tonai site, Fujimi, Nagano Prefecture. Idojiri Archaeological Museum, Fujimi.

17 (above right). Simple earthenware jar. Early Yayoi. Height, 27 cm. Karako site, Tawaramotomachi, Nara Prefecture. Yamato Historical Museum, Kashihara.

18 (right). Stone plaque with eyes. Terminal Jomon. Length, 16 cm. Yaishitate site, Hayakuchi, Tashiro, Akita Prefecture. Hayakuchi Junior High School.

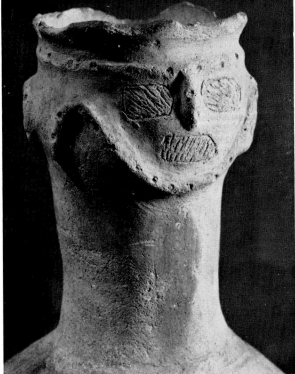

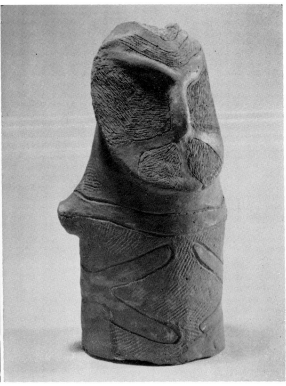

19. *Detail of earthenware jug decorated with two faces. Middle Yayoi. Takinomori site, Omotego, Fukushima Prefecture. Omotego Primary School No. 2. (See also Figure 12.)*

20. *Combed-pattern earthenware figurine. Middle Yayoi. Height, 18.5 cm. Kaminojiri site, Nishi Aizu, Fukushima Prefecture. Tokyo National Museum.*

the clemency of the natural surroundings, the abundance of food on land and in the sea, and the safety afforded by the surrounding seas, which protected Japan from any large-scale invasion.

Thus the people of the Jomon period seem to have enjoyed a life with a degree of peace and plenty that raised it above the simple struggle to survive. The surest evidence of this lies in Jomon pottery itself, some of which shows a decorative quality and variety of form beyond anything required in an object of simple practical use, and which is not infrequently worthy of appreciation as art in its own right. The patterns that form the most important elements of decoration are not exclusively the cord-impression patterns (*jomon*) that give the period its name but include a variety of

designs executed with a wide range of techniques, and a considerable number of the shapes display a rich artistic creativity (Fig. 36). Pottery of this kind remained both quantitatively and qualitatively a prominent feature of Jomon culture throughout the whole of its course.

The clay figurines, or *dogu,* produced in large numbers in eastern Japan around the middle of the period are a direct embodiment of the robust, if unsophisticated, artistic urges of Jomon man. The stone figurines, clay masks, and clay tablets that are closely associated with the clay figurines, as well as the articles of personal adornment in bone and horn, also show elements of decorative art. But the twin pillars of Jomon art are, without doubt, the earthenware vessels and figurines of the Middle and

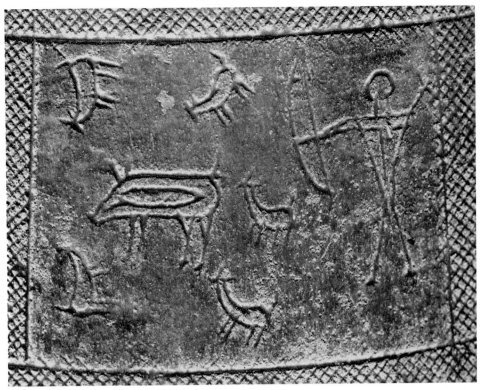

21. *Detail of hunting scene on ribbon-type* dotaku. *Late Yayoi. Kagawa Prefecture. Collection of Hachiro Ohashi. (See also Figures 29, 76, 151.)*

later eras. It is highly significant that both use clay as their medium. In Europe and western Asia, the hunting peoples of the Paleolithic era are characterized by the creation of pictorial and sculptural art in rock and stone—rock painting and engraving, as well as bas-relief or carving in the round in stone and bone. It was the primitive agrarian peoples of the Neolithic and Chalcolithic ages who were responsible for earthenware vessels, figurines, and other semidecorative arts employing clay. Thus objects of semidecorative art made of clay during the Jomon period, though produced by men who engaged in hunting and gathering, correspond less to the art of the hunting peoples of the Paleolithic age in Europe and western Asia than to the art of the primitive agrarian peoples

of the Neolithic or Chalcolithic age. This fact may well be related both to the comparatively strong tendency for the hunting and gathering people of the mid-Jomon and later periods to settle in one spot and to the primitive agriculture in which some of them apparently engaged.

It should be pointed out, nevertheless, that Jomon-period art is to a considerable extent alien to Japanese art as we know it today. While it is true that various elements of the art of the Jomon period persisted long afterward in isolated areas from the Kanto district through northeastern Honshu and as far north as Hokkaido, giving the art of these districts a special local flavor of its own, it is essentially different in nature from the traditional art of Japan that began in the Yayoi period.

The Yayoi Period:
An Agrarian Culture

ALTHOUGH IN SOME areas Jomon man may have grown tubers and fruit, his life, dependent as he was on hunting, fishing, and gathering, was unrelated to the rice growing that has for so long been a central feature of the economic life of Japan. A society and culture centered on hunting and gathering was, unquestionably, different from the traditional society and culture of the rice-growing Japanese, and it is correspondingly difficult to see the former as responsible for that traditional culture.

However, in the Yayoi period (200 B.C.–A.D. 300) rice cultivation, and more specifically wet-rice cultivation, came to form the basis of the economy, and an agrarian society given continuity by the cycle of rice production emerged throughout most of the Japanese archipelago. Linguistically also, it seems likely that the Japanese language was already in use. What is certain is that the Japanese of the Yayoi period and the Japanese of the historical period show consistent features in the basic aspects of their economic, social, and cultural lives, and that the two are of the same ethnic stock. Thus it would seem natural to trace the starting point of the Japanese people to the Yayoi period.

The men of the Yayoi period—referred to in Chinese histories as the men of Wa—were distinguished from other Asian peoples as a people sharing a single common culture. That these men of Wa should have been considered as the first appearance of the Japanese people is important in any consideration of Japanese art. With the Yayoi period the features that were to characterize Japanese art for long centuries to come were already clearly apparent, and the beginning of a national tradition of Japanese art can be detected.

What kind of culture and what kind of men created the art of the Yayoi period, an art that plays such a momentous role in the national tradition? What brought about the transition—and a comparatively rapid one at that—from the lengthy Jomon period, with its roots in hunting and gathering, to the Yayoi period, in which life was based on wet-rice cultivation? Excavations already completed make it clear that this change took place around the third or second century B.C., but there are conflicting opinions as to whether such a major change in the lives of the islands' inhabitants came about spontaneously, in the natural course of the development of Jomon culture, or whether it was a result of the arrival of foreign culture from overseas.

Champions of the former theory are far from few, but others, including myself, who prefer always to consider Japan in its relation to the rest of East Asia, reject any possibility that the Yayoi

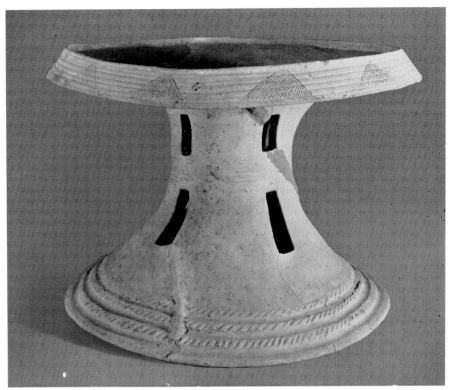

22. *Large earthenware stand. Late Yayoi. Height, 36.5 cm. Joto site, Sho, Okayama Prefecture. Kurashiki Archaeological Museum.*

culture could have evolved without external influence and as part of a continuous process from the Jomon period. It is inconceivable that during the Late and Terminal eras the Jomon hunting and gathering economy should have gradually attained a higher level until the final transition to the productive economy—wet-rice cultivation—of the Yayoi period occurred spontaneously. This does not apply to Japan alone: nowhere in the world has the transition from a hunting and gathering economy to a productive economy involving the cultivation of fields or the rearing of domestic animals occurred spontaneously as a normal stage of development. Such an epoch-making change requires some epoch-making event to trigger it.

There is no evidence pointing to any change in the natural environment sufficiently serious to provoke such a revolutionary change, or to any cultural movement sweeping the whole of the Japanese archipelago during the Late or Terminal Jomon eras. Nothing suggests, for instance, that some sudden change of climate generated such major mutations in the flora and fauna of the Japanese islands that man was obliged to seek some form of livelihood other than that in which he had always engaged. Nor did the culture of the Late and Terminal Jomon eras, for all its inner refinement, show the robustness and creativity found in Middle Jomon culture in the Tohoku (northern Honshu) and Kanto districts, much less any evidence of a

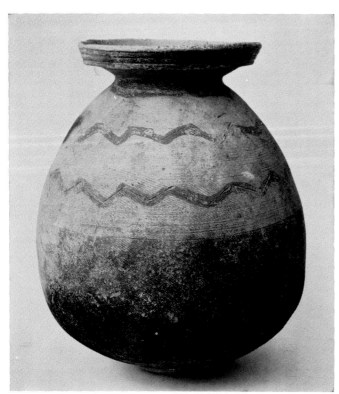

23. *Red-painted earthenware jar. Late Yayoi. Height, 32.8 cm. Ishibotoke site, Iwakura, Aichi Prefecture. Kyoto University.*

24 (*opposite page, left*). Dotaku *with flowing-water pattern. Late Yayoi. Height, 44.8 cm. Kaichi-yama site, Yao, Osaka Prefecture. Tokyo National Museum.* ▷

25 (*opposite page, right*). *Ribbon-type* dotaku. *Late Yayoi. Height, 47.5 cm. Uzumori site, Kobe, Hyogo Prefecture. Tokyo National Museum.* ▷

vitality powerful enough to provoke a nationwide cultural revolution that could have induced an economic revolution in turn. Moreover, the fact that the northern Kyushu area, where Yayoi culture first appeared, lay on the outskirts of the Jomon culture of the Late and Terminal eras makes it still more difficult to see the former culture as having evolved spontaneously from the latter.

Compared with the cultivation of tubers that was widespread in the islands of the Pacific and in South America, or the cultivation of millet and wheat that was universal in northeastern Asia, the wet-rice cultivation that formed the foundation of Yayoi culture required a far higher level of agricultural technique. That the comparatively easy stages of tuber or millet and wheat cultivation should have been skipped entirely in the Japanese archi-

pelago, or at least passed over before they had a chance to become universal, and that wet-rice cultivation should have been taken up suddenly and spread so rapidly hardly suggests a process of spontaneous development. Furthermore, the wild strain of rice does not occur naturally in the islands of Japan, so that neither the botanical selection of rice as a grain for cultivation nor the beginning of the farming processes involved, whether in paddies or in dry fields, seems likely to have originated in Japan. Thus one is inevitably drawn to the conclusion that the productive economy based on wet-rice cultivation was imported.

Among those who agree that rice cultivation originated outside the Japanese archipelago, it is generally accepted that it first entered via Kyushu: Yayoi culture did, in fact, begin in Kyushu. There

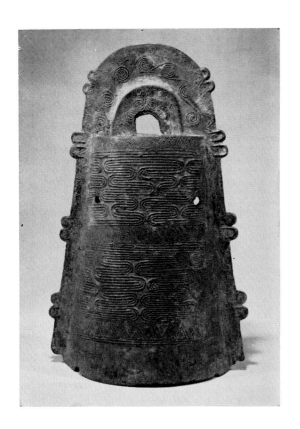
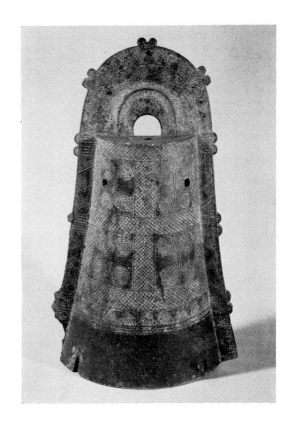

are still conflicting theories concerning its provenance, but it is certain that it came from the Asian continent and not from the islands of the South Pacific. Opinion differs, again, as to where on the continent the home of rice cultivation was situated. For long, many scholars located it in northern China, but the theory most favored in recent years is that it lay in southeastern and central eastern China and southeastern Asia, whence it came to Japan via the East China Sea or southern Korea.

It is important that various elements of continental culture came to Japan along with rice cultivation as part of a single culture complex. Some scholars, while agreeing that rice cultivation came from the continent, maintain that it was the Jomon people who assimilated it and played the main role in changing Japan from a hunting and gathering society to an agricultural society. However, what came into Japan was not merely the custom of growing and eating rice as such but also many other inseparable culture traits—the knowledge, techniques, and tools necessary for wet-rice cultivation and the preparation of rice as food—as well as various rites associated with them. Furthermore, many life ways, customs, and traditions originating in Southeast Asia came over at the same time. Such facts oblige one to conclude that the Yayoi culture was the result not merely of the introduction of rice cultivation and those aspects of culture associated with it but also of a large-scale migration of the men who were responsible for it.

The men from the continent and the new culture that they brought with them traveled across the East China Sea and spread not only to western

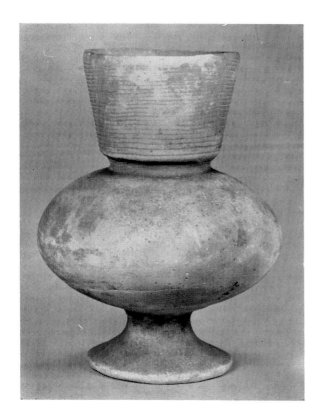
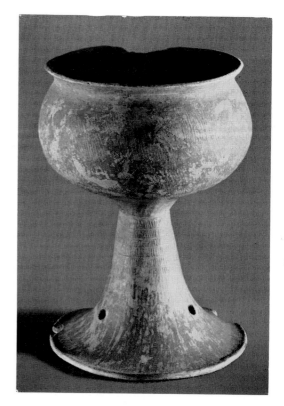

Japan but to southern Korea as well, a fact that had a vital significance in another and different sense. During the Jomon period, relations between Japan and Korea had for the most part been tenuous, and there were few opportunities for the culture of the continent to reach Japan via the peninsula. In the Yayoi period, however, a close connection grew up between western Japan on the one hand, especially northern Kyushu and the western extremity of Honshu, and Korea on the other, southern Korea in particular. In short, both simultaneously took over from the outside a productive economy based on rice cultivation, and thus came together to form a special cultural sphere. Circumstances such as these give considerable credibility to the theory that holds that Yayoi pottery had its origin in Korea.

It is also important that southern Korea came to form a link between western Japan and northeastern Asia. The "northeast-Asian type" bronze and iron cultures then predominant in such places as eastern Mongolia, Liaoning Province in northeast China, and northern Korea, as well as the Lo-lang culture developed by Han-dynasty China in northern Korea, could thus be transmitted to Japan.

Yayoi culture was thus an amalgamation of, on the one hand, the wet-rice culture from central eastern and southeastern China and, on the other, Jomon culture, with added elements of the polished-stone culture of southern Korea and the metal cultures of northeastern Asia; the whole being given still greater complexity by variations peculiar to Japan and, in some fields, by the adoption of culture

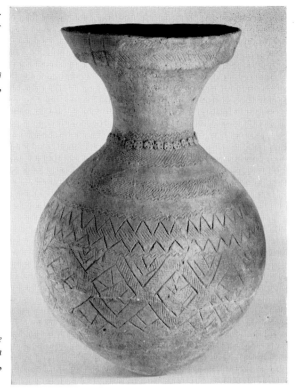

26 (opposite page, left). *Footed earthenware pot. Late Yayoi. Height, 18 cm. Chiharagasaki site, Toyama City, Toyama Prefecture. Tokyo National Museum.*

27 (opposite page, right). *Red-painted earthenware bowl with high foot. Late Yayoi. Height, 17.5 cm. Sono site, Iwakura, Aichi Prefecture. Kyoto University.*

28. *Large earthenware jar with incised patterns and buttonlike ornaments on neck. Late Yayoi. Height, 38 cm. Urashimayama site, Yokohama, Kanagawa Prefecture. Honcho Primary School, Yokohama.*

elements from Han-dynasty China. As a result, various subcultures developed and a number of cultural spheres of varying size came into existence. Broadly speaking, the Yayoi cultural sphere, extending from northern Kyushu in the west to the Hokuriku (central Japan Sea coast of Honshu) and Chubu districts in the east, can be divided into two subzones: one characterized chiefly by bronze swords and spears, centered in northern Kyushu, and the other characterized by bronze ceremonial bells (*dotaku*), centered in the Kinai area. It is essential for any understanding of the mainsprings of Japanese art to remember that various mixtures of the new Yayoi and traditional Jomon cultures, as well as strongly traditional cultures with only the slightest influence from the Yayoi, survived in outlying areas of Kyushu and the Tohoku, San'in (western Japan Sea coast of Honshu), and Hokuriku districts.

Yayoi culture is generally believed to have originated in northern Kyushu and other areas of western Japan around the third century B.C. and to have continued in eastern Japan until about the third century A.D.; but during that period there were local variations from district to district, as well as variations from age to age, arising from the development of the Yayoi culture itself. However, some features were common to the culture as a whole. It was the culture of an unsophisticated agricultural people engaged in wet-rice cultivation, a culture that was generally peaceable, occupied pre-eminently with the business of living, simple-hearted, moderate, and turned in upon itself. It also seems to have had a strong religious tendency

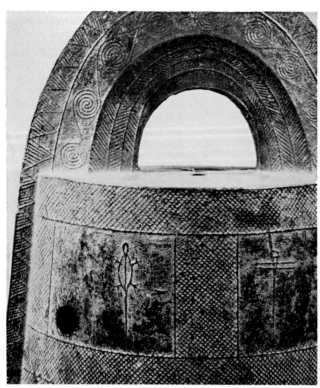

29. *Detail of line-relief turtle on ribbon-type* dotaku. *Late Yayoi. Kagawa Prefecture. Collection of Hachiro Ohashi.* (*See also Figures 21, 76, 151.*)

and to have been much occupied with magic and ritual. The concern with everyday life is a consistent feature—Yayoi ceremonies, for example, being mostly associated with agriculture or with techniques essential to production. This feature is not peculiar to Japan alone but is common to most primitive agrarian societies all over the world.

In most cases, primitive agrarian people develop farming communities in which the emphasis is on ties with the soil and ties of blood, communities in which traditional relationships of cooperation are established and that develop festivals and rituals associated with agriculture. On the other hand, they are negative in their attitudes toward the outside world, and conservative by nature. This is in part a natural outcome of the principle of self-sufficiency that holds sway in such agrarian societies. It frequently happens as a result that a

primitive agrarian society survives for a long period in much the same state. At the same time, taking as a premise that in an agrarian society increased childbearing leads to increased agricultural output and the building of a secure, firmly established society, such a culture tends to become strongly traditional, in some cases growing into a kind of organic entity with religious authority at its core. This religious focal point is commonly associated with magic rituals and ceremonies. As it develops, it tends to give birth to government by divine authority or to other authoritarian forms of government, and to give spontaneous rise to a proto-state.

Such was the nature of Yayoi culture in Japan. It seems safe to assume that compared with the vital, creative hunting, fishing, and gathering society of Jomon times it was a tidy, well-behaved

Traditional Districts and Their Modern Prefectures

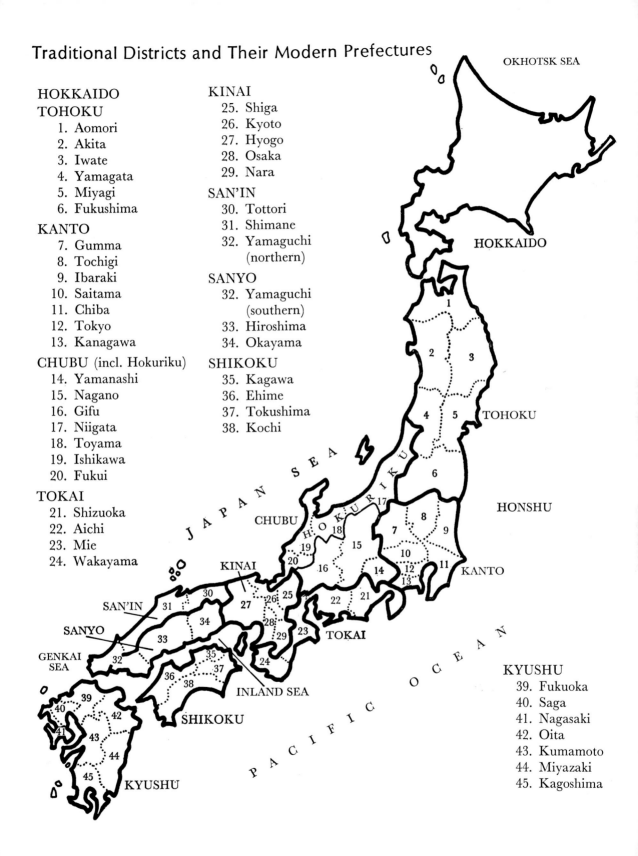

HOKKAIDO

TOHOKU
1. Aomori
2. Akita
3. Iwate
4. Yamagata
5. Miyagi
6. Fukushima

KANTO
7. Gumma
8. Tochigi
9. Ibaraki
10. Saitama
11. Chiba
12. Tokyo
13. Kanagawa

CHUBU (incl. Hokuriku)
14. Yamanashi
15. Nagano
16. Gifu
17. Niigata
18. Toyama
19. Ishikawa
20. Fukui

TOKAI
21. Shizuoka
22. Aichi
23. Mie
24. Wakayama

KINAI
25. Shiga
26. Kyoto
27. Hyogo
28. Osaka
29. Nara

SAN'IN
30. Tottori
31. Shimane
32. Yamaguchi (northern)

SANYO
32. Yamaguchi (southern)
33. Hiroshima
34. Okayama

SHIKOKU
35. Kagawa
36. Ehime
37. Tokushima
38. Kochi

KYUSHU
39. Fukuoka
40. Saga
41. Nagasaki
42. Oita
43. Kumamoto
44. Miyazaki
45. Kagoshima

society that tended to be rather set in its ways. Therefore it is natural that cooking and eating utensils, farming implements, and other objects for use in everyday life should be the most important products bequeathed to us by that society. They were produced in great quantities, and they clearly show Yayoi art as the first manifestation of Japanese art as we know it today. This is especially apparent in Yayoi pottery.

Unlike Jomon pottery, Yayoi pottery depends on form rather than decoration to produce its artistic effect. Moreover, while never losing sight of the function of the object, it frequently succeeds in producing a beauty characterized by a purity and a grace that are unmistakably Japanese.

Wood also was frequently used for cooking and eating utensils and agricultural implements, probably because the manufacture of such objects in wood was part of the rice-growing culture complex that had come from central eastern and southeastern China. We know this because special stone axes, hollowed on one side or with one flat chisel-like edge, which are believed to have been used to fashion wooden implements, are found over an area extending from central eastern and southeastern China to southwestern Korea and western Japan.

A large number of edged tools and mirrors in bronze, and occasionally *heki* (circular jade ornaments) and other objects of semiprecious stone or glass, also entered Japan from the continent during the Yayoi period. For the most part, Yayoi man treated these articles as precious objects; even swords, spears, and halberds seem, in most cases, to have been looked on not as weapons for practical use but as ceremonial objects for use in religious rites or as symbols of authority. In the same way, mirrors, beads, and so on were kept less for personal use than as precious objects with religious or magical significance, or as charms to ward off evil. At this stage one can already see the beginnings of the idea underlying the "Three Sacred Treasures" later handed down in the imperial family. In a similar fashion a Chinese musical instrument, the *taku,* became in Japan the flattened, elongated *dotaku* (bronze *taku*), an unusual bronze object no longer suited to the practical purpose of producing a musical note but probably used in some ritual or ceremony.

In this sense, the fine art of the Yayoi period might even be described as a kind of religious plastic art. Moreover, this religion was not a matter of individual faith but the type of religion that forms the core of a society based on the agricultural community, and the objects produced were thus public works rather than private artistic creation. Therefore the bronze articles of the Yayoi period have a particular nature and purpose, which suggests in turn that their form and decoration were probably determined in accordance with definite ceremonial rules or conventions. They form a strong contrast with the clay pots and figurines made by Jomon men, who were able to give rein to their individual creative energies and to make patterns and shapes at will.

CHAPTER FOUR

The Tumulus Period: An Equestrian Culture

THE YAYOI PERIOD was followed by the Tumulus period. At some point during this period Japan became a unified nation and acquired writing and written records, thus entering upon what is known as the protohistoric age. In the same period, the national characteristics of the Japanese people became clearly defined and their culture became more diversified.

Some scholars divide the Tumulus period into three eras, Early, Middle, and Late, while others divide it into only two, Early and Late. I consider the latter division more appropriate; according to it, the Early Tumulus era lasted from the late third or early fourth century until the middle of the latter half of the fourth century, while the Late Tumulus era continued until the latter half of the seventh century. Between the Early and Late eras there is a great cultural discrepancy, so great that it is even doubtful whether the two represent a single line of development.

During the Early Tumulus era, tumuli put in their first appearance, and both round tombs and the distinctive "keyhole-shaped" tombs (round at the back and square at the front), making use of natural hills, began to be constructed. Inside these tombs, wooden coffins of the type known as "split bamboo" or "boat," made by hollowing out the two halves of a split log, were placed on a floor packed with a thick layer of clay. There were also boxlike stone coffins of a type carried over from the Yayoi period. Both wooden and stone coffins were sheltered in a long stone chamber, the so-called pit-type stone chamber. Coffins and chambers were all situated at a point close to the summit of the mound.

In the tombs of the Early era the objects buried with the dead consisted not so much of articles of practical use as of articles considered to symbolize wealth or authority or to have magical properties—things such as mirrors, swords, beads, stone bracelets, and hoe- or wheel-shaped stones. This burying of objects of symbolic or magical significance was already practiced in the tombs of individuals during the Yayoi period and was merely carried over into the Early Tumulus era. Technically, however, the objects are far more sophisticated—bronze mirrors and stone bracelets alike—than those of the Yayoi period. The quality of the materials is better, and many are of excellent design. This is particularly true of bronze mirrors. Whereas during the Yayoi period almost all these had been imported from China, in this period they were frequently made by the Japanese themselves. Many of them merely copy Chinese models, but some, decorated with original Japanese designs, bear witness to the development of metalwork as a decorative art in Japan.

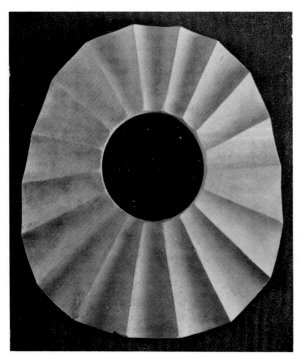
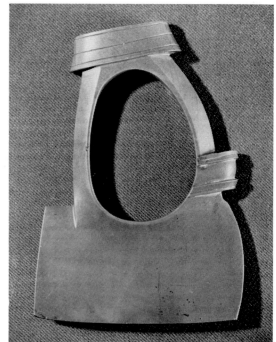

As a whole, the culture of the Early Tumulus era was a prolongation of that of the Yayoi period. It retained a considerable number of elements from the earlier period, and almost certainly had a strong flavor of the magical and the religious. It seems likely that the society that produced this culture, like the land of the Wa described in the Wei history, was still far from being a unified nation, and that sources of political authority were scattered in different parts of the country. Even so, it also seems likely that there was a fairly powerful concentration of authority in those areas where large tombs are more densely distributed. In the Kinai district, for example, in the area extending from present-day Nara Prefecture into present-day Osaka Prefecture in particular, many large tombs from the Early Tumulus era are found within a comparatively small area.

In some cases, large numbers of bronze mirrors brought over from China are found in these tombs, which suggests that those who held central authority in the Kinai district observed the custom of apportioning Chinese-made mirrors among those who held authority in the provinces. This custom of giving Chinese mirrors as symbols of power is one indication that authority at the time still, as in the Yayoi period, relied on the mystical and ritual sway it exerted over the people, rather than on the use of military or other force. One thing that should be noted here, however, is that the objects that had such importance in the Yayoi period as symbols of social authority or as objects for ritual use did not necessarily persist into this period. For example, the *dotaku*, bronze swords, and bronze spears disappear completely in the Early Tumulus era, and their roles are taken over by mirrors and beads or by stone bracelets, hoe-shaped stones, and the like.

During the Yayoi period, mirrors and bracelets

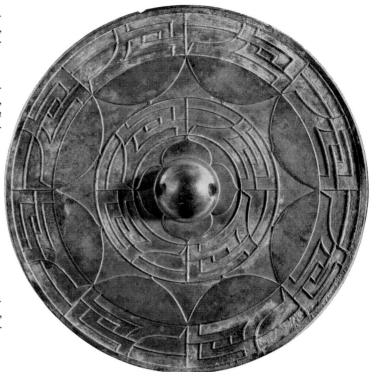

30 (opposite page, left). Wheel-shaped jasper bracelet (?). Early Tumulus. Length, 16.6 cm. Ishiyama Tomb, Ueno, Mie Prefecture. Kyoto University.

31 (opposite page, right). Hoe-shaped jasper bracelet (?). Early Tumulus. Length, 13.4 cm. Shikinyama Tomb, Ibaraki, Osaka Prefecture. Osaka Municipal Board of Education.

32. Bronze mirror decorated with chokkomon pattern. Early Tumulus. Diameter, 28 cm. Niiyama Tomb, Koryo, Nara Prefecture. Imperial Household Agency.

had been the personal possessions of individuals. This and the fact that the bronze swords, spears, and *dotaku,* which had been the symbols of religious or magical authority in the agricultural communities of the time, disappeared completely in the Tumulus period can perhaps be seen as an indication that the power of individuals and of clans over the agricultural community had increased significantly. This extended clan influence led to the development of local regional governments so powerful that they could have tumuli erected for influential individuals or their family members. Although the magical and religious traditions of the Yayoi period persisted to some extent into the Tumulus period, a social change had, it seems, occurred. Where there had been only scattered, classless agricultural communities, there now developed sources of political authority centering on individuals or on families. This marks the

emergence of a class society in which the symbols of social authority inevitably changed from those appropriate to an agricultural community to those appropriate to an individual or a family.

In the Late Tumulus era, massive tombs of the type typified by those of the emperors Ojin (r. end of the fourth century) and Nintoku (r. beginning of the fifth century) suddenly came to be erected on areas of level ground. Built in the keyhole shape, the round rear section and square front section being of approximately the same size and height, their most outstanding feature is their monumental scale, which at first glance might almost suggest the mausoleums of the continent. In their details, too, they differ considerably from those of the Early Tumulus era; the boat-shaped and split-bamboo wooden coffins of that era disappear in favor of wooden or stone coffins—such as the so-called assembled or chest-type stone coffins

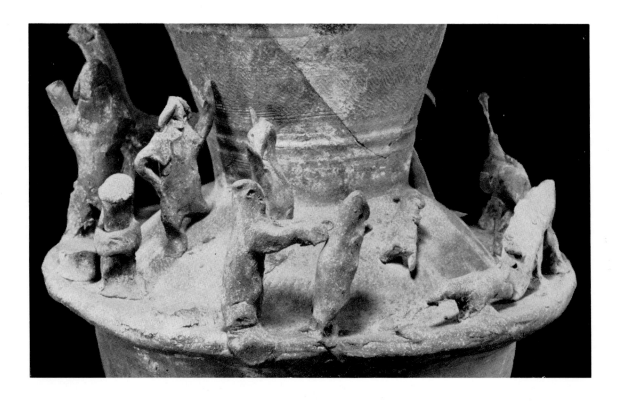

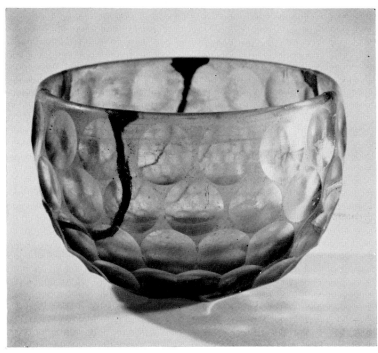

33 (above). Detail of figurines on shoulder of sueki jar. Late Tumulus. Minamizuka Tomb, Ibaraki, Osaka Prefecture. Osaka Municipal Board of Education.

34. Ancient glass bowl possibly of west Asian provenance. Height, 8.1 cm. Tomb of Emperor Ankan, Habikino, Osaka Prefecture. Tokyo National Museum.

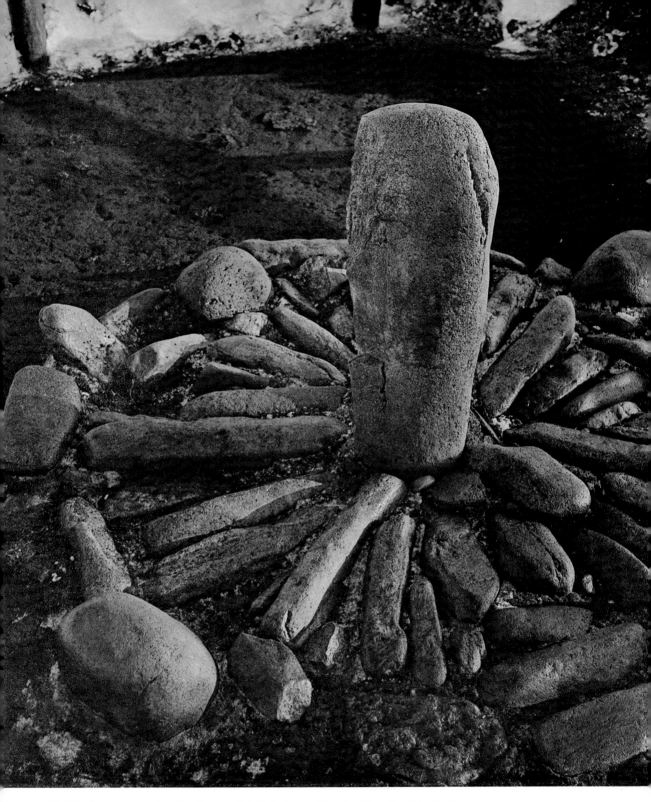

35. *Nonakado stone group said to be a sundial. Late Jomon. Oyu site, Towada, Akita Prefecture.*

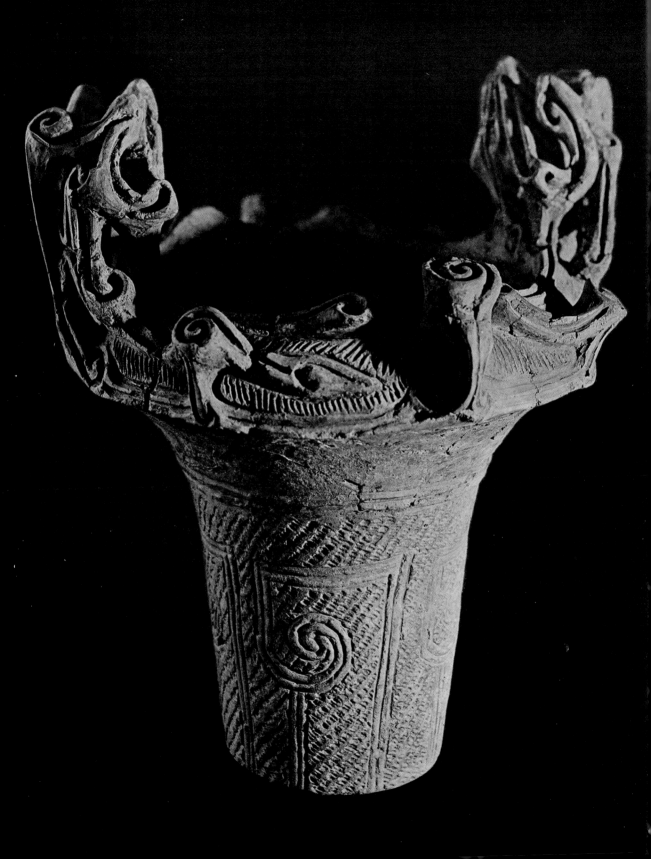

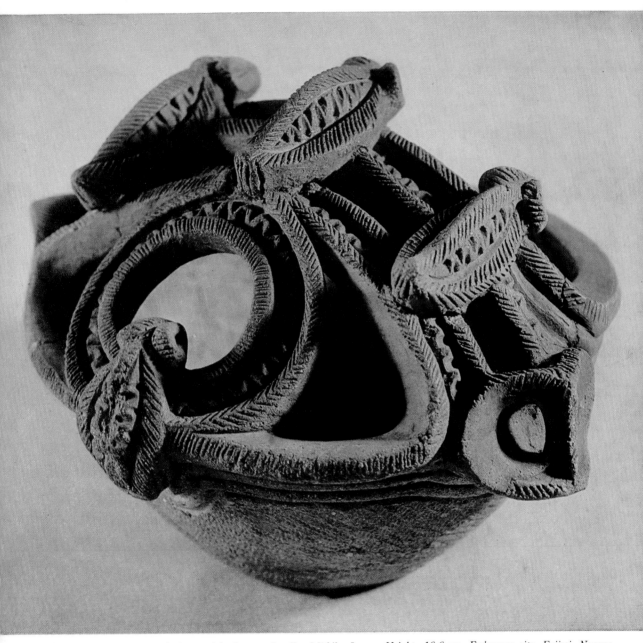

37. *Earthenware bowl with decorated basket-type handle. Middle Jomon. Height, 16.6 cm. Fudazawa site, Fujimi, Nagano Prefecture. Collection of Haruo Niwa.*

◁ 36. *Deep pot with elaborate ears projecting upward. Middle Jomon. Height, 33.4 cm. Umataka site, Nagaoka, Niigata Prefecture. Nagaoka Municipal Natural Science Museum. (See also Figure 86.)*

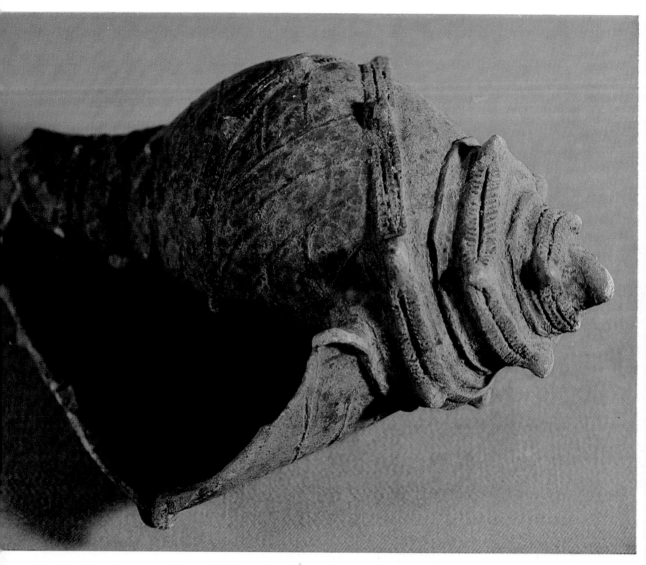

38. *Painted earthenware vessel in seashell shape. Late Jomon. Length, 16.6 cm. Ueyama site, Samboku, Niigata Prefecture. Collection of Koshiro Uehara.*

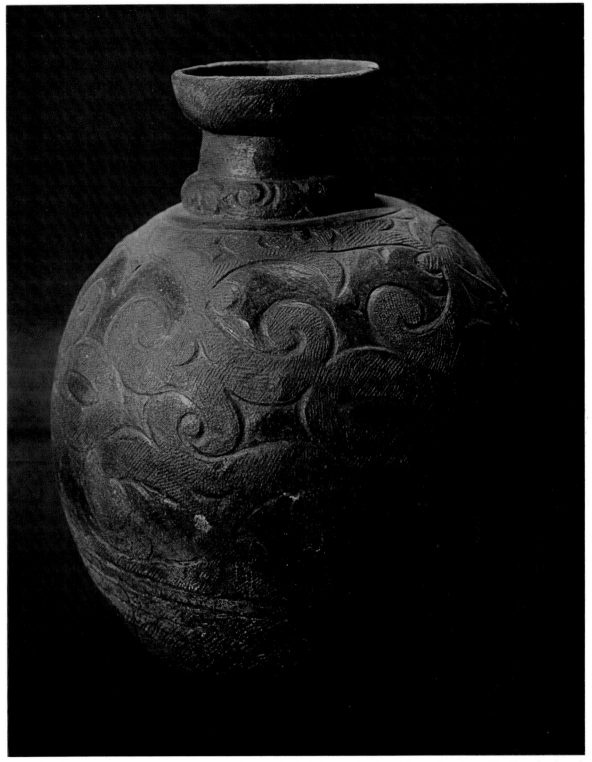

39. *Large painted jar with erased cord-impression design. Terminal Jomon. Height, 41.3 cm. Kawahara site, Towada, Aomori Prefecture. Collection of Mugeji Hakamada.*

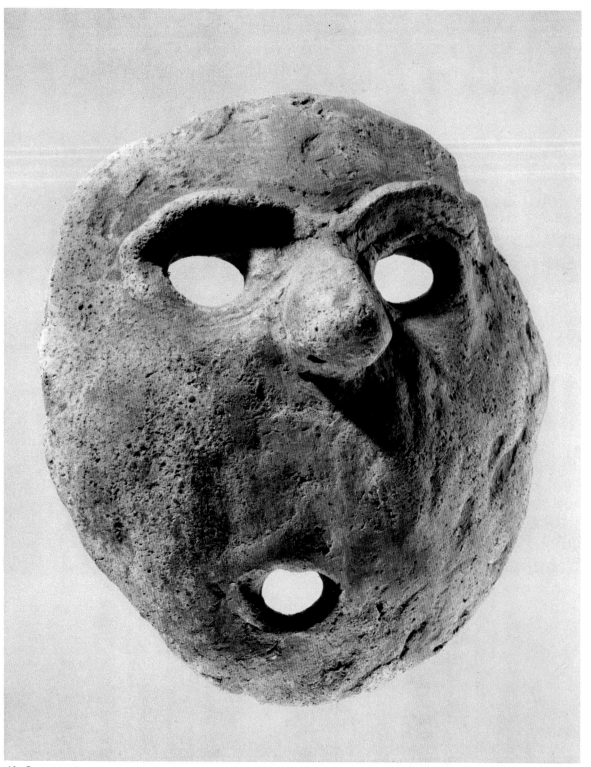

40. *Large-nosed earthenware mask with open mouth and eyeholes. Late Jomon. Diameter, 15.6 cm. Nakashimohara site, Hata, Nagano Prefecture. Tokyo National Museum.*

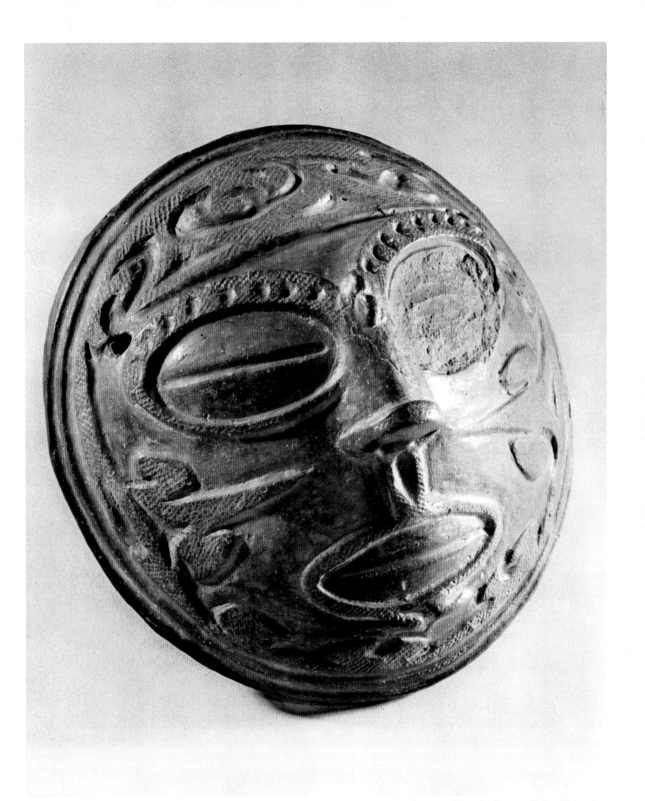

41. *Large-eyed earthenware mask. Terminal Jomon. Diameter, 14.6 cm. Aso site, Konosu, Akita Prefecture. Tokyo University.*

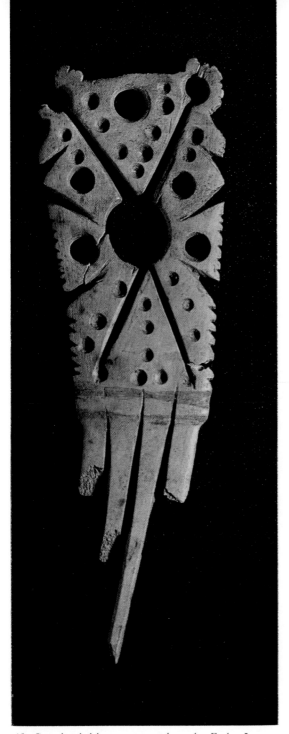

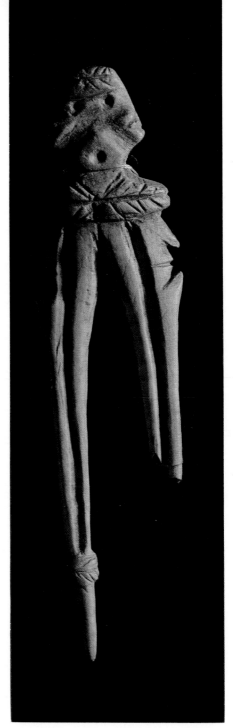

42. *Carved whalebone ornamental comb. Early Jomon.*
Length, 12 cm. Enokibayashi shell mound, Temmabayashi,
Aomori Prefecture. Hirosaki University.

43. *Deerhorn hair ornament carved in the shape*
of a man. Late Jomon. Length, 8.2 cm. Numazu
shell mound, Inai, Miyagi Prefecture. Collection
of Masasuke Kusumoto.

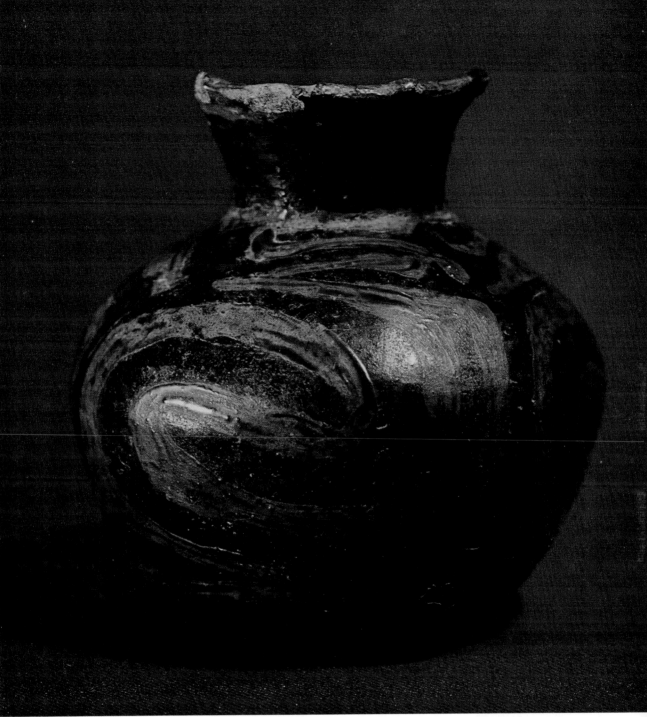

44. *Small jar with red lacquer design on black lacquer ground. Terminal Jomon. Height, 9.3 cm. Kamegaoka site, Kizukuri, Aomori Prefecture. Collection of Hisa Hirano.*

45 *(overleaf, left-hand page). Carved tuff figurine. Early Jomon. Height, 14.6 cm.* ▷
Mujinazawa site, Kosaka, Akita Prefecture. Keio University, Tokyo.

46 *(overleaf, right-hand page). Detail of head of carved wooden spatula (?). Terminal* ▷
Jomon. Nakai site, Hachinohe, Aomori Prefecture. Hachinohe Municipal Board of Education. (See also Figure 175.)

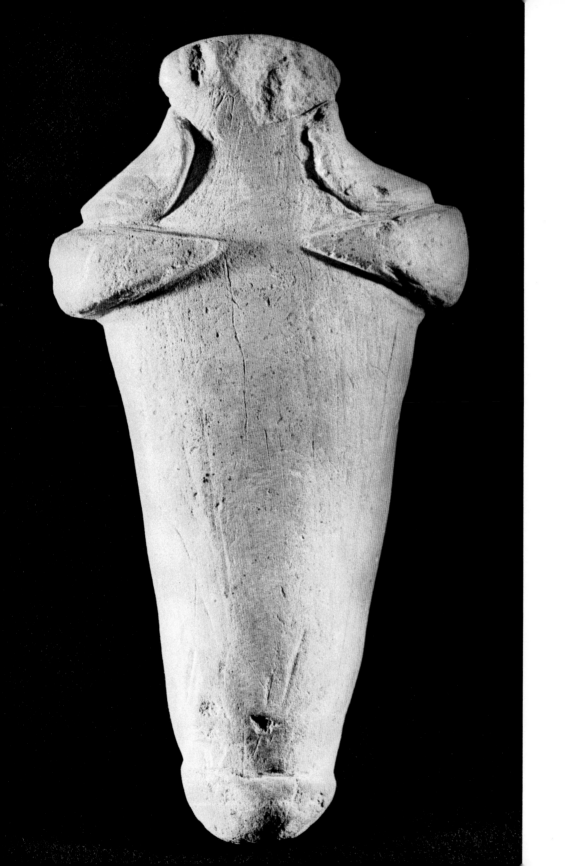

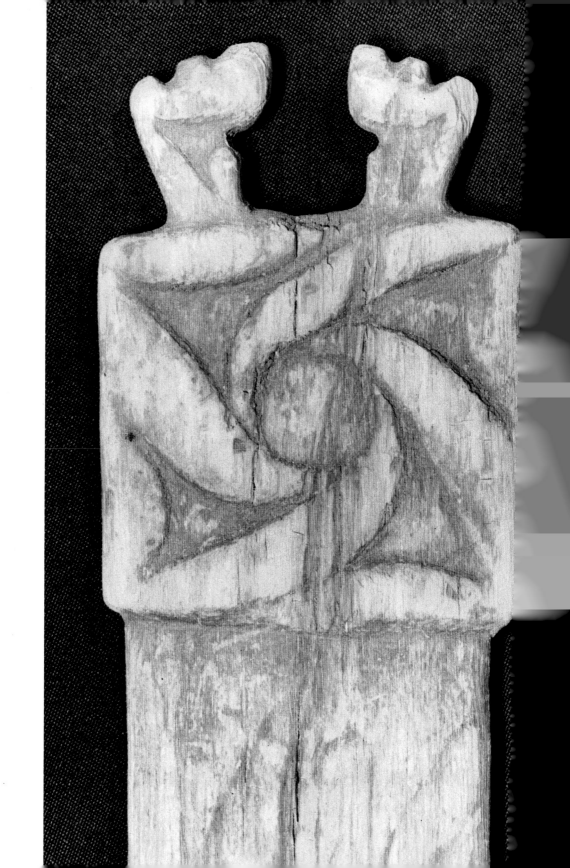

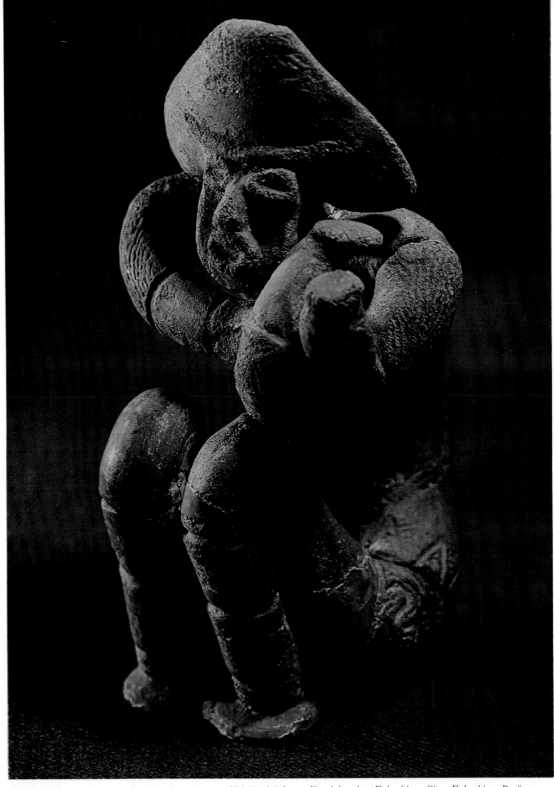

47. *Crouching earthenware figurine. Late Jomon. Height, 21.5 cm. Kamioka site, Fukushima City, Fukushima Prefecture. Collection of Ishichi Ohara.*

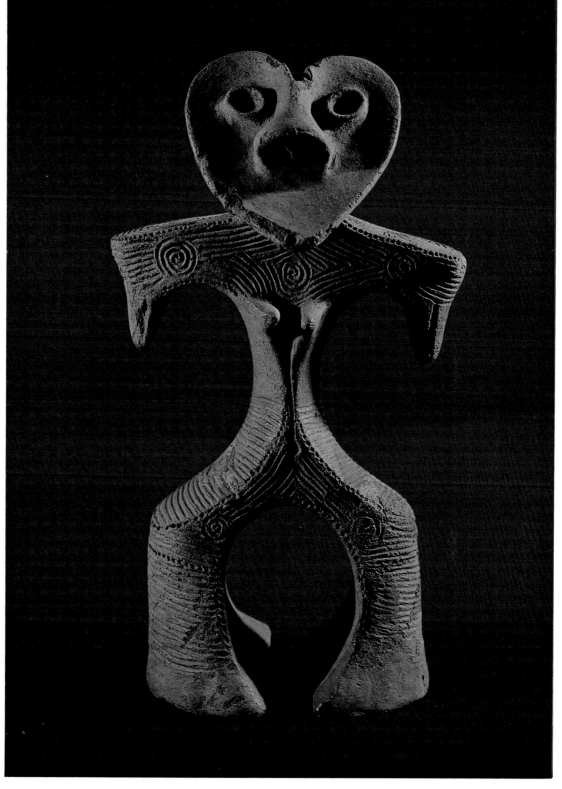

48. *Earthenware figurine with heart-shaped face. Late Jomon. Height, 31 cm. Gohara site, Agatsuma, Gumma Prefecture. Collection of Kane Yamazaki.*

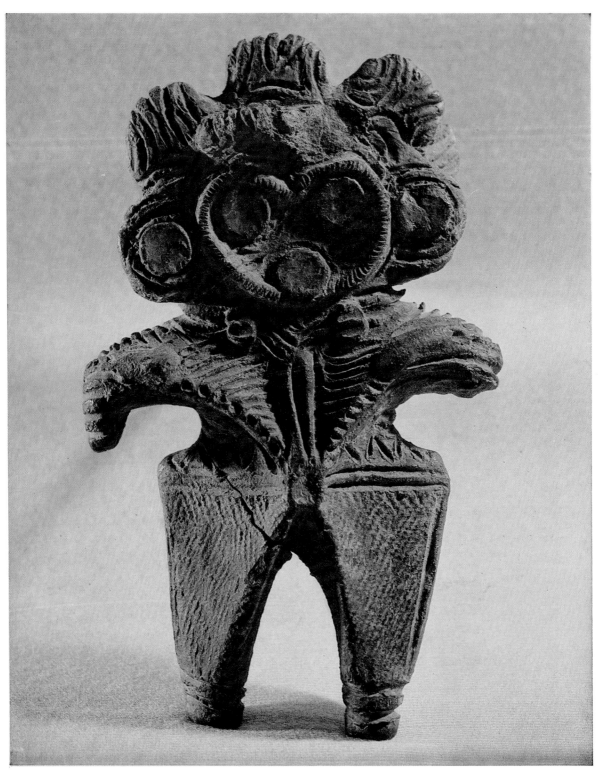

49. *Owl-faced painted earthenware figurine. Late Jomon. Height, 20.2 cm. Shimpuku-ji shell mound, Iwatsuki, Saitama Prefecture.*
Collection of Take Nakazawa.

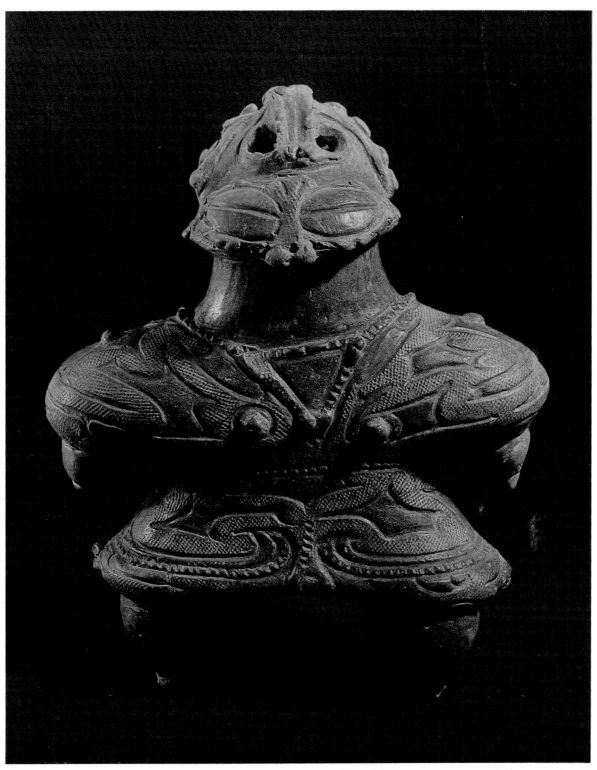

50. *Earthenware figurine with snow-goggle eyes and elaborate erased-cord-impression-pattern costume. Terminal Jomon. Height, 26.2 cm. Izumisawa site, Kitakami, Miyagi Prefecture. Collection of Masasuke Kusumoto.*

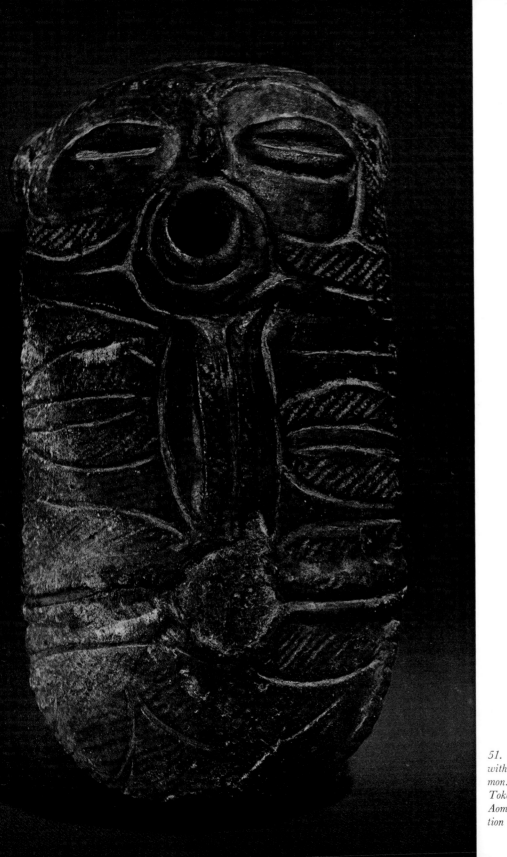

51. *Earthenware flute (?) with face design. Late Jomon. Length, 18.3 cm. Tokoshinai site, Hirosaki, Aomori Prefecture. Collection of Naohiko Kunika.*

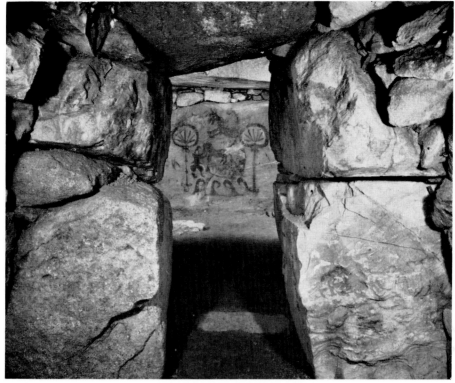

52. *Chamber-type tomb with wall painting of man and horse. Late Tumulus. Height of back wall, 140 cm. Takewara Tomb, Wakamiya, Fukuoka Prefecture. (See also Figure 110.)*

—that suggest a derivation from the Chinese continent and that were usually buried directly in the soil. As a result, the pit-type stone chambers, which had been long and narrow in the Early Tumulus era, now became wider than they were long.

Following this again, tombs with corridor-type stone chambers that clearly derive from the continent were built in large numbers, some of them with decorations, including mural painting inside the chamber. Thus, though in tombs of the Late Tumulus era the outer form—the keyhole shape—remains much as it always was, there are variations in the form of the inner stone chamber and the coffins, until finally there develops a completely continental corridor-type stone-chamber tomb.

The most striking difference between tombs of the Early and Late Tumulus eras is in the objects that were placed alongside the dead. Whereas in the Early Tumulus era these objects had a religious or magical significance—in a sense, as a treasure—in the Late Tumulus era they were replaced by weapons and objects of everyday use, or by stone replicas of these articles. Still later, dishes and bowls, articles of personal adornment, and equine trappings were placed in the tombs, as well as *haniwa* representing men and women, horses with decorative trappings, birds and animals, houses, weapons, boats, and many other objects. These *haniwa* had much the same significance as the *ming ch'i* (ancient Chinese funerary figures) of the

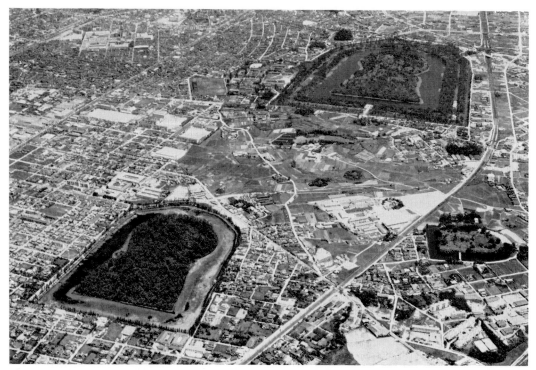

53. *Great tumuli: above, tomb of Emperor Nintoku; below left, tomb of Emperor Richu. Late Tumulus. Sakai, Osaka Prefecture. (See also Figure 161.)*

continent and show that the funeral rites being performed in Japan were inspired by a view of life after death similar to that held on the continent.

The weapons, equine trappings, articles of personal adornment, and so on (which are known to us not only directly but also via the *haniwa*) are almost identical with those of the equestrian peoples of northeastern Asia—the "barbarian" tribes to the Chinese—who were active in Mongolia and the northern and northeastern districts of China during the Wei, Chin, and Northern and Southern dynasties periods, from the third on into the fifth century. The culture of these northeast Asian tribes was a mixture of those of the equestrian peoples who dwelt in northern Eurasia at the time and of the Han people in China. From Chin times (263– 420), there was a large-scale migration of the

people of northern Asia to the area on either side of the Great Wall of China, some founding the states known as the Sixteen Kingdoms, while others established the kingdoms of the Koguryo and Puyo peoples to the northeast of China. As a result, a Sinicized version of their equestrian culture came into being and spread over a wide area of the Eurasian continent from Koguryo in the east as far as Hungary in the west. This culture is not unrelated to the so-called Scythian equestrian culture. Indeed, it is likely that the latter formed the foundation on which it developed, but so strong was the influence of Chinese culture to the east and so diverse were the forms it developed in different areas that it came to differ considerably from the Scythian culture. Moreover, it prevailed over a far wider area than the Scythian culture, and its

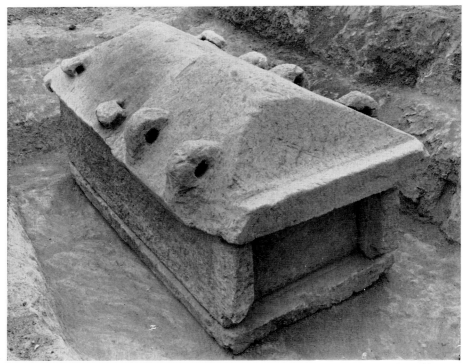

54. Assembled-type stone sarcophagus. Late Tumulus. Height, 135 cm. Otani Tomb, Wakayama City, Wakayama Prefecture. Wakayama Municipal Board of Education.

sphere of influence extended in the east as far as Korea and Japan.

While it is possible to distinguish between the culture of the Scythians and that of the northeast Asian tribes, they share the most characteristic feature of cultures created by equestrian peoples— the emphasis on saddles, bridles, reins, and other articles made to facilitate the firing of arrows while riding horseback; the bows and arrows themselves; clothing and armor suitable for riding; and decorative trappings for the horses. In Japan the Late Tumulus era saw the prevalence of a culture with a warlike, practical nature contrasting strongly with the peaceful, religious, and symbolic nature of the culture that had characterized the period from Yayoi times through the Early Tumulus era. The personal adornments of this earlier period had been

relatively crude, but in the Late Tumulus era many of them were elaborate and had a pronounced exotic flavor.

It is noteworthy that all of these features are identical with the cultures of the peoples of northeastern Asia. To take an example from men's clothing, the jackets with pipelike sleeves and the baggy trousers used for riding were worn with a leather belt with a buckle from which various ornaments were hung. Precisely the same type of clothing was found everywhere from the northeastern districts of China and Korea in the east to southern Russia and Hungary in the west.

A short armor protecting only the chest and trunk also appeared, and armor made by threading together a large number of iron laminae came into general use. A type of sword known as *kanto-no-tachi*

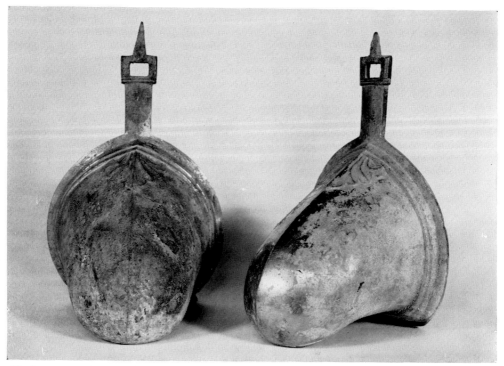

55. Bronze cup stirrups with palmette design. Late Tumulus. Height, 27 cm. Miyajidake Tomb, Tsuyazaki, Fukuoka Prefecture. Miyajidake Shrine, Tsuyazaki.

(ring-pommeled sword), its round pommel decorated with phoenix and dragon designs (Fig. 56), was widely used. Bows and arrows included an unusual arrow made of bone or horn, which emitted a sound when fired. This type of arrow, peculiar to the peoples of northern Asia, was used in battle as a signal to charge. Horse trappings included elaborately decorated saddles, bits, stirrups, and even armor for the horse itself.

It is clear from ancient relics and records that weapons and horse trappings such as these were used in northern China from the third into the fifth century by the Hsiung-nu, Hsien-pei, and other tribes that came south from the areas north of China. They were spread to the northeastern districts of China by the peoples of Koguryo and Puyo, among others. Taking a broad view, one might say that the Late Tumulus culture of Japan marked the easternmost limit of this horse-riding culture that covered the whole of inland Eurasia.

The Late Tumulus era entombment of large numbers of the products of this military, eminently practical culture, including a wealth of everyday articles, marks the appearance of the idea that after death man enjoyed the same kind of life he had lived on earth. Thus, during the Late Tumulus era the peaceful, agricultural, magico-ritualistic, Southeast Asian qualities of the culture of the Yayoi period and the Early Tumulus era were replaced to a large extent by the very practical, warlike, king-and-noble-dominated, North Asian qualities of the equestrian people. There is an essential difference between the Early and

56 (right). Bronze pommel of iron kanto-no-tachi *with openwork design of twin dragons fighting over jewel. Late Tumulus. Width of pommel, 12 cm. Kinreizuka Tomb, Kisarazu, Chiba Prefecture. Kisarazu Municipal Board of Education.*

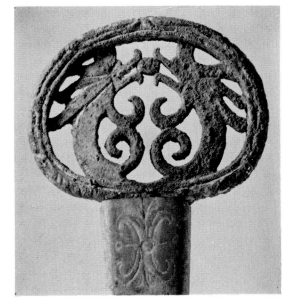

57 (below left). Large earthenware replica of archer's arm protector, restored. Late Tumulus. Height, 38.5 cm. Doyama Tomb, Iwata, Shizuoka Prefecture. Iwata Municipal Board of Education.

58 (below right). Bronze belt ornament with dragons in openwork, above, and relief, below. Late Tumulus. Overall length, 10.4 cm. Kokuzuka Tomb, Kyoto. Tokyo National Museum.

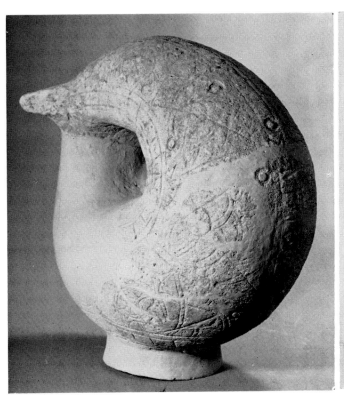

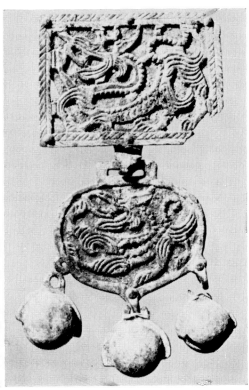

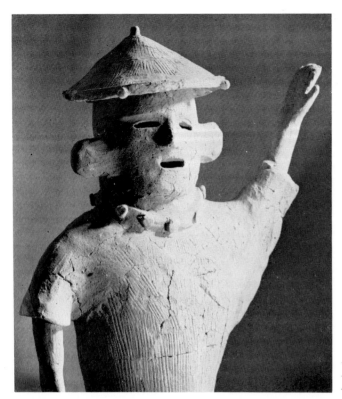

59. Haniwa *farmer wearing hat. Late Tumulus. Height, 98 cm. Himezuka Tomb, Yokoshiba, Chiba Prefecture. Shibayama Haniwa Museum.*

Late Tumulus eras, a difference that by arising suddenly and within a short period of time makes it difficult to see the latter era as a logical continuation of the former.

Because Japan still had no written records at the time, it is difficult to determine the causes and processes of these unheralded changes. However, they were probably not due to any voluntary decision by the Wa people—the men responsible for the Yayoi and Early Tumulus cultures—to introduce this new culture. It would seem likely that a body of men invaded northern Kyushu from the continent via Korea, bringing the culture with them and going on to conquer the Kinai district, establish the Yamato court, and play a central role in the building of a unified nation.

In the field of art, northeast Asian elements are prominent in the forms and designs of horse trappings, weapons, and the like. Characteristics of continental art of the period are also apparent in the construction of the tombs and the form of the coffins, as well as in the mural paintings inside the tomb chambers and the *haniwa* that were stood on the grave mounds. All are obviously related to the continent, reflect the practical temperament of the equestrian peoples, and give uncomplicated, unaffected expression to various aspects of everyday life. The religious quality seen in the art of the preceding period gives way to works that are intensely concerned with the business of living.

Aesthetic trends from the continent (the traditions of Han art with an admixture of Hellenistic and Buddhistic art) were being transplanted with little change to Japan, where they found a ready

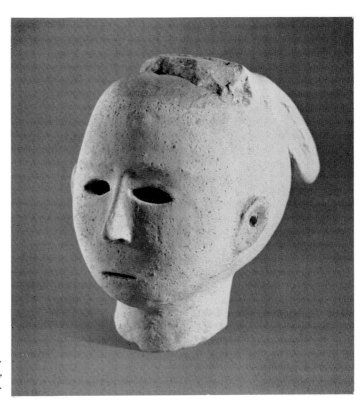

60. *Head of* haniwa *woman. Late Tumulus. Height, 20 cm. Tomb of Emperor Nintoku, Sakai, Osaka Prefecture. Imperial Household Agency.*

welcome at the Yamato court and among the ruling class as a whole. They were taken over and in time gave birth to new, Japanese variations. It should be noted that when the equestrian people of northeastern Asia conquered and took control of Japan—when, in terms of Japanese mythology, the celestial gods, *amatsukami,* gained control of the local gods, *kunitsukami,* of the men of Wa—they were unable, partly because of the fact that Japan is an island country, to drive out what they found there. Skilled though they were in conquest by military force and government by political means, they were obliged to rely on the men of Wa where economic matters were concerned. It was this that brought about the intermingling and blending of the two peoples and the emergence of a new nation in Japan. This is important to understanding Japanese culture as a whole.

CHAPTER FIVE

The Center of Jomon Culture: Hokkaido and the Tohoku Area

ARCHAIC AND EARLY JOMON POTTERY The area extending from Hokkaido down into the northern part of Honshu was most likely, geographically speaking, to be influenced by the culture of the continent and of Siberia in particular, and was accordingly one of the first areas of the Japanese archipelago to develop a special culture of its own. During the pre-pottery period, a culture represented chiefly by stone blades developed over a wide area of Hokkaido. In a large number of districts this went over into a microlithic culture, while there was also a stone culture that used the so-called stone-blade arrowheads derived from the stone-blade culture. These various elements of stone culture clearly represented the spread of, or influence from, the culture of the Siberian and Mongolian areas.

Facts such as these tend to confirm the theory that the first appearance of pottery in Japan was part of a cultural incursion from the same areas of Siberia that brought the stone-blade arrowhead and that this period (what we have called the Primeval Jomon era) probably began about three thousand years before the Christian era.

The pottery of the Archaic Jomon era is extremely characteristic, much of it consisting of pots or urns with pointed bases, though there are also some with rounded or flat bases. Outside Japan

this kind of vessel with a pointed base appeared at a very early date in the areas around the Baltic; for long after that it was the characteristic shape of ancient pottery in Russia and Siberia, and it also served as the basic shape for combed-pattern pottery. The facts that this combed-pattern pottery spread from Baikal into Mongolia, the northeastern districts of China, and Korea and that Archaic Jomon pottery found in Hokkaido and the northern extremity of the Tohoku area is often embellished with shell-impressed, grooved patterns and other patterns similar to the combed pattern suggest that around the time when pottery began to be made in this area there was an influence from the combed-pattern pottery of Siberia.

Many of the patterns on pottery were originally evolved not out of any desire for decoration as such but from the technical necessity of giving some kind of finish to the surface. However, even in the Archaic Jomon era the pottery of Hokkaido and the Tohoku district shows patterns that must surely have been intended as decorative from the very outset. In particular, there is a tendency to decorate the rims of pots with bands of pattern (Fig. 61). There are also various types of patterns that are applied to the whole pot, including twisted-string and cord-impression patterns and shell-impressed and marked patterns, as well as all kinds of pat-

61. Deep earthenware pot with pointed base, greatly restored. Archaic Jomon. Height, 42 cm. Tatedaira site, Hachinohe, Aomori Prefecture. Keio University, Tokyo.

terns created by combining or mixing these (Fig. 62). Archaic pots with twisted-string or cord-impression patterns are distributed over a wide area of southern Hokkaido and the northern Tohoku area, while pots with patterns made by coiled-cord or shell impression are common in northeastern and southern Hokkaido. Therefore it seems likely that the pottery culture of the continent came across in two streams: one that flourished in both Hokkaido and the northern part of the Tohoku district, and another that went no farther than Hokkaido. The Jomon pottery culture that came into being as a result of the intermingling of these two streams not only spread throughout almost the whole country but also formed the mainstream of pottery culture in Japan for close to three thousand years.

With the Early Jomon era, the shapes of the clay vessels began to change, and the so-called cylindrical type—roughly cylindrical, with a flat bottom—

became common. This type of vessel seems to have been centered in the Tohoku district, where many specimens have been unearthed. They have a band of pattern on the rim and are frequently decorated with raised ridges, feather-shaped or oblique cord-impression patterns, or other fine cord patterning over the whole of the body (Fig. 64). The general appearance is nevertheless plain. There is little evidence of any desire to place emphasis on the pattern in exaggerated decoration; the total effect is one of solid utility, and not a few of the pots have a great dignity and assurance.

Besides the cylindrical urns there are pots that narrow toward the base and mouth. A good example of these pots is the one with a stand and wide, flared lip excavated at Fukura in Yamagata Prefecture, which is interesting for the decorative pattern of raised lines on its body (Fig. 63). This decoration can probably be seen as a precursor of

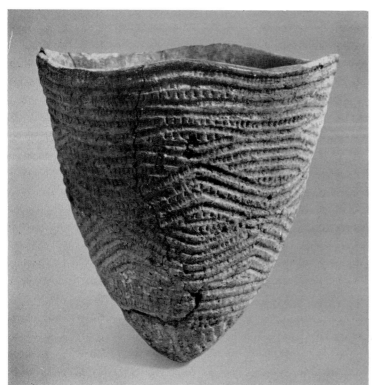

62. *Earthenware pot with pointed base and wave-pattern decoration. Archaic Jomon. Height, 16.6 cm. Todohokke site, Hokkaido. Hakodate Museum.*

63 *(opposite page, left). Footed earthenware* ▷ *bowl with raised-line decoration. Early Jomon. Height, 19.7 cm. Fukura site, Yusa, Yamagata Prefecture. Chido Museum, Tsuruoka.*

64 *(opposite page, right). Deep earthenware* ▷ *pot with incised feather-shaped pattern. Early Jomon. Height, 36 cm. Kanisawa site, Hachinohe, Aomori Prefecture. Keio University, Tokyo.*

the raised-line patterns that were popular in the Middle Jomon era.

Until the Early Jomon era the areas embracing Hokkaido and the northern part of the Tohoku district were the center of the Jomon culture sphere: the site of all the most advanced and creative cultural activity. This fact is probably related to the supreme suitability of these areas for the hunting and fishing life. A comparatively large number of Early Jomon shell mounds and dwelling sites have been found in these areas. There is also a large variety of bone or horn fishhooks, harpoons, and the like—which suggests that there was a plentiful supply of prey for the hunter and fisherman.

By this time, various articles of personal adornment, including the so-called "broken circle" earrings and all kinds of decorative beads, were being made and worn: culture was already catering to man's spiritual, and not merely his material, needs. A striking example of this development can be seen in the clay and stone figurines that first appeared, chiefly in the Tohoku area, during the Early Jomon era.

The oldest stone figurine known (Fig. 45) is that unearthed at Mujinazawa in Akita Prefecture. In form it might suggest a figure of the earth goddess, but it also resembles a phallus in some respects and may indeed have been related to phallic worship. Most of the clay figurines of the Early Jomon era are simple, having no features other than a flat face and two breasts. It is difficult to determine the motives that inspired the making of such figurines, but they are a sign that Japan was no exception to the general rule that sculptural

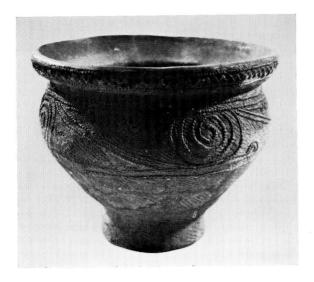

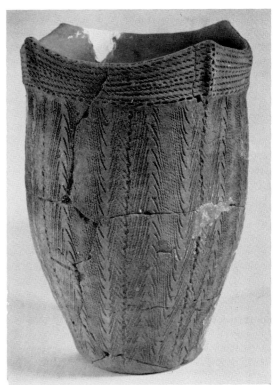

creation begins with the making of figurines from materials such as clay, stone, bone, or horn.

THE TERMINAL JOMON CREATIVE REVIVAL

In the Middle Jomon era, the center of the Jomon pottery culture shifted to the Kanto and Chubu districts, where it developed highly sculptural and decorative pottery forms whose influence extended back again to the Tohoku district. However, the waves of this pottery culture do not seem to have reached Hokkaido. In the Tohoku area, cylindrical pots in the tradition of Early Jomon continued to be made (Fig. 65), and some of them were decorated with the raised-line whorl patterns (Figs. 10, 168) that originated in the Kanto area. However, compared with the raised-line patterns on Middle Jomon pottery from the Kanto area, they are timid and lack depth.

In the Late Jomon era, pottery with flowing patterns of curved lines reminiscent of seaweed put in an appearance; a typical example is the urn found at Sannohe in Aomori Prefecture (Fig. 66). As decorative design, these vessels show great originality and a grace unusual in Jomon pottery, and in this respect are worthy of note as the special product of a particular locality.

In the Terminal Jomon era, the hunting and fishing people of the Tohoku area began to be active once more. The pottery culture revived, and remarkable strides were made in the production of stone, bone, and horn implements. The vessels are predominantly jars, though bowls (Fig. 173) and pots with spouts (Figs. 4, 68) also put in an ap-

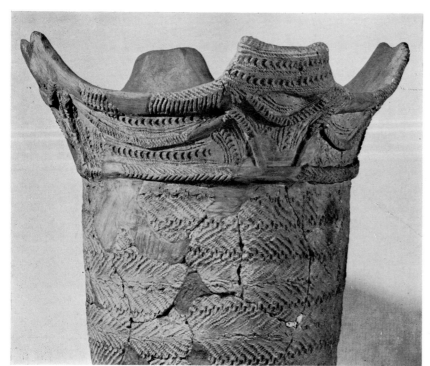

65. Detail of mouth and ears of deep earthenware pot, restored. Middle Jomon. Ichioji shell mound, Hachinohe, Aomori Prefecture. Tokyo University.

66. Detail of seaweedlike pattern on deep earthenware urn. ▷ Late Jomon. Izumiyama site, Sannohe, Aomori Prefecture. Collection of Yashichi Hakamada.

pearance. Furthermore, there was a general tendency for vessels to become smaller. They are decorated with raised-line patterns on a ground of cord-impression pattern, though use was also made of a special technique termed "erased cord impression," in which parts of the cord-impression pattern were rubbed out so as to leave a decorative pattern standing out against a plain background (Figs. 39, 68, 173).

Kamegaoka-type pottery, the most important pottery of the Terminal Jomon era, acquires its name from the Kamegaoka site in Aomori Prefecture, where large numbers of the pots have been unearthed. They include ware of a refinement scarcely paralleled in pottery of the prehistoric period anywhere else in the world. It is noteworthy that it was produced in such large quantities, with such a variety of shapes and patterns. Occasionally

there are vessels too small to serve any practical purpose, while others, such as the so-called incense-burner pots (Fig. 67), are too odd in shape to have been of any practical use. It is interesting that together with Kamegaoka-type pots we find lacquer vessels done on wooden or plaited-bamboo bases—objects of a luxury hitherto completely unknown in Jomon culture. Indeed it seems possible that the high-grade pottery and lacquerware were intended not for use in everyday life but principally as ritual vessels with some religious significance.

The question arises of whether this characteristic culture of the Terminal Jomon era really emerged spontaneously from the traditional hunting and fishing ways of life pursued throughout the period so far, or whether it represents a transformation wrought by the influence of the Yayoi culture. The existence of lacquerware in the Tohoku area at this

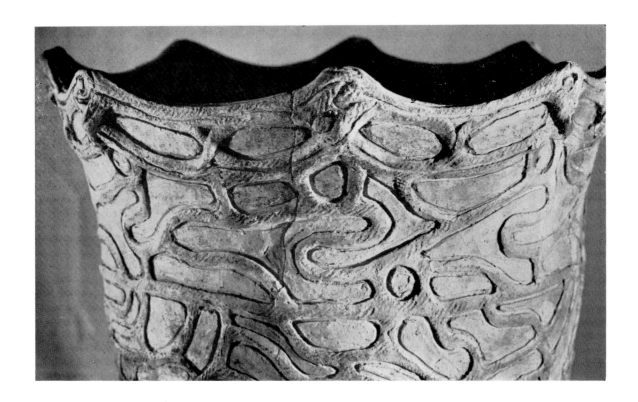

time would seem to offer one key to the solution. Lacquerware, from the very nature of its materials, is generally considered to be a product of southern Asia, and if its production in Aomori Prefecture, in northernmost Honshu, originated in isolation from other areas, we must look for some very special circumstances. It is at least significant that so much lacquerware should have been excavated at Terminal Jomon sites in Kamegaoka, Korekawa, and elsewhere in the very north of Honshu.

By the Middle Jomon era, clay figurines were already developing more sculptural qualities in this region, and in the Late era and on into the Terminal era the figurines begin to show considerable originality of design (Figs. 47, 69, 70). In the Terminal Jomon era, figurines dressed in richly decorative clothing and with the characteristic eyes popularly referred to as "snow goggles" were pro-

duced in large numbers (Figs. 8, 50, 174). Female figurines with the same type of eyes have been found in Central America, and these eyes are known in the West as "coffee-bean eyes." The similarity is doubtless coincidental, but it is an interesting phenomenon.

The sculptural creativity of the men of Jomon times gave birth to richly decorative forms in stone figurines (Fig. 79), and in other spheres a large number of elaborate works were made from the Late era onward. For example, a wooden spatula (Figs. 46, 175) and the head of a stone club (Fig. 80) are decorated with low-relief carving, and objects made of deerhorn and believed to have been hair or waist ornaments are also carved. The desire for greater beauty in personal possessions was leading to the production of a variety of decorative art objects.

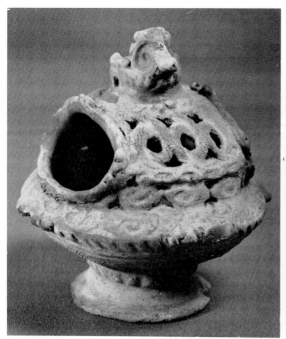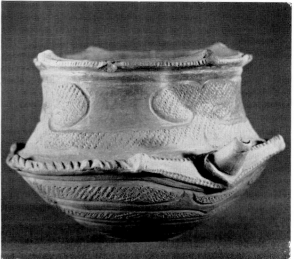

EXPRESSIONS IN STONE Other special phenomena that occurred in the north of the Tohoku area and in Hokkaido include arrangements of stones such as stone circles and menhirs; the "salmon rocks," which are simple depictions of salmon engraved on living rock; and pictures carved in the walls of caves.

The most important specimens of stone circles are found near Otaru in Hokkaido and at Oyu, Akita Prefecture, in the Tohoku area. The stone circles found in Hokkaido include some up to 30 meters in diameter. They have a square pit in the center in which bones were buried, and there are signs that pebbles were strewn on top, so the theory has been advanced that they were tombs. Similar tombs with stone circles were made in large numbers in Siberia from the Bronze Age on into the early Iron Age. The stone circle at Oyu (Figs. 35, 179) has a large upright stone in the center, with other stones arranged about it like the spokes of a wheel. Noth-

ing precisely like this is to be found on the continent, but there are many types of stone arrangements extending from Siberia into the Mongolian steppes, and a connection with them seems likely.

In Japan the salmon rocks (Figs. 81, 181) are unique to the southern part of Akita Prefecture, but many fish-shaped stone carvings suggestive of salmon have been unearthed at Neolithic sites in the Lake Baikal area of Siberia. The latter are believed to have been offerings made to the gods in the hope of an abundant haul of salmon, and it seems likely that the Jomon men of the Tohoku area carved the salmon rocks with the same idea in mind.

In Hokkaido, a rockface at the Temiya site (Fig. 182) and the Fugoppe Cave (Fig. 82) both bear engravings believed to be extremely simplified pictures of human beings and animals. These, too, are almost certainly closely related to the continent. The patterns are close to certain of the signs

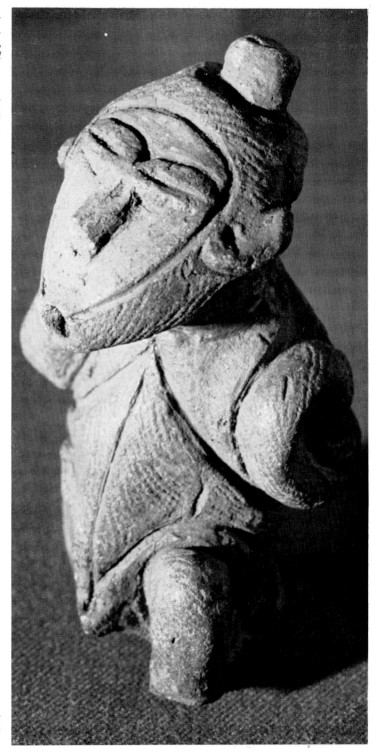

69. Monkeylike earthenware figure decorated with incising and cord-impression pattern. Late Jomon. Height, 11.3 cm. Yuasatate site, Nambu, Aomori Prefecture. Nambu Town Board of Education.

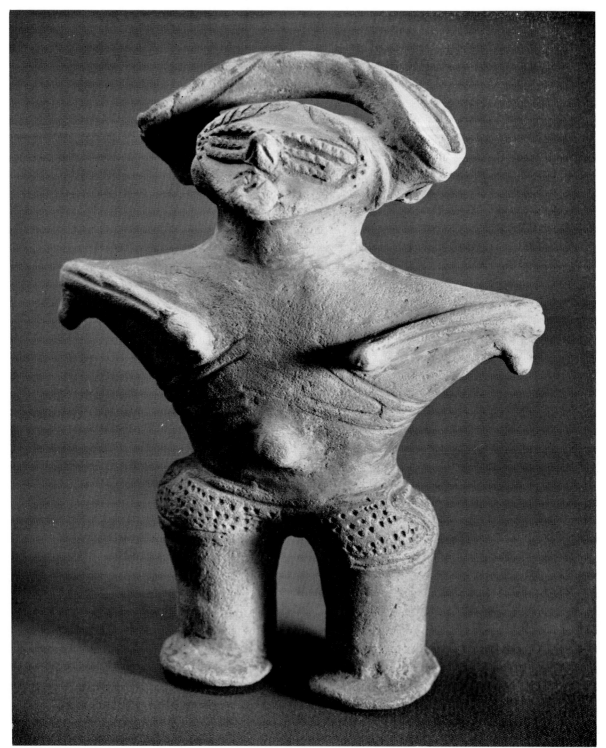

70. *Female earthenware figurine with unusual topknot. Terminal Jomon. Height, 23 cm. Kamabuchi site, Mamurogawa, Yamagata Prefecture. Shogen-ji, Mamurogawa.*

71. *Earthenware ewer with decorative incised patterns. Middle Yayoi. Height, 22 cm. Niizawa site, Kashihara, Nara Prefecture. Sugahara Primary School, Nara.* ▷

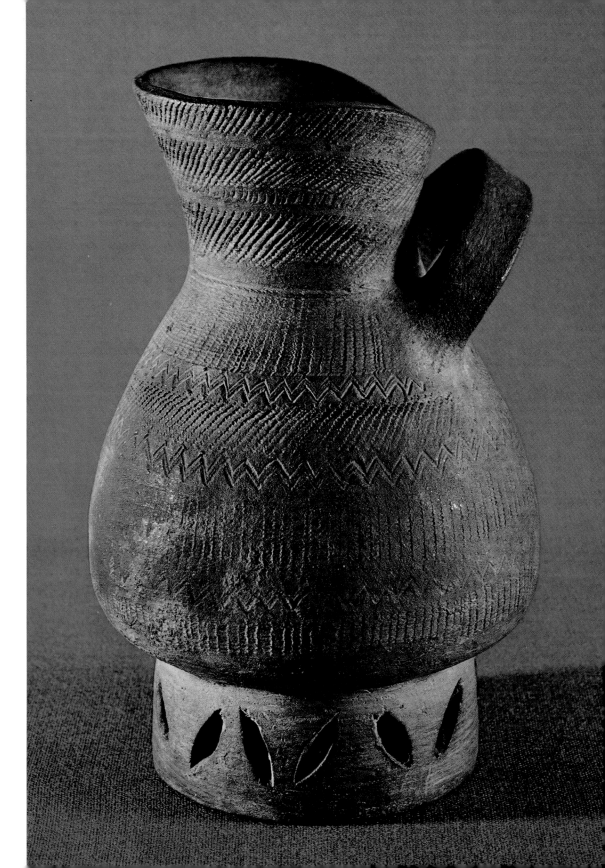

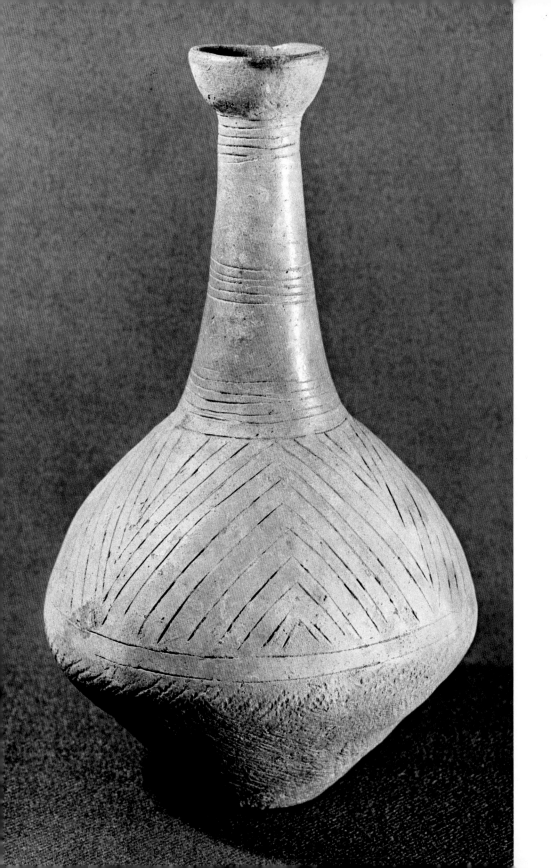

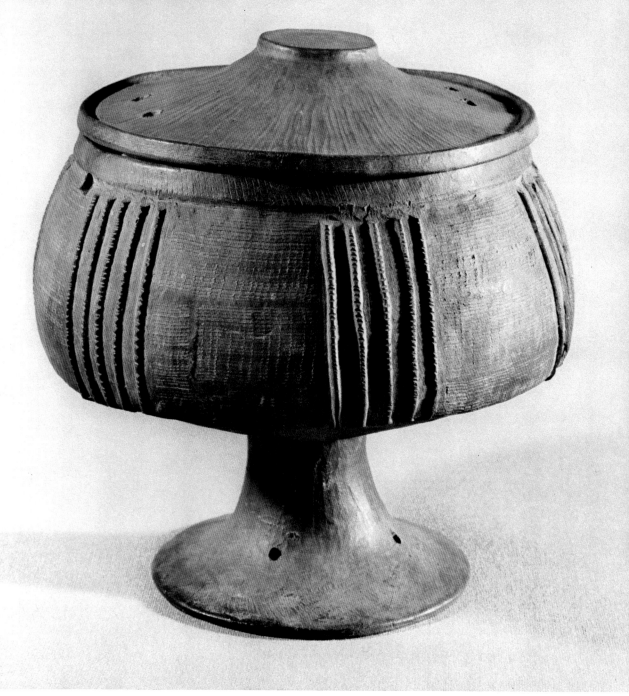

73. *Lidded earthenware vessel with raised foot. Middle Yayoi. Height, 21.5 cm. Uriwari Nishinocho site, Osaka. Collection of Shigezo Umano.*

◁ 72. *Long-necked earthenware jar. Middle Yayoi. Height, 29 cm. Enda site, Zao, Miyagi Prefecture. Tohoku University, Sendai.*

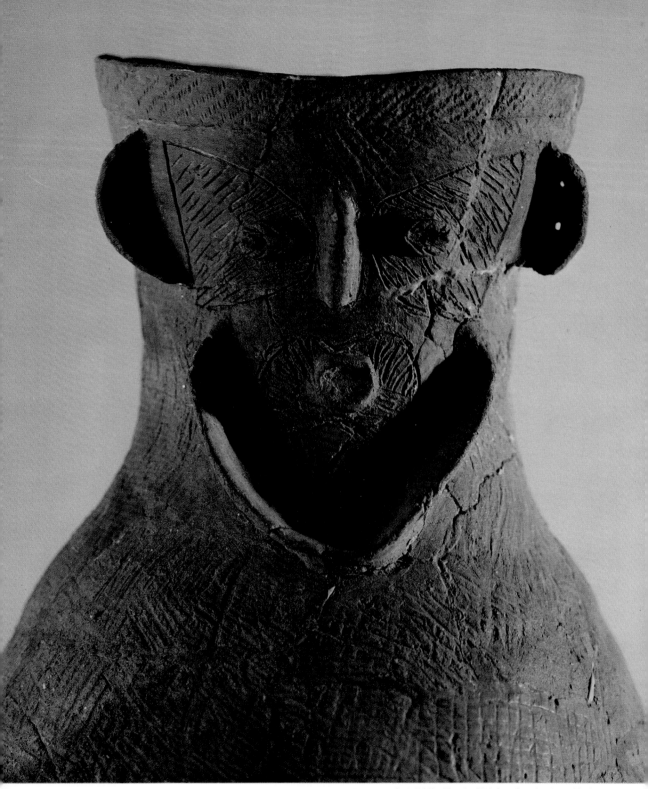

74. *Detail of large earthenware jug with face decoration on neck, partly restored. Middle Yayoi. Height of entire jar, 69.5 cm. Osakata site, Shimodate, Ibaraki Prefecture. Tokyo National Museum.*

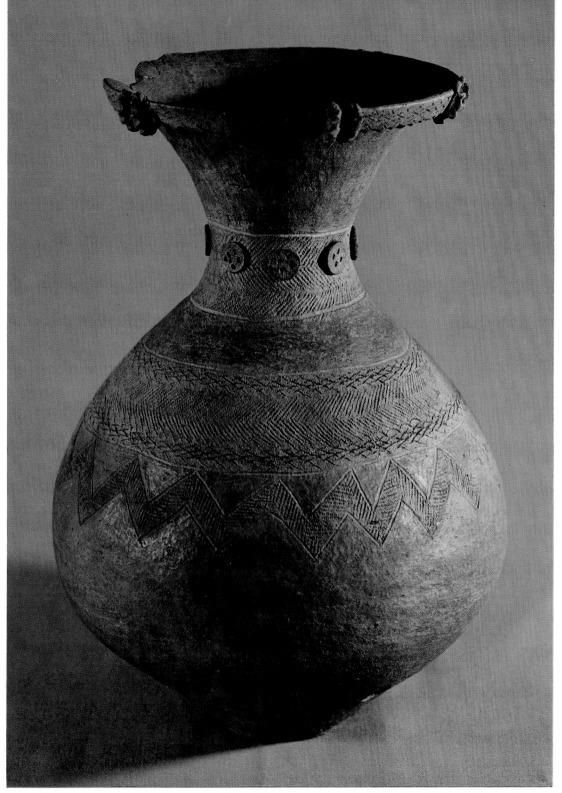

75. *Earthenware jar with incised patterns and buttonlike ornaments on neck. Middle Yayoi. Height, 36.3 cm. Kugahara site, Tokyo. Collection of Hisatsugu Ochiai.*

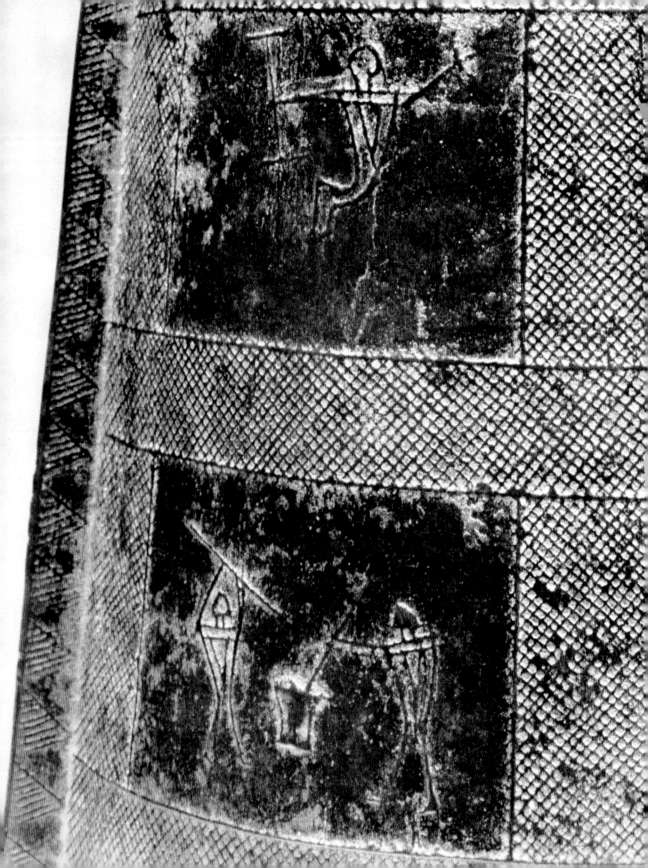

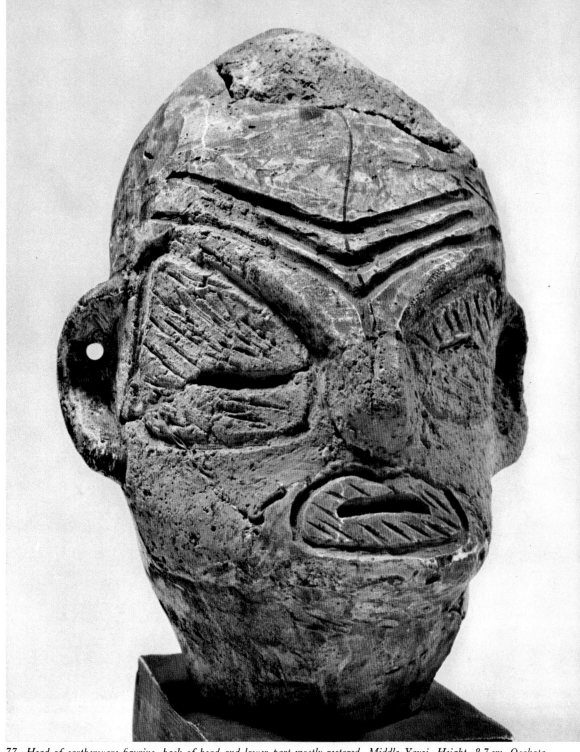

77. *Head of earthenware figurine, back of head and lower part mostly restored. Middle Yayoi. Height, 8.7 cm. Osakata site, Shimodate, Ibaraki Prefecture. Tokyo National Museum.*

◁ 76. *Detail of line-relief drawings on ribbon-type* dotaku: *top, dancer; bottom, rice pounding. Late Yayoi. Kagawa Prefecture. Collection of Hachiro Ohashi. (See also Figures 21, 29, 151.)*

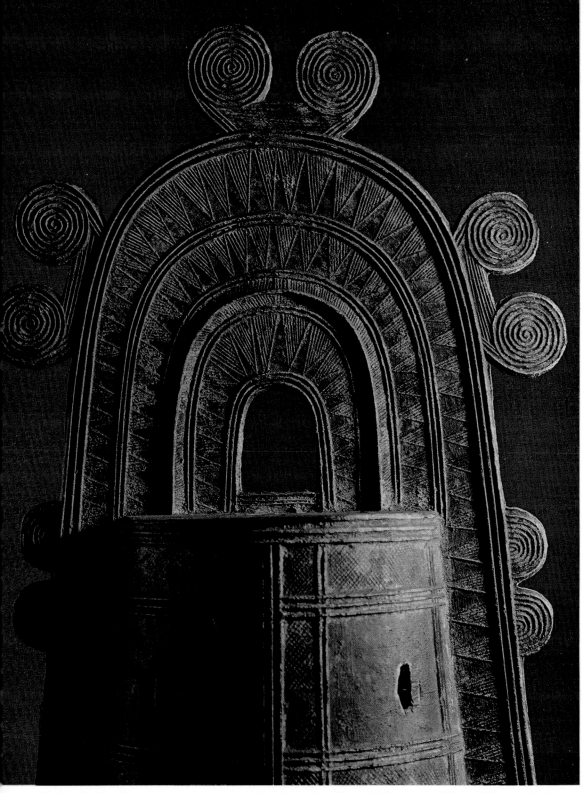

78. Detail of dotaku *with decorative ears of whirlpool design. Late Yayoi. Mukoyama site, Hitaka, Wakayama Prefecture. Tokyo National Museum. (See also Figure 153.)*

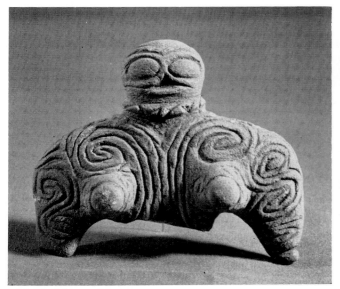

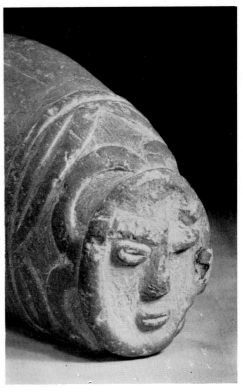

79. *Tuff figurine decorated with incised whorl pattern. Terminal Jomon. Height, 10 cm. Komukai site, Nambu, Aomori Prefecture. Nambu Town Board of Education.*

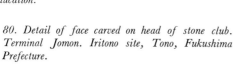

80. *Detail of face carved on head of stone club. Terminal Jomon. Iritono site, Tono, Fukushima Prefecture.*

and rockface carvings made by the original inhabitants of Siberia. The date of their production is not known, but they probably belong to the culture known as post-Jomon (discussed below) that ran more or less parallel to Yayoi culture at a period slightly later than the Jomon period proper.

Depictions of deer have been discovered on a rock surface in Aomori Prefecture (Fig. 83). These are unquestionably in the same category as the deer-shaped carvings or paintings frequently found in Siberia and Mongolia, and it might be surmised that they have some relation to totem worship.

THE CULTURES
AFTER JOMON

With the beginning of the Yayoi period, wet-rice cultivation spread as far north as the southern part of the Tohoku district, the Yayoi culture replacing the Jomon wherever it went.

However, in the northern half of Tohoku, and more especially in Hokkaido, climatic and topographical factors delayed the transfer to a productive, rice-growing economy, and the old hunting and gathering life continued as before. A new hunting and gathering way of life emerged in northeastern Hokkaido and the coastal areas facing the Okhotsk Sea, remote from the main Jomon cultural sphere, developing a pottery culture that was in some ways different from the hitherto existing Jomon pottery culture, and for this reason it is referred to as post-Jomon culture.

The post-Jomon culture is characterized by a special type of pattern done in fine raised lines on cylindrical urns or pots (Fig. 84). These patterns are believed to be imitations of the patterns of fine raised lines found on cast metal objects made on the continent and thus cannot be seen simply as

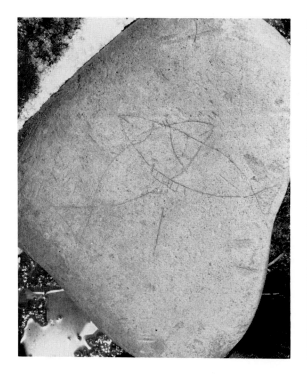

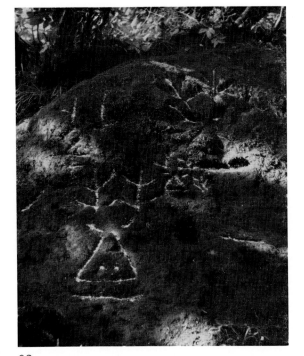

81 (above left). Salmon incised on rockface. Nejiro site, Yashima, Akita Prefecture. Yashima Town Board of Education.

82 (above right). Animal-like figures carved on cave wall. Fugoppe cave, Yoichi, Hokkaido.

83 (left). Deer incised on rockface. Hasezawa site, Kuroishi, Aomori Prefecture.

developments from the Jomon pottery culture. The culture they represent, though centered in northeastern Hokkaido, also spread to central and southern Hokkaido and eventually to the northern part of the Tohoku district.

In time, the Tumulus culture, with its *hajiki* (a red, low-fired pottery) and *sueki* (a dark gray, high-fired pottery), spread northward and replaced the pottery culture of Hokkaido and the northern reaches of the Tohoku district, but the result was

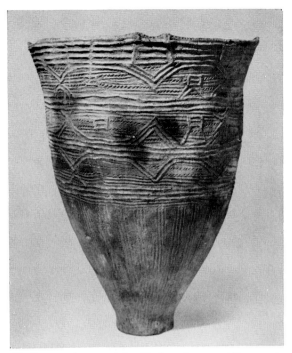

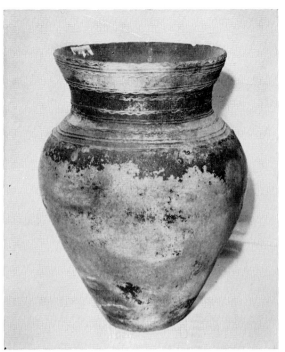

84. *Deep earthenware pot with decoration resembling a cast pattern. Post-Jomon Culture. Height, 39.7 cm. Naganuma, Hokkaido. Hokkaido University, Sapporo.*

85. *Wide-mouthed earthenware jar with fine raised-line design. Okhotsk Culture. Height, 34.4 cm. Moyoro shell mound, Abashiri, Hokkaido. Abashiri Municipal Local Museum.*

different in nature from the Tumulus culture of the rest of Honshu. The men of this culture were mostly fishers who developed bone and horn implements, such as harpoons and fishing hooks. Their pottery, with its geometric patterns of fine raised lines on jars, still shows signs of a relationship with continental metal and wooden vessels.

Around the same period, under influences from the continent, what is known as the Okhotsk culture flourished in the coastal areas facing the Okhotsk Sea. Most of its pottery consists of bowls or pots with patterns of raised lines extending from the rim down onto the body (Fig. 85). The fishing implements and articles of personal adornment, in accordance with the pronounced North Pacific or northeast Siberian flavor of the culture as a whole, use mostly the bones of whales and other sea animals. The men of this culture were close in physical character to the Aleuts; they seem to have hunted bears in the same way as the Ainu, and they preserved large numbers of bear skulls.

In Hokkaido, the emphasis in later years generally changed to bone, horn, and wooden articles, and the production of pottery declined. Later, during the period of Ainu domination, great store was attached to wooden and lacquer vessels; pottery fell completely out of use, and even the methods of manufacture were forgotten. This trend may well relate to the emphasis on woodcarving still to be seen in the folk crafts of this area.

CHAPTER SIX

The Sculpturesque Tradition: The Kanto and Chubu Area

THE CENTER OF THE MIDDLE JOMON POTTERY CULTURE

By the Early Jomon era, the Kanto and Chubu districts were inhabited over a wide area, and pottery, principally the same type of pointed-base pots as found in the Tohoku district, was being produced. The pots excavated at the Natsushima shell mound near Yokosuka attracted great attention in the academic world when carbon-14 tests suggested that they dated from 7000 B.C.

However, it is not until the Middle Jomon era, when a cultural sphere with the characteristic Jomon pottery appeared over a wide area, not merely on the coasts and plains but in the uplands and mountain districts as well, that the Kanto and Chubu districts first become noteworthy in terms of pottery and the other plastic arts.

Foremost among this pottery is what is known as the Katsusaka type. The types known as Umataka (from Niigata Prefecture) and Kasori E (from Chiba Prefecture) belong, broadly speaking, to the same general category and can be classed together under the general name of Katsusaka type (see chart facing page 153). The most sculpturesque and richly decorated, as well as the most dynamically creative, of all Jomon pottery, it is generally agreed to have great artistic value.

In basic shape, the Katsusaka-type pottery re-

sembles that of the preceding period, consisting chiefly of cylindrical urns or pots, but it exhibits lavish use of emphatically three-dimensional designs. Thus a thick body is decorated with a bold raised-line pattern of fat clay coils (Figs. 87, 170), or a spatula or fingertip is used to make strong patterns of whorls, curved lines, or straight lines (Figs. 7, 16, 88, 166). In many cases, the rim has ears that stand straight up in highly fanciful forms (Figs. 9, 36, 86, 92). Sometimes there are four ears, sometimes two, sometimes only one, but they all thrust boldly upward in exaggeratedly decorative forms that are highly sculptural in effect. In other cases, the decorative handle becomes the most important part of the pot, forming the "basket handle" type of vessel (Figs. 37, 89, 90). Equally odd are the representations of faces (Figs. 91, 93), snakes (Figs. 6, 94), and the like that form the ears of some of these vessels. Most violent of all in their effect are the vessels known as "flame type" (Fig. 165) because of the resemblance of their ears to fiercely leaping flames.

A significant feature of Katsusaka-type pottery, a feature found in no other pottery of the Jomon period, is the frequent incorporation into their design of snakes, frogs, or other related beings apparently representing gods (Figs. 5, 7, 92, 95, 96, 97). This has led scholars to suspect that the

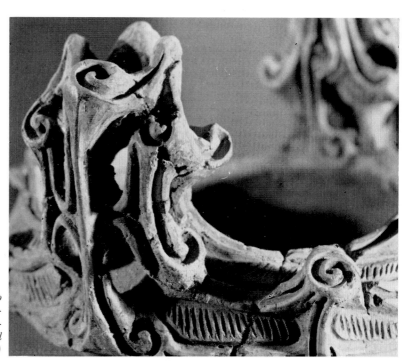

86. Detail of elaborate ear on deep earthenware pot. Middle Jomon. Umataka site, Nagaoka, Niigata Prefecture. Nagaoka Municipal Natural Science Museum. (See also Figure 36.)

culture and society that created the Katsusaka-type pottery were somewhat different from those of the ordinary hunting, fishing, and gathering folk of the day.

These unusual pots have been found principally at the dwelling sites situated on flattened elevations, or *dankyu*, such as those at Togariishi and Idojiri in Nagano Prefecture. In many cases the sites show a number of large dwellings gathered together. Very often these dwellings have stones laid in one corner to create a dais with a single upright stone in the center, thus forming a kind of altar. The pottery unearthed at such sites frequently includes vessels of various shapes forming a kind of set that gives the impression of having been used in making ritual offerings. All this would suggest that in such places there existed communities that were relatively affluent and stable and had a pronounced religious character.

Since community life centering in the village or settlement is difficult where the economy depends on hunting and gathering, it seems likely that the inhabitants engaged in some type of primitive agriculture. And since the stone implements discovered with the Katsusaka-type pottery include polished *nyubojo* (pestle-shaped) stone axes and flat chipped-stone axes that seem to have been used for digging earth, one may surmise that some simple agriculture, such as tuber growing, was in fact practiced. Besides these tools, a great number of stone dishes and stone mortars used for crushing and powdering nuts and bulbs have also been found. On the other hand, stone implements such as arrowheads and blades—used in hunting and preparing the catch—tend to be scarce.

The characteristic animal designs—especially snakes and frogs—that one finds on this pottery are universal in societies engaged in primitive agriculture. It is not uncommon in such societies to find gods of agriculture, or gods of the earth or rain,

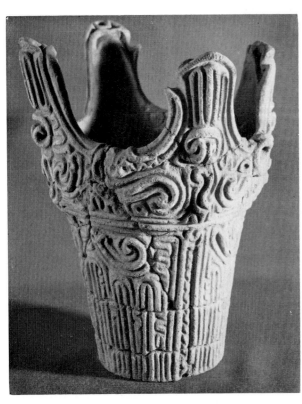

87. Earthenware pot with large ears and decorated with high-relief designs. Middle Jomon. Height, 29.5 cm. Umataka site, Nagaoka, Niigata Prefecture. Nagaoka Municipal Natural Science Museum. (See also Figure 170.)

88. Deep earthenware pot with decorative ears and pattern resembling armor plates. Middle Jomon. Height, 37.4 cm. Asahi shell mound, Himi, Toyama Prefecture. Tokyo University.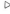

associated with these animals and represented in grotesque anthropomorphic forms. Thus it is possible to see the human or grotesque man-beast figures that frequently decorate the Katsusaka-type pottery as representing gods associated with primitive agriculture.

It seems safe, therefore, to infer the existence of primitive agriculture within the cultural sphere represented by Katsusaka-type pottery. However, the sudden emergence of a special culture such as this, in an area extending from the Kanto district into the Chubu district, obliges one to consider the possibility of outside influence. The flat chipped-stone axes and polished *nyubojo* axes that characterize this cultural sphere are believed to have been used for digging the soil, and the resemblance of the latter to the polished ax widely distributed in Melanesia and other South Pacific islands was

pointed out long ago. This has led to the suggestion that there was some influence from that area, brought to Japan on the Kuroshio (Japan Current). The inhabitants of those islands, which were mostly devoted to the crude cultivation of tubers, produced a great deal of woodcarving of a highly sculpturesque nature, and both figures of ancestral spirits and masks occurred in many different forms.

Even if there was no direct connection between the Katsusaka-type culture of the Middle Jomon era and the culture of the natives of Melanesia and other islands of the South Pacific, the many points of similarity between the two would still be undeniable. In particular, the primitive art universal in Melanesia and parts of Polynesia—whose grotesque and intricate designs represent a three-dimensional explosion of the robust and vital, yet mythical, spirit peculiar to primitive peoples—has

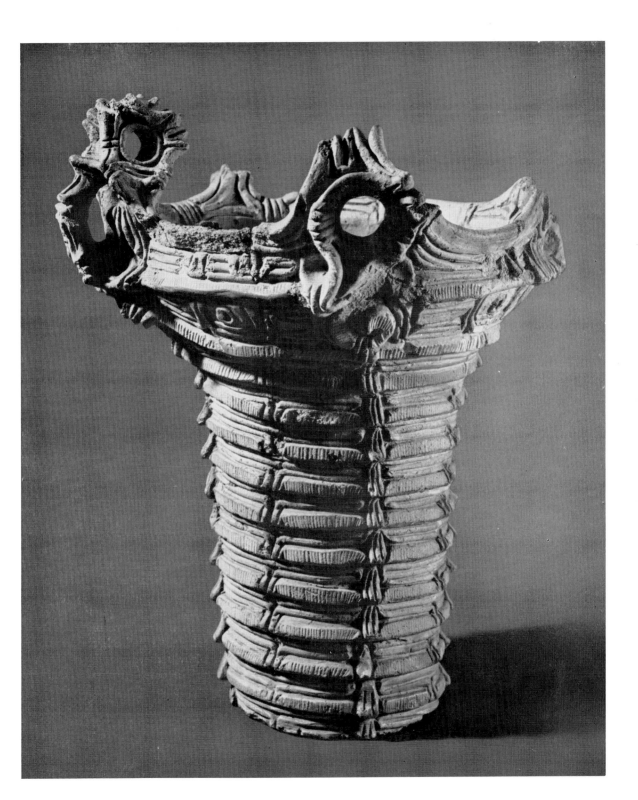

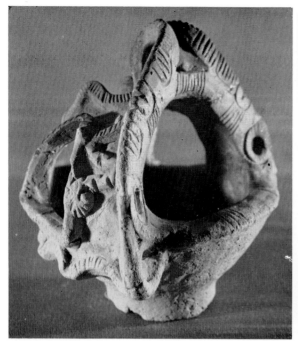

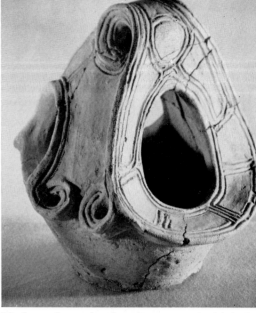

89. *Incense-burner-shaped earthenware vessel with decorative basket-type handle. Middle Jomon. Height, 23.5 cm. Idojiri site, Fujimi, Nagano Prefecture. Idojiri Archaeological Museum, Fujimi.*

90. *Incense-burner-shaped earthenware vessel with basket-type handle. Middle Jomon. Height, 22.5 cm. Mukogahara site, Tokyo. No. 2 Commercial High School, Tokyo.*

something in common with the Katsusaka-type pottery. Viewed in this light, the Katsusaka-type culture may surely be seen as one branch of what one might call the "Kuroshio culture."

From a still broader point of view, one finds that plastic art with a strongly sculpturesque quality is widespread among the indigenous peoples of the whole Pacific area. All around the Pacific one finds intensely alive, three-dimensional expressions of the primitive spirit—the bronze vessels of Shang and Chou China, for example; the totemistic wood-carvings of the Tlingit and Haida Indians along the northwestern coast of America; the similar carvings found in Melanesia and Polynesia; and the stone carvings of the ancient cultures of Mexico and Peru. One may be justified in seeing the Katsusaka pottery as the Japanese representative of this type of primitive art.

Significant in this connection is that the Katsu-saka-type culture encompassed the prolific production not only of pots but also of clay figurines that suggest some connection with the wooden figurines and masks of the pan-Pacific culture. These clay figurines are extraordinarily grotesque and fantastic in form and are quite obviously not the usual human figurines. The grotesque figurine with the inverted-T mouth (Fig. 98) excavated in Yamanashi Prefecture is especially remarkable, and seems likely to have been a kind of totemistic or ancestral-spirit image. The face, which is given its character by the sharply slanting eyes and the mouth, is obviously not human. The same unusual features are shared by certain of the face-decorated ears of the Katsusaka-type pots—for example, those unearthed at Nakahara in Tokyo (Fig. 91) and Tonai in Nagano Prefecture (Fig. 93).

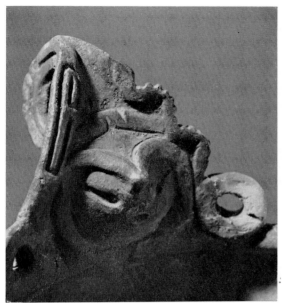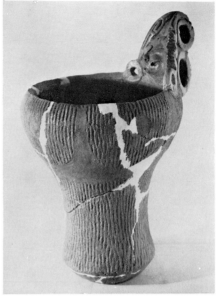

91. Earthenware pot with face decorating inner surface of ear. Left, detail; right, entire vessel. Middle Jomon. Height, 33.3 cm. Nakahara site, Tokyo. No. 2 Commercial High School, Tokyo.

Another interesting point is that among the Katsusaka-type pots are some of an unusual shape (Fig. 97): large jars with swollen bellies and a large number of small holes pierced around the rim. It is possible that these were intended for cords to hold a drumskin stretched across the mouth, for the jars are similar to the jar-drums common in the South Pacific. Among those jars believed to have been drums are some embellished with anthropomorphic features that could belong neither to human beings nor to frogs and that probably represent supernatural spirits. This supports the view that these vessels were used as drums in some festival of spirits —which again underlines the possible connection between the Katsusaka-type culture and the South Pacific cultural sphere.

As the preceding will have made clear, the pots and figurines of the Middle Jomon era found in the Kanto and Chubu districts were produced under rather special circumstances. They seem likely to have been the products of a primitive agricultural society devoted to growing tubers, such as taro, much as is found in the South Pacific; and they have a relatively pronounced local character. Thus, despite their high artistic qualities, it is doubtful whether they can be called typical works of the Jomon period in Japan.

The pan-Pacific features that are apparent in the clay pottery and figurines of the Middle Jomon era find still more concrete substantiation in bone and horn artifacts from the Late Jomon era. One good example is the special type of harpoon with a head that detaches from the shaft when it strikes the prey; similar harpoons in bone or horn are found in all the areas bordering the North Pacific, proving that the same type of fishing, using the same

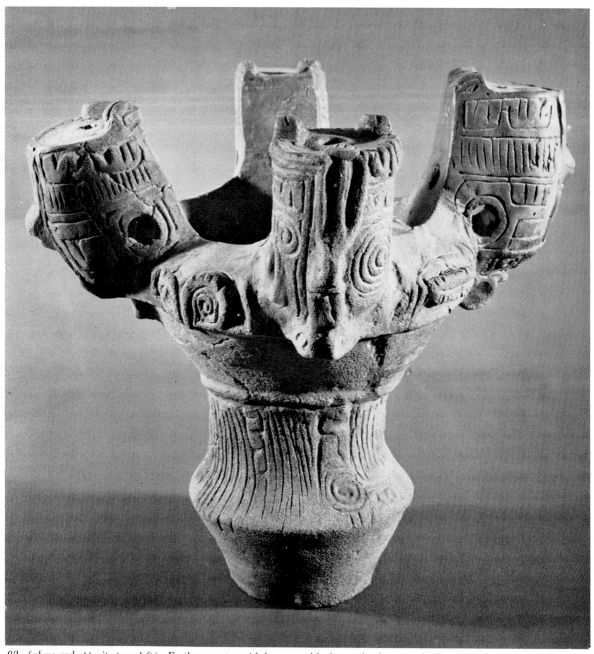

92 *(above and opposite page left). Earthenware pot with large ears like human heads, restored. Above, entire vessel; opposite page, detail. Middle Jomon. Height, 35 cm. Idojiri site, Fujimi, Nagano Prefecture. Idojiri Archaeological Museum, Fujimi.*

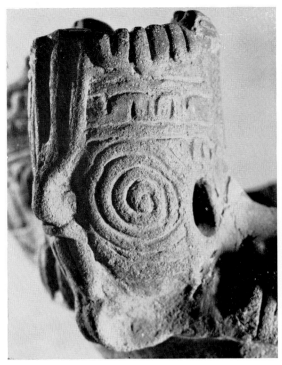

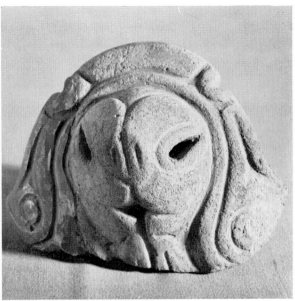

Detail of Figure 92.

93. Face-shaped earthenware ear, restored. Middle Jomon. Height, 10.5 cm. Tonai site, Fujimi, Nagano Prefecture. Togari-ishi Archaeological Museum, Chino.

types of weapons, was practiced over the whole North Pacific area from the Kanto district in Japan to the northwestern coast of America.

LATE JOMON ARTISTIC CHANGES

In the Late Jomon era, there was a sharp decline in the decorativeness that characterized the pottery of the Middle era, and a large number of relatively unpretentious vessels were produced. However, they did show a rich variety of form, including pots and dishes, as well as vessels with spouts and hooks for hanging, all with thinner walls and exhibiting fine workmanship. This suggests that there was a corresponding improvement in and diversification of the quality of life. The designs preferred for ornament were rela-tively plain—a shallow, cord-impression-pattern ground largely erased to leave only bands of pat-tern (Figs. 118, 119) or a plain ground with a relief pattern in one area—so that some pots came to be artistic in their shape rather than in their patterns as before. In this sense, they were utterly different from the highly decorative and sculpturesque pot-tery of the Middle era. An outstanding example of the variety of Late Jomon forms is the vessel in the shape of a seashell (Fig. 38) excavated in Niigata Prefecture. The motives that led to its production are probably connected with the fact that fish and shellfish were an important item in the diet in the Kanto and Chubu districts at the time, as evidenced by the many coastal settlements that have left shell mounds.

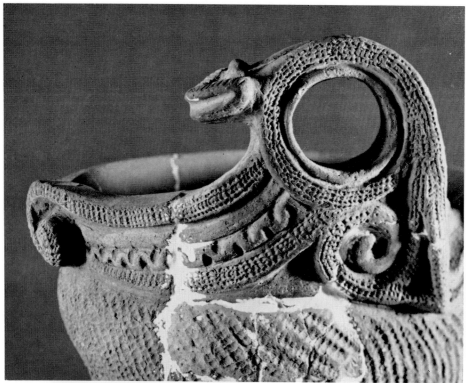

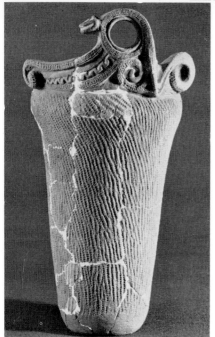

Around the end of the Late Jomon era and the beginning of the Terminal era, the Tohoku district once more became the center of culture; the Kanto and Chubu districts came under its influence, acquiring a similar type of pottery culture. A question arises regarding the pottery of this period: its connection with wooden vessels. The bodies of earthenware vessels of this period are generally thin, and the surface is polished to produce a gloss that is in itself a kind of decorative element. The surface is also incised to form shallow band-patterns. Considered along with the appearance of shapes that suggest wooden rather than clay vessels, this could possibly indicate an influence from woodenware.

The sudden increase in the number of different shapes from Late Jomon on may also mean that the variety possible in woodenware had been carried over into pottery. Until the Middle Jomon era, the

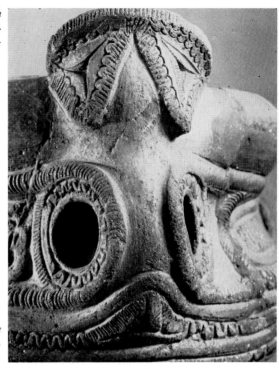

94 (opposite page, top and bottom). Deep earthenware pot with snake-shaped ear. Top, detail; bottom, entire vessel. Middle Jomon. Height, 39 cm. Miyashita site, Tokyo. Collection of Hanjuro Shiono.

95. Detail of grotesque animal (?) decoration on earthenware pot. Middle Jomon. Tokuri site, Fujimi, Nagano Prefecture. Togariishi Archaeological Museum, Chino. (See also Figure 7.)

standard pottery shape had been the cylindrical urn or jar, but in the Late and Terminal eras pots, dishes, bowls, and jars were produced indiscriminately. This new differentiation into various shapes, stemming basically from an improvement in the quality of life itself, no doubt had the effect of liberating potters from traditional forms and techniques and of fostering a new spirit of freedom to create whatever the practical needs of the community or the spiritual needs of the maker demanded.

This would explain the variety of pottery from Late Jomon on. Middle Jomon pottery, on the other hand, despite its obvious artistic value, was produced not in accordance with the creative spirit of its maker but in accordance with the requirements of society, as a manifestation of the religious spirit, and was social and communal by nature.

From the Late Jomon era on, the clay figurines that had such a strong air of religious and communal needs during the Middle Jomon era seem to be more closely related to everyday life, even assuming that they still proceeded from the same spiritual or religious background. Some of the figurines made during this period look almost like toys (Fig. 100), while others look as though they were made for the pure pleasure of handling the clay. A case in point is the figurine with a heart-shaped face (Fig. 48), unearthed in Gumma Prefecture; it is simplified and symmetrical, with an extremely narrow trunk, a large face, and legs spread wide apart. Though this figure may represent a god, the feeling it gives is not that it was based on some traditional form, but that it was made to satisfy the artist's own sculptural instincts.

Among the figurines of this period there is

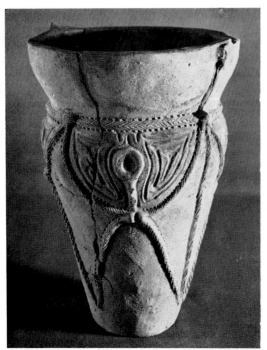

96. *Earthenware pot decorated with anthropomorphic form in relief. Middle Jomon. Height, 27 cm. Kyube-onè site, Fujimi, Nagano Prefecture. Idojiri Archaeological Museum, Fujimi.*

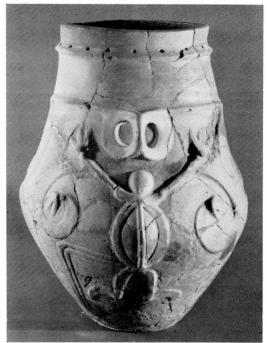

97. *Large drum-style jar perforated around mouth and decorated with anthropomorphic form in relief. Middle Jomon. Height, 51.2 cm. Tonai site, Fujimi, Nagano Prefecture. Idojiri Archaeological Museum, Fujimi.*

one recurrent type. Apparently representing a female figure, it has a flat, roughly triangular face with large eyes, nose, and mouth, and exaggerated breasts and other features that seem to emphasize the female sex characteristics (Fig. 99). These female figurines characteristic of the Late Jomon era, which appeared not only in the Kanto and Chubu districts but also in the Tohoku district, give the impression of representing some earth goddess. They also seem to be related to the figurines with owl-like faces that appear later (Fig. 49). These owl-woman figurines are grotesque in the extreme. They can be seen as wearing a fur

hood over their heads, Eskimo style, or they can be seen as an anthropomorphization of some large-eyed bird, such as the owl. Among the forest dwellers of northern Eurasia, the owl was revered as a guardian god of the home or village, and anthropomorphic representations were made over a wide area for use as charms. In Japan, many examples of these "owl" figurines have been found in the Kanto area. Eventually, they were transformed into the figurines with snow goggles that developed in the Tohoku district toward the end of the Late Jomon era and on into the Terminal Jomon era.

Other related clay products of the period include

98. *Unusual earthenware figurine with slanted eyes and inverted-T-shaped mouth. Middle Jomon. Height, 25.2 cm. Kami-kurokoma site, Misaka, Yamanashi Prefecture. Tokyo National Museum.* ▷

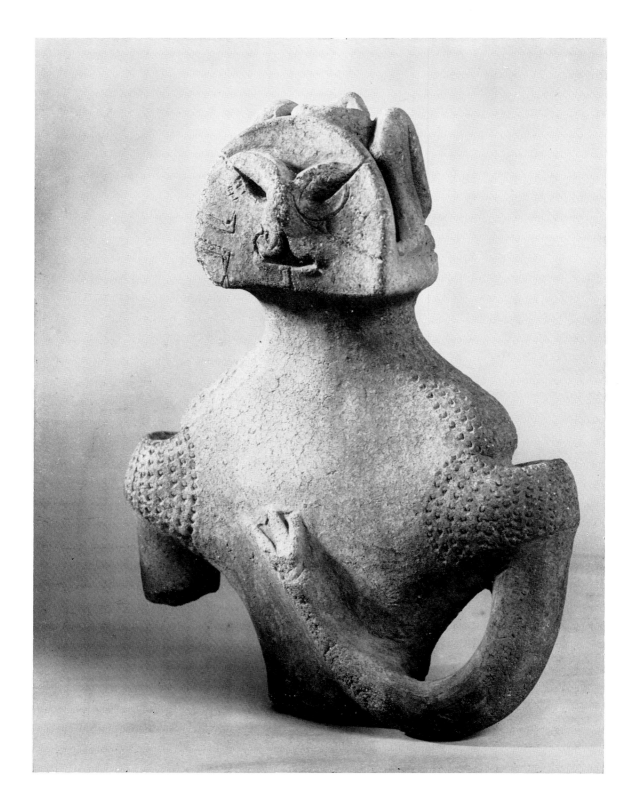

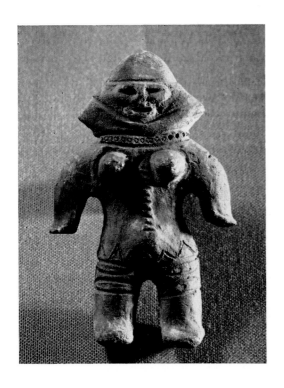

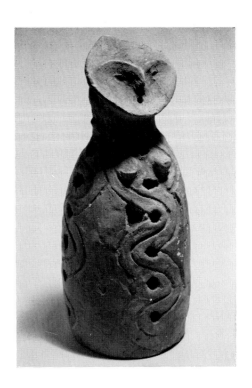

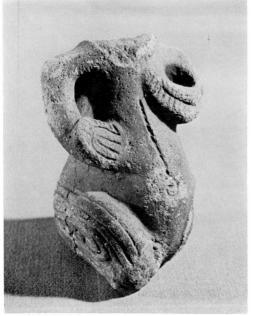

99 (above left). Earthenware figurine of woman with triangular head. Late Jomon. Height, 12.5 cm. Shiizuka shell mound, Edosaki, Ibaraki Prefecture. Osaka Municipal Museum.

100 (above right). Earthenware figurine resembling a kokeshi (limbless traditional Japanese doll). Late Jomon. Height, 20.4 cm. Inariyama shell mound, Yokohama, Kanagawa Prefecture. Collection of Takeo Ikeda.

101 (left). Small earthenware figurine of pregnant woman. Middle Jomon. Height, 8.5 cm. Togariishi site, Chino, Nagano Prefecture. Togariishi Archaeological Museum, Chino.

102. Megalithic corridor-type tomb. Late Tumulus. Height of back ▷ wall, 3.6 m. Tsukaanayama Tomb, Tenri, Nara Prefecture.

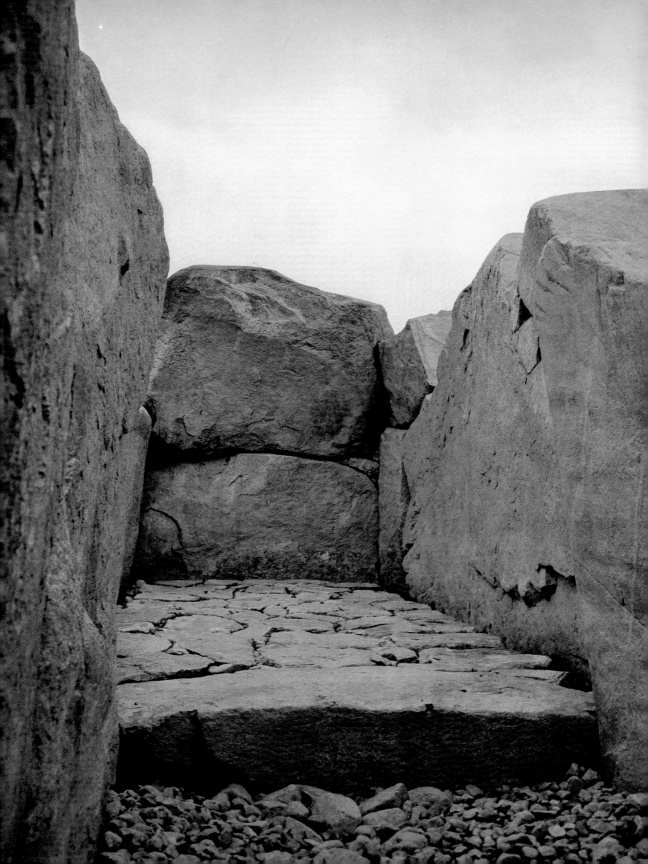

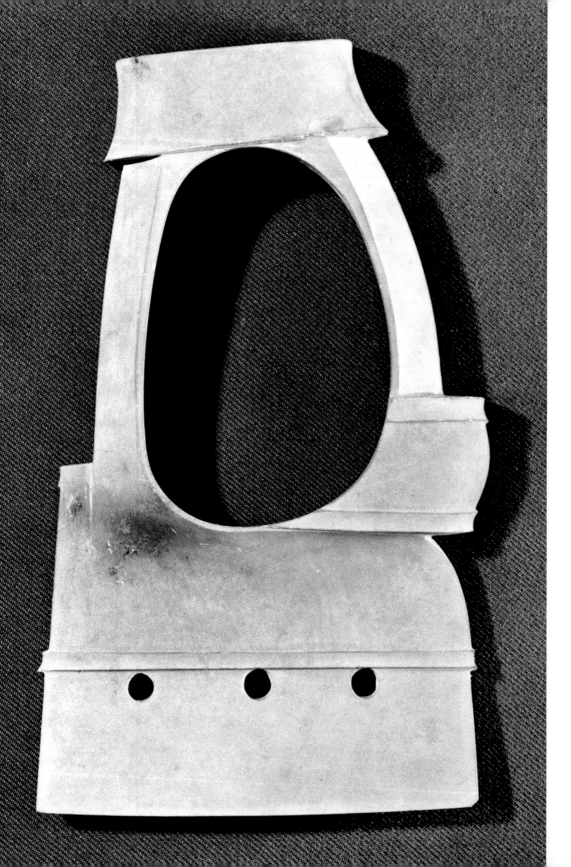

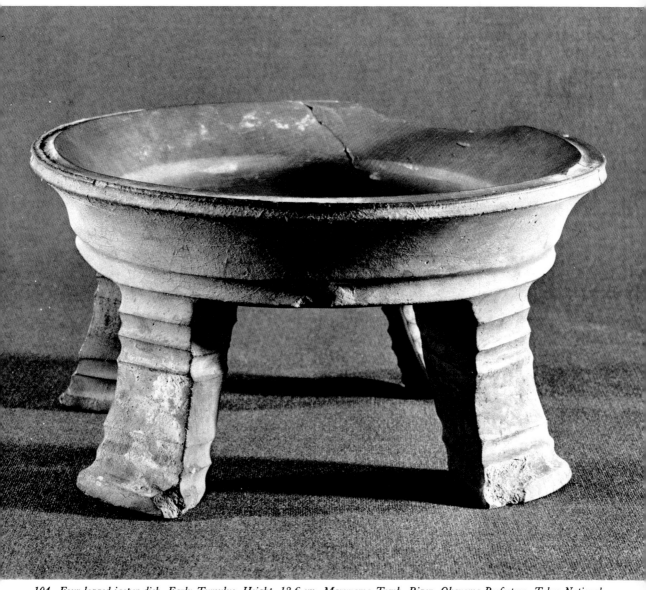

104. *Four-legged jasper dish. Early Tumulus. Height, 12.6 cm. Maruyama Tomb, Bizen, Okayama Prefecture. Tokyo National Museum.*

◁ 103. *Hoe-shaped jasper bracelet (?). Early Tumulus. Length, 17.8 cm. Ishiyama Tomb, Ueno, Mie Prefecture. Kyoto University.*

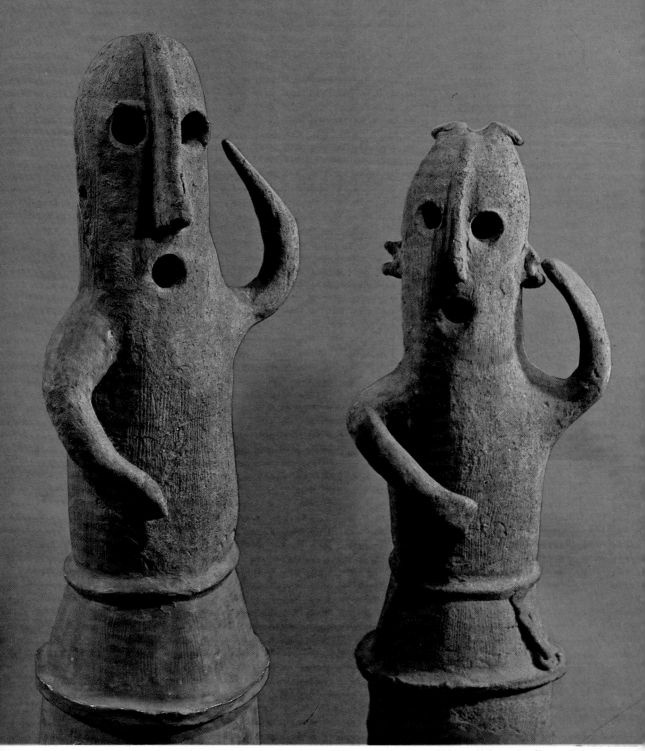

105. *Dancing* haniwa *couple. Late Tumulus. Height: left figure, 63.9 cm.; right figure, 56.6 cm. Nohara site, Konan, Saitama Prefecture. Tokyo National Museum.*

106. *Head of laughing* haniwa *man. Late Tumulus. Height, 34.3 cm. Gyoninzuka Tomb, ▷ Takahagi, Ibaraki Prefecture. Tokyo University.*

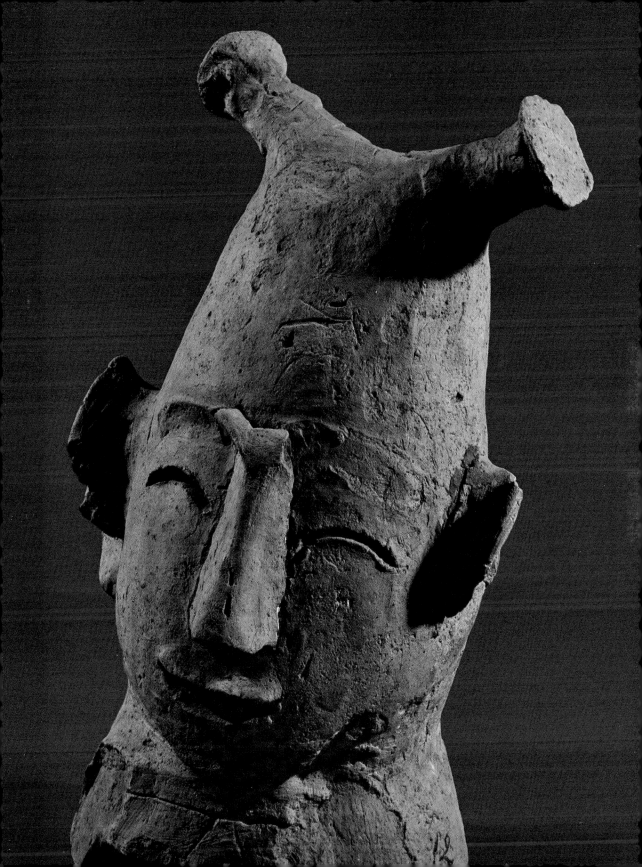

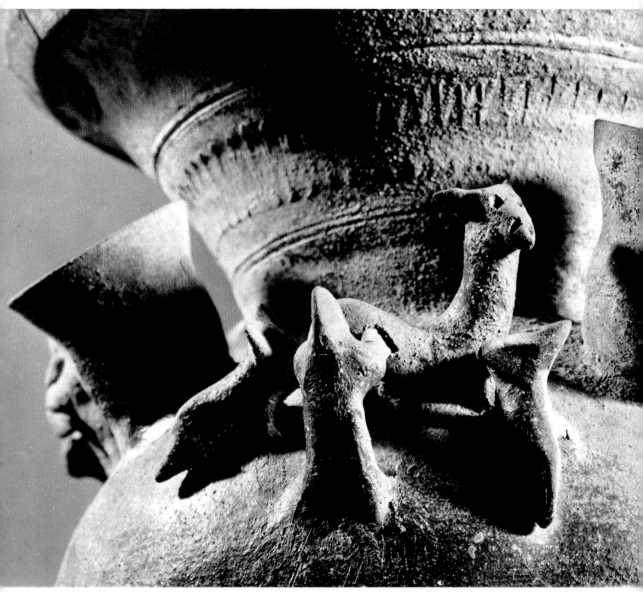

107. Detail of deer decorations on shoulder of sueki *jar. Late Tumulus. Nishinomiya-yama Tomb, Tatsuno, Hyogo Prefecture. Kyoto National Museum. (See also Figure 163.)*

108. Haniwa boat. Late Tumulus. Length, 101 cm. Saitobara Tomb, Saito, Miyazaki Prefecture. ▷
Tokyo National Museum.

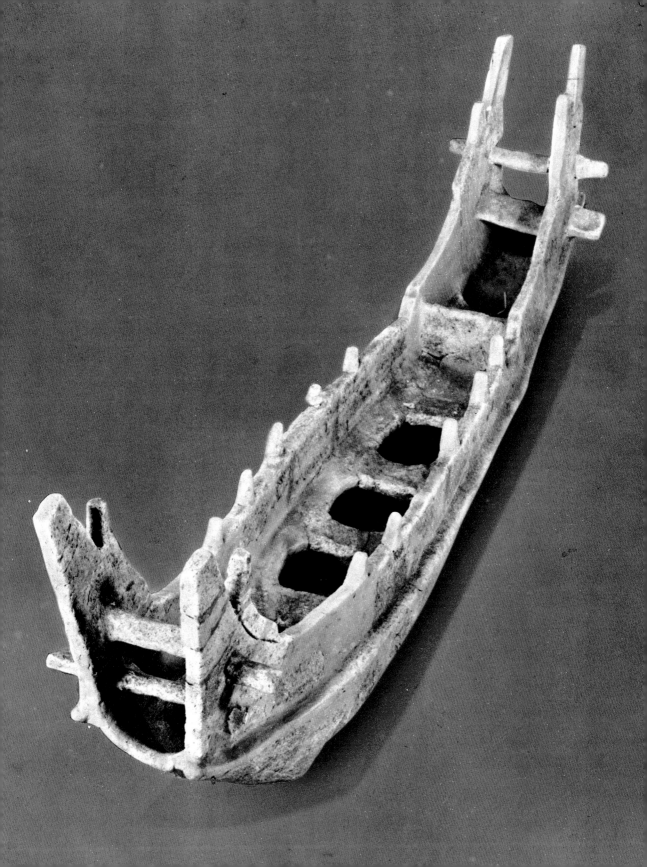

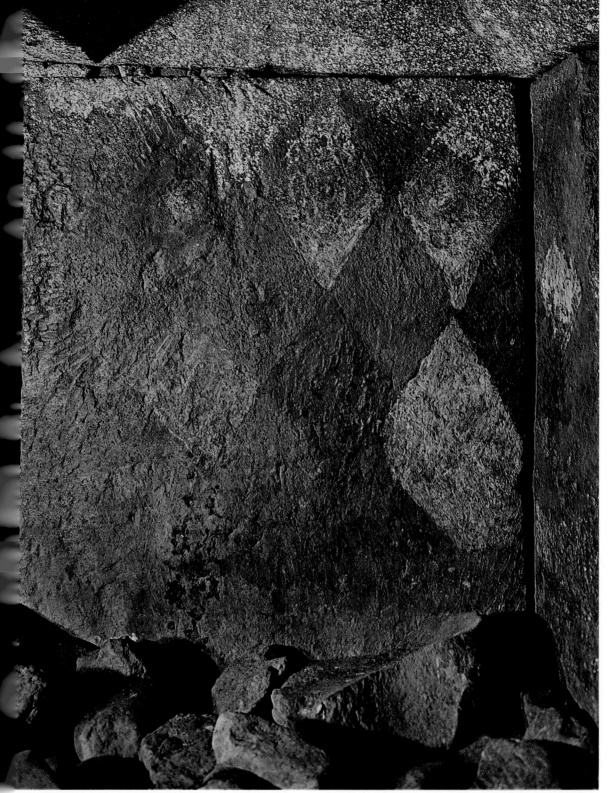

109. Diamond pattern painted on inner wall of tomb chamber. Late Tumulus. Height, 98 cm. Chibusan Tomb, Yamaga, Kuma-moto Prefecture. (See also Figure 136.)

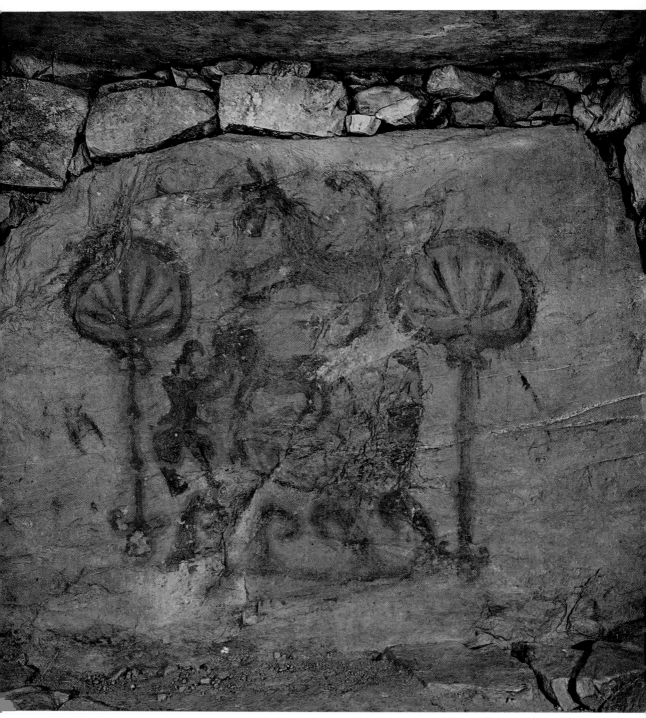

110. Man leading a horse: painting on inner wall of tomb. Late Tumulus. Height of wall, 140 cm. Takewara Tomb, Wakamiya, Fukuoka Prefecture. (See also Figure 52.)

111. Detail of raised-floor dwelling in relief on bronze mirror. Early Tumulus. Diameter, 23 cm. Takarazuka Tomb, Kawai, Nara Prefecture. Imperial Household Agency.

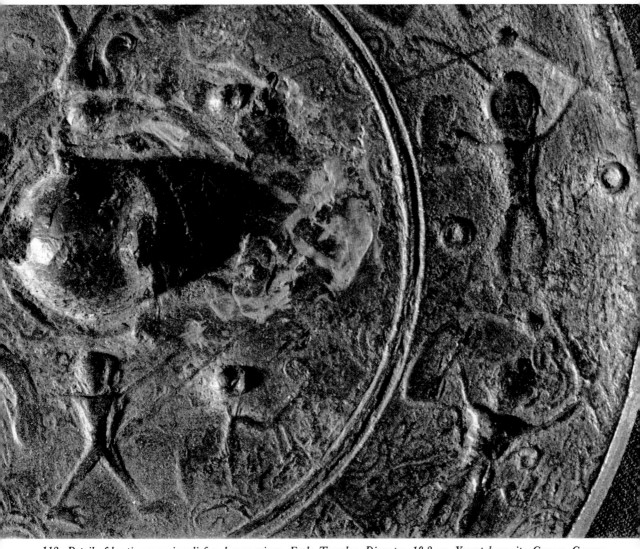

112. *Detail of hunting scene in relief on bronze mirror. Early Tumulus. Diameter, 18.2 cm. Yawatabara site, Gunnan, Gumma Prefecture. Tokyo National Museum.*

113. *Bronze harness ornament decorated with openwork dragons. Late Tumulus. Diameter, 11 cm. Otani Tomb, Wakayama City, Wakayama Prefecture. Wakayama Municipal Board of Education.*

114. *Honeysuckle arabesque on bronze harness ornament. Late Tumulus. Length, 19.5 cm. Otani* ▷ *Tomb, Wakayama City, Wakayama Prefecture. Wakayama Municipal Board of Education.*

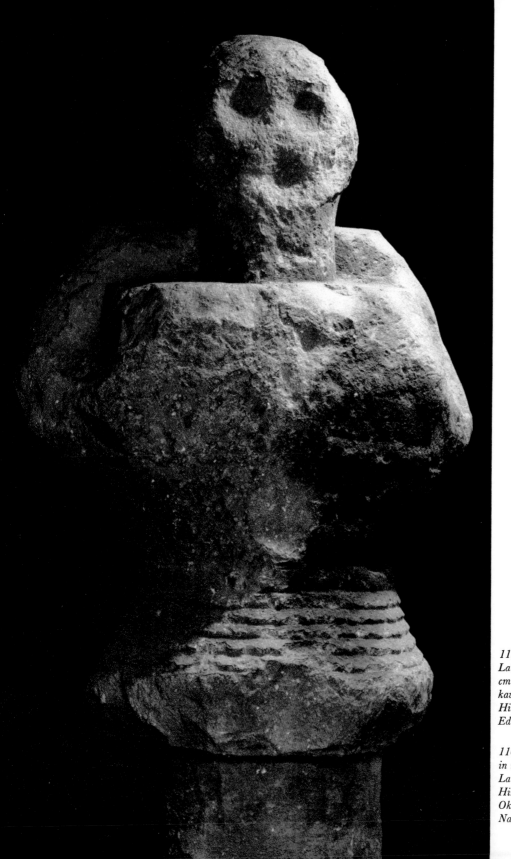

115. Carved tuff warrior. Late Tumulus. Height, 180 cm. Sekijinyama Tomb, Hirokawa, Fukuoka Prefecture. Hirokawa Town Board of Education.

116. Man and horses ▷ in relief on earthenware coffin. Late Tumulus. Height, 88 cm. Hirafuku Tomb, Mimasaka, Okayama Prefecture. Tokyo National Museum.

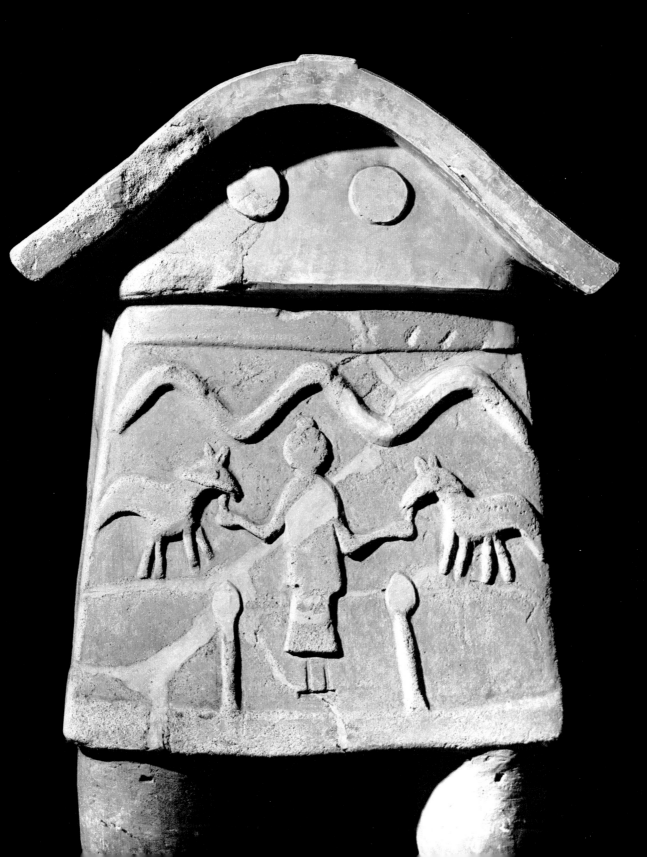

117. *Granite monkey stone. First half of seventh century. Height, 105 cm. Kibitsuhime-o Tomb, Asuka, Nara Prefecture. Imperial Household Agency.*

119. *Shallow earthenware bowl decorated with erased cord-impression patterns. Terminal Jomon. Diameter of mouth, 19 cm. Nado shell mound, Taiei, Chiba Prefecture. Waseda University, Tokyo.*

118. *Earthenware pot with girdlelike cord-impression patterns. Terminal Jomon. Height, 34 cm. Kohara shell mound, Kozaki, Chiba Prefecture. Waseda University, Tokyo.*

clay masks (Fig. 40) and clay plaques (Fig. 120). Some of the clay masks seem to have been made for actual use, but generally speaking they—as well as the clay plaques that seem to be abbreviated versions of them—were probably kept as some kind of charm against evil.

The objects usually referred to as "pulley-shaped earrings" (Fig. 169) include some with openwork that qualifies them to be considered as decorative art.

THE FRONTIER OF
THE YAYOI AND
TUMULUS CULTURES
In the Yayoi period, the Kanto and Chubu districts as a whole took over the Yayoi culture that reached them from western Japan, and ways of production also changed. Large numbers of sites are found in the Tokai area facing the Pacific,

along rivers in the Kanto Plain around Tokyo Bay, and close to river mouths. Particularly celebrated among Yayoi sites are the Yayoi-cho site in Tokyo, which gave its name to the period, and the Toro site in Shizuoka City, famous for the discovery of traces of early paddy fields. Yayoi-period sites have yielded an abundance of agricultural implements and cooking and eating utensils in wood, and a considerable number of remains of round-plan pit dwellings, and rectangular-plan raised-floor granaries have also been discovered. The Yayoi culture thus revealed in this area shows no important differences from that of western Japan.

Nevertheless, in those parts of the Chubu district that lie closest to the Japan Sea or are contiguous with the Tohoku district, the traditions of the Jomon period persisted strongly, and pottery ap-

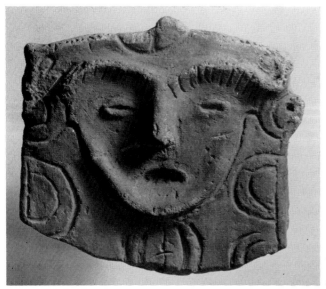

120. *Earthenware plaque decorated with human face.
Terminal Jomon. Height, 11.5 cm. Yumada site, Iwai,
Ibaraki Prefecture. Tokyo University.*

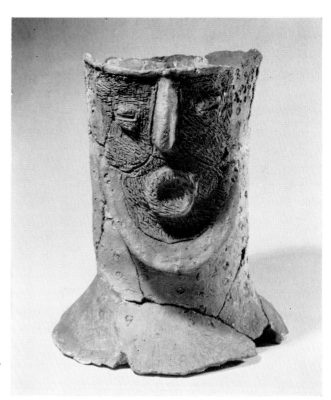

121. *Neck of jar decorated with face, restored. Middle
Yayoi. Height, 19 cm. Utsunomiya, Tochigi Prefecture.
Tokyo University.*

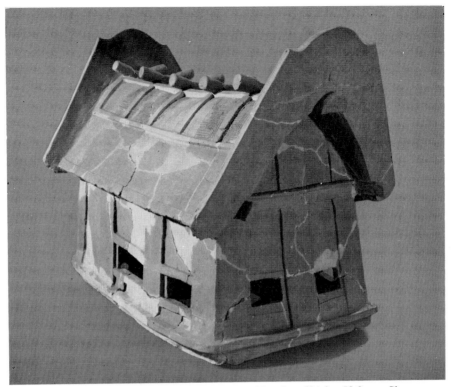

122. Haniwa house with ridge logs, restored. *Late Tumulus. Height, 53.2 cm. Chausuyama Tomb, Akabori, Gumma Prefecture. Tokyo National Museum.*

peared that combined both Yayoi and Jomon features. A similar phenomenon appeared in the area around the north of the Kanto district and the south of the Tohoku district. Generally speaking, in the Yayoi period both clay figurines and pots decorated with faces disappear almost completely, but in Ibaraki, Fukushima, and other neighboring prefectures they are found as a regional product (Figs. 12, 19, 20, 74, 77, 121). These fairly obviously derive from the tradition of Jomon culture.

The Kanto district, an extensive plain with many rivers of varying size, is well suited to wet-rice cultivation. Thus a comparatively large number of settlements grew up there, resulting in a large population. The Tohoku district, however, is not suited to wet-rice cultivation, and for this reason, among others, Yayoi culture penetrated little farther than into the southern half. Thus from the Yayoi period onward the Kanto district became the northern "frontier territory" of the rice-oriented economy, society, and culture of Japan. The areas to the north, especially Hokkaido and the northern half of the Tohoku district, remained Ezo territories; a completely different world where the hunting and gathering traditions of the Jomon period and the non-Japanese culture of the Ainu, known in historical times as the Ezo, could flourish.

IN THE TUMULUS PERIOD, the Yamato court conquered a large part of Japan and unified the country under its rule. However, the area from the Tohoku district northward to Hokkaido remained

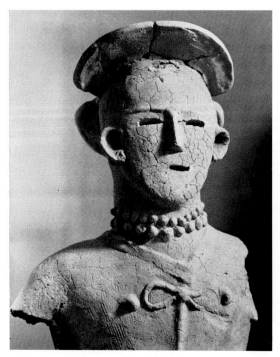

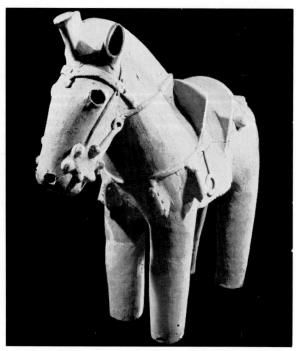

123. Haniwa *woman. Late Tumulus. Height, 89 cm. Himezuka Tomb, Yokoshiba, Chiba Prefecture. Shibayama Haniwa Museum.*

124. Haniwa *horse. Late Tumulus. Height, 85 cm. Kamichujo site, Kumagaya, Saitama Prefecture. Tokyo National Museum.*

outside its jurisdiction and the Ezo maintained their alien culture. On the other hand, the Kanto district (and very occasionally the south of the Tohoku district) not only received the direct impact of Tumulus culture but also became a vital base for the suppression of the Ezo to the north. In present Gumma Prefecture, at the northern edge of the Kanto district, and Chiba Prefecture, which was an important focus of land and sea communications, many tombs have been discovered. They probably indicate that powerful military units were stationed for long periods in these militarily vital areas. The local chieftains who commanded these forces seem to have wielded great authority over

their territories; their graves are often on a considerable scale and contain a wealth of grave goods.

Particularly noteworthy are the *haniwa;* large numbers of these in the shapes of men, women, houses, and so on have been found in Gumma, Ibaraki, and Chiba prefectures. Some of them, such as the *haniwa* house that might be a model of the typical residence of a powerful family of the day (Fig. 122), or the female figure with a necklace and other adornments (Fig. 123), or the figures believed to represent farmers (Figs. 59, 125), are extremely interesting socially, economically, and culturally, besides being of great artistic importance in themselves.

125. *Smiling* haniwa *farmer with plow blade on shoulder. Late Tumulus. Height, 92 cm. Akabori site, Gumma Prefecture. Tokyo* ▷ *National Museum.*

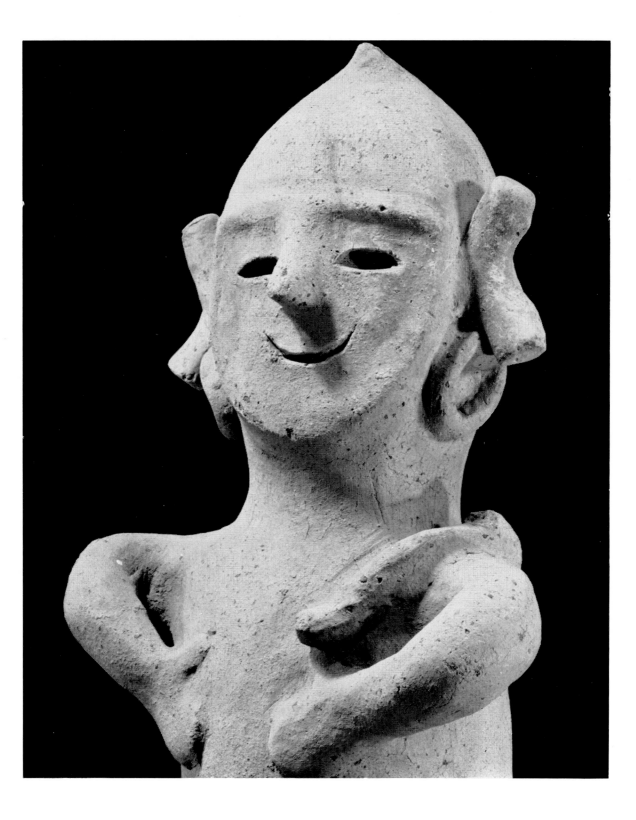

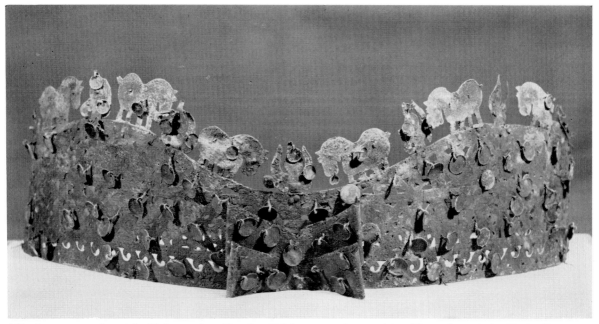

126. *Bronze crown decorated with horses. Late Tumulus. Height: center, 9 cm.; sides, 13 cm. Sammaizuka Tomb, Tamatsukuri, Ibaraki Prefecture. Ibaraki Prefectural Art Museum, Semba. (See also Figure 15.)*

Other objects discovered in the tombs of this area include a considerable number of weapons and equine trappings. They were probably used by influential members of the military forces that were stationed there in order to pacify the anti-Yamato forces. As might be expected of the bearers of a culture deriving from the horse riders of northeastern Asia, there are a large number of *haniwa* horses (Fig. 124) and other special objects, such as the bronze crown decorated with horses (Figs. 15, 126). A crown with similar decorations has been discovered in southern Russia. Though a direct connection between the two is unlikely, the resemblance doubtless derives from the fact that both were products of the equestrian culture so widely distributed over Eurasia. On the other hand, a great difference between the tombs of the Kanto district and those of the Yamato area (present-day Nara Prefecture) is the small number of bronze mirrors discovered in the Kanto area.

Though the culture centered in the Kinai district spread as far as the Kanto district, one detects definite local characteristics that in not a few cases may be ultimately traced to traditions persisting from Jomon times. At the same time, the Kanto district's position as a base for operations against the Ezo led to an emphasis on the elements of an equestrian culture. This may well relate to the fact that the samurai culture of later ages had its center in the Kanto district.

CHAPTER SEVEN

Continental Gateway: The Kyushu Area

THE DAWNING OF THE YAYOI PERIOD Just as Hokkaido and the Tohoku district, lying close to the continent, played a special role in cultural development, so the Kyushu area also, thanks to its connections with the continent, came to constitute a special cultural zone with a pronounced local character. Because of its geographical location, Kyushu had links with the Asian mainland via the Korean Peninsula, while the Kuroshio brought it into contact with central eastern and southeastern China and ultimately southeastern Asia as well. In Kyushu, these two routes converged and joined with the main route from Honshu to give birth to a unique regional culture.

The first striking example of this is the Sobata pottery that appeared during the Early Jomon era. This pottery, its surface given finish and decoration with grooved stripes, obviously belongs to the same stock as the combed-pattern pottery of Korea. Apart from the Sobata type, the only other pottery that can be linked so clearly with the continent is the shell-impressed-pattern pottery of Hokkaido and the Tohoku district, which derives from the combed-pattern pottery of Siberia. However, from the middle of the Jomon period, exchanges between Kyushu and the continent became sporadic and at one period almost nonexistent.

In the Yayoi period, relations with Korea and the continent once again became close, and the Yayoi culture, with northern Kyushu as its base spread throughout western Japan and on into eastern Japan. This was a result of the introduction into Japan of an economy based on rice cultivation; the same settlers also took this economy to southern Korea, with the result that southern Korea and northern Kyushu came to form parts of one more or less homogeneous cultural sphere. Thus it seems safe to assume that once various cultural elements from the continent had reached Korea they could be easily transmitted from southern Korea to northern Kyushu.

Southern Korea and northern Kyushu thus came to be linked not only by a shared rice-growing culture but also by the bronze culture of northeastern Asia and the Han culture that spread to the common cultural sphere. The Wa men of Kyushu extended their trading activities as far as Lo-lang, the center of Han culture in northern Korea, and also began to settle in parts of southern Korea. The *Wei Chih*, the portion of the third-century Chinese history *San-kuo Chih* that describes late-Yayoi Japan, says that the Wa lands began in Kinkaiwan in southern Korea, whence the territories extended to the islands of Tsushima and Iki and to Tsukushi in Kyushu, and that the Wa men were con-

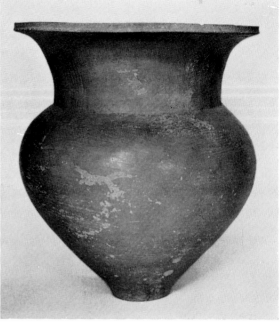

127. *Wide-mouthed earthenware burial urn. Middle Yayoi. Height, 45.5 cm. Yoshii site, Nijo, Fukuoka Prefecture. Tokyo National Museum.*

128. *Polished cinnabar-painted earthenware jar. Middle Yayoi. Height, 34 cm. Shironohara site, Fukuoka City, Fukuoka Prefecture.*

tiguous with the Koreans at Kinkaiwan. This implies that around the third century some of the Wa had a base in southern Korea, where they engaged in seafaring activities.

As one might expect of the home of Yayoi culture, Yayoi sites are extremely common in northern Kyushu. A typical site of the early Yayoi period is that at Itazuke in Fukuoka Prefecture, where pots have been excavated with comb markings that suggest a connection with Korea.

In the middle Yayoi period, wide-mouthed burial urns (Fig. 127) became common and were accompanied by dolmens (discussed below) of a type universal in southern Korea, a fact that still further underlines the close connection with that area.

The bronze and iron articles that eventually came into use are an offshoot, on the one hand, from the bronze culture—mainly sharp-edged

tools—that extended from Jehol in eastern Mongolia to northeastern China and northern Korea and, on the other hand, from the iron-tool culture of China.

At first, the sharp-edged implements such as bronze swords and spears appeared in the original narrow forms that they had had in northeastern Asia, but in Japan they were not used for their original purposes and gradually their forms were broadened and elongated (Figs. 129, 131, 132). Most probably they were used as ritual objects or as symbols of the owner's authority. Just as the Chinese mirror, originally an article of purely practical use, acquired a magical significance in Japan, even the flat, circular jade *heki* imported from China were almost certainly revered in the same way by the men of the Yayoi culture of northern Kyushu. By this time, not only bronze

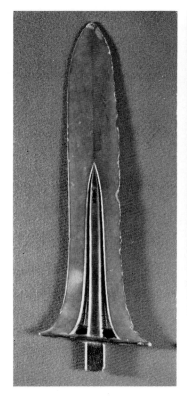

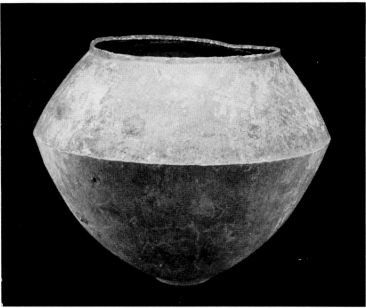

130. *Wide-mouthed bronze urn. Late Yayoi. Height, 34 cm. Sago Kubiru site, Kamiagata, Nagasaki Prefecture. Tokyo National Museum.*

129. *Daggerlike bronze axhead. Late Yayoi. Length, 28.8 cm. Nishitsudome site, Otsu, Kumamoto Prefecture. Kyoto National Museum.*

implements but even glass was being made by the men of Wa themselves.

This tendency of the Yayoi men of northern Kyushu to alter foreign things into something religious and ceremonial is probably closely linked with the fact that theirs was a primitive agricultural society with a pronounced religious flavor. Generally speaking, primitive agricultural societies formed communities whose members were closely tied to the land and the family, communities knit together by shared religious beliefs and shared rituals associated with agriculture. Thus it was usual for the ritual or ceremonial objects used on such occasions to show marked development in such societies. In fact, apart from these ceremonial objects, almost the only art left by the Yayoi culture is its earthenware vessels; yet these vessels—reflecting the unsophisticated, peaceful, and stable lives

of the men who made them—have a harmonious, satisfying simplicity of their own.

Compared with Jomon ware, Yayoi pottery might at first seem to lack artistic and creative qualities. But in fact these forms consciously dispense with all unnecessary decoration. The two-dimensional patterns applied in harmony with the shape of the vessel, the polishing, and the sparingly used red coloring give a sense of quiet depth to the surface of the clay and together create a beauty peculiar to Yayoi ware alone. Almost all Yayoi ware consists of basic forms such as pots, bowls, jars, stemmed bowls, and other practical forms, with few of the unusual shapes seen in Jomon pottery.

These general characteristics of Yayoi ware are easily detected in a kind of burial urn (Fig. 127) found in northern Kyushu. Two of these vessels buried with their mouths joined were large enough

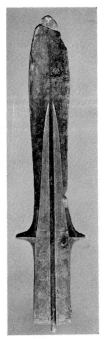 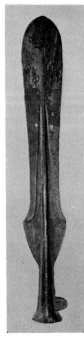

131 (above left). Flat bronze sword. Late Yayoi. Length, 46.7 cm. Yugayama site, Kojima, Okayama Prefecture. Collection of Masao Oga.

132 (above right). Bronze spear. Late Yayoi. Length, 86 cm. Kuroshima site, Toyotama, Nagasaki Prefecture. Tokyo National Museum.

is mention, on the other hand, of a large number of Wa states, including that of Yamatai, ruled by a queen, Himiko, and considerable information is given concerning their internal affairs. For many years scholars have disagreed as to whether they should place Yamatai in northern Kyushu or in the Kinai area. I myself, while agreeing that in the later half of the Yayoi period the cultural center shifted to the Setouchi and the Kinai districts, am not entirely convinced that Yamatai should be equated with Yamato, the name of the old province situated in present-day Nara Prefecture. The *Wei Chih* shows that by the third century a considerable number of what seem to have been protostates had emerged in northern Kyushu, and that some of them were maintaining diplomatic and trade relations with Later Han and Wei China. At an early date the Later Han court presented a gold seal to the "Han Vassal, King of the Wa state of Na," in northern Kyushu; and later, envoys from Wei also came to Kyushu. Such circumstances would seem to suggest that northern Kyushu was constantly ahead of other areas not only culturally and economically but also in the fields of domestic politics and foreign diplomacy.

Although there is no doubt that during the Yayoi period the culture of the continent reached Kyushu principally via southern Korea, this was not the only route, and it seems likely that the culture of central eastern and southeastern China also came in via the Satsunan Islands and southern Kyushu. This view is supported by the discovery in the Hirota sand dunes on Tanegashima Island of a special type of personal ornament made of seashells (Figs. 133, 134). The designs of fabulous beasts—a debased version of the *t'ao-t'ieh*, or animal mask, pattern of Chou China—found on them are obviously not Japanese but derive from a continental culture of Chinese origin. However, this culture was probably not Shang, Chou, Ch'in, or Han culture in its original form but instead the culture of the aboriginals of central eastern and southeastern China, who assimilated the cultures of Shang and Chou China and produced local and tribal variations of them.

Ever since the Jomon period, Japan had main-

to hold a human body and were obviously made with no idea of artistic creation; yet the massive form, swelled bulge, and sturdy construction bespeak an agricultural people with its feet firmly planted on the good earth.

In the later half of the Yayoi period, the cultural center shifts away from Kyushu to the Setouchi (the region around the shores of the Inland Sea) and Kinai districts, and the importance of northern Kyushu declines. In this period, the area formed a cultural sphere characterized by bronze swords and spears. But the *Wei Chih*, based on the reports of Wei envoys to northern Kyushu, mentions neither bronze swords nor spears, which suggests that they were by then already a thing of the past. There

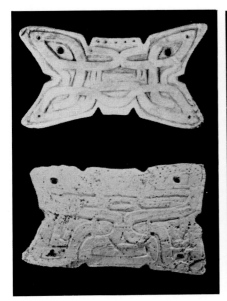

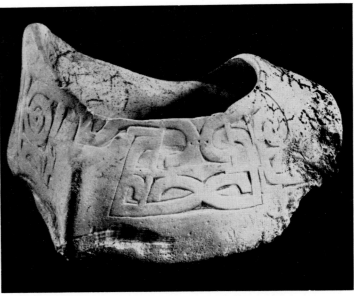

133. *Shell amulets with* t'ao t'ieh *pattern. Middle Yayoi. Hirota site, Shimotane, Kagoshima Prefecture. Tezukayama University, Nara.*

134. *Shell bracelet with* t'ao t'ieh *pattern. Middle Yayoi. Hirota site, Shimotane, Kagoshima Prefecture. Tezukayama University, Nara.*

tained the custom of building pit-style dwellings, but in the Yayoi period raised-floor buildings, at first intended for storing grain, were erected. The raised-floor building is a style of architecture commonly found in the coastal districts of southeastern Asia, and probably came into Japan along with the cultivation of rice.

Investigations since World War II have revealed the existence in northern Kyushu of many of the tombs known in Japanese as the "go-board-type dolmen." They consist of a large natural slab of rock that acts as a cover and is supported by a few smaller rocks (Fig. 135), and their name derives from the resemblance to the wooden board used for playing go (a Japanese board game). I am not sure whether they can be called dolmens in the accepted sense of the term, but it seems possible that they too are of Southeast Asian origin, since similar tombs are found in the Indochina region. Their distribution extends from southern Korea to northern Kyushu, which probably means that this

system of burial was brought in together with the rice-growing culture of central eastern and southeastern China or Southeast Asia.

INFLUENCES IN THE
TUMULUS PERIOD

In the Tumulus period, Kyushu came within the sphere of the burial-mound culture that centered in the Kinai district, and large numbers of burial mounds were erected in the northern half and in the southeast of the island. The Saitobaru site in Miyazaki Prefecture is especially celebrated for its dense cluster of burial mounds. A large number of mounds of varying sizes and shapes are found within a small area and are one of the supports of the traditional belief that Hyuga Province (present-day Miyazaki Prefecture) was the spot where the ancestors of the imperial family originally descended from heaven. The existence in the southeast of Kyushu of such a large concentration of tombs belonging to the Yamato tradition suggests that this region was an

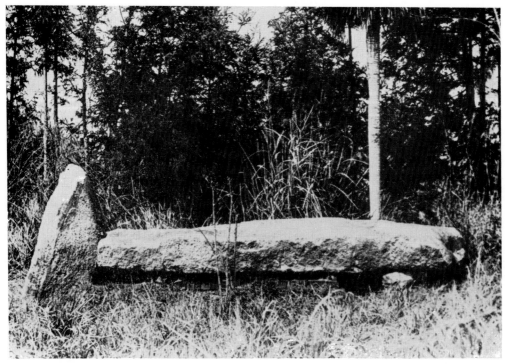

135. Remains of go-*board-type dolmen. Middle Yayoi. Okamoto site, Kasuga, Fukuoka Prefecture.*

important military outpost in the struggle to quell the Hayato and other anti-Yamato forces in southern Kyushu. The discovery in one of the Saitobaru tombs of a comparatively large *haniwa* in the shape of a ship (Fig. 108) further suggests that the area was a focal point in sea transport and encourages the supposition that the Hyuga outpost was both military and naval.

The decorated tombs of northern Kyushu—tombs in which the inner walls or the stone coffins are decorated with paintings or engraved pictures—are one product of tomb culture that is peculiar to Kyushu. The designs used include both geometric patterns, such as the *chokkomon* (intersecting curved and diagonal lines) or concentric circles, and figurative patterns, such as depictions of men and horses, shields and quivers, ships, and so on. The *chokkomon* pattern (Figs. 137, 139), a decora-

tion peculiar to Japan, may have been invested with some special significance, while the concentric circles that occur still more frequently (Fig. 141) may well have some connection with sun worship. The *chokkomon* and circles seem to have been executed with the aid of rules and compasses.

Weapons of various kinds figure comparatively prominently among the designs, and almost certainly were intended, like *haniwa*, to give protection to the tomb. The boats, horses, and human figures (Figs. 52, 110), and the boats carrying birds (Fig. 140) have given rise to various theories concerning their connection with the continental tombs with mural paintings. On the continent, the tombs with mural paintings at both Chi-an and P'yong-yang in Korea are the better-known examples. If one does trace this type of tomb with murals back to its source, of course, one may find examples in the decorated

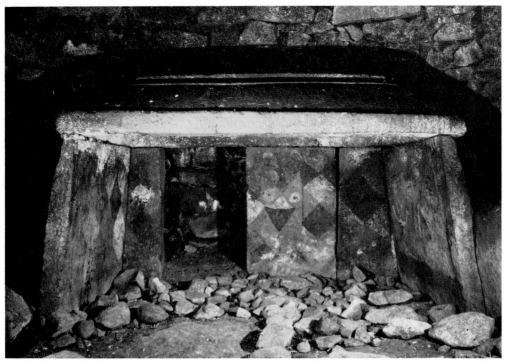

136. *Stone tomb chamber with diamond pattern painted on inner walls. Late Tumulus. Height of inner walls, 98 cm. Chibusan Tomb, Yamaga, Kumamoto Prefecture. (See also Figure 109.)*

tombs of the Han dynasty, and especially at Liao-yang in northeast China; and it seems likely that such tombs were erected not only in Koguryo but in Paekche also. Since Japan, and northern Kyushu in particular, had close relationships with northeastern China and Korea, especially southern Korea, it is likely that the continental murals and tomb decorations influenced those in Japan. Therefore, as is generally true of the culture of the later part of the Tumulus period, it is no wonder that other obviously continental features are apparent. For example, the baggy breeches of the men leading horses in Figures 52 and 110 are the same style as worn by the continental equestrian peoples of the time.

There has been speculation that the ship with a bird perched on it (Fig. 140) that appears in some murals is a representation of the "heavenly-bird boat" of Japanese myths. What immediately comes to mind in connection with boats is the many traditions of tribes of the north and east of Kyushu relating to the sea or sea gods. The *haniwa* ship unearthed at Saitobaru probably has some relevance to this. These murals and engraved pictures in the decorated tombs of northern Kyushu represent the pictorial achievements of the Tumulus period in the same way that the *haniwa* of the Kinai district and eastward into the Kanto district represent its sculptural achievement.

The next tangible evidence of the relationship between western Japan and northeast China and Korea during this period is the *kogo-ishi* that are found exclusively in northern Kyushu and the western reaches of Honshu. The term *kogo-ishi* (literally, divine-protection stone) refers to a large number of stone blocks piled on top of each other

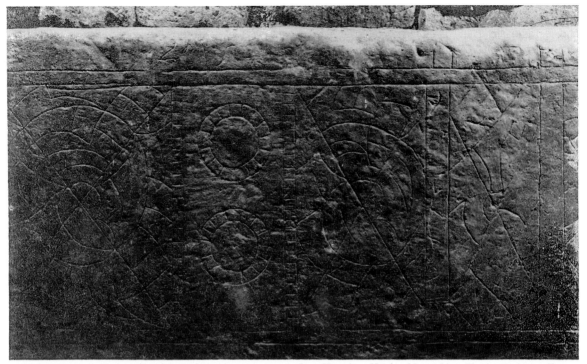

137. Stone inner wall of tomb with incised chokkomon *pattern. Late Tumulus. Height, 85 cm. Idera Tomb, Kashima, Kumamoto Prefecture.*

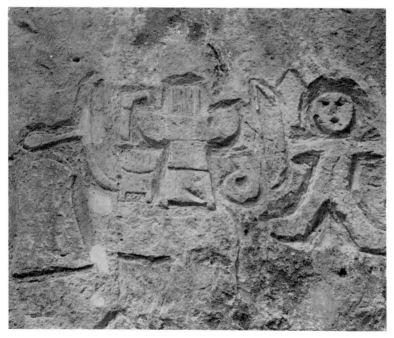

138. Detail of hunter carved in relief on tomb entrance. Late Tumulus. Nabeta hillside tomb, Yamaga, Kumamoto Prefecture.

139. Stone sarcophagus with chok- ▷ *komon design. Late Tumulus. Length, 280 cm. Sekijinyama Tomb, Hirokawa, Fukuoka Prefecture.*

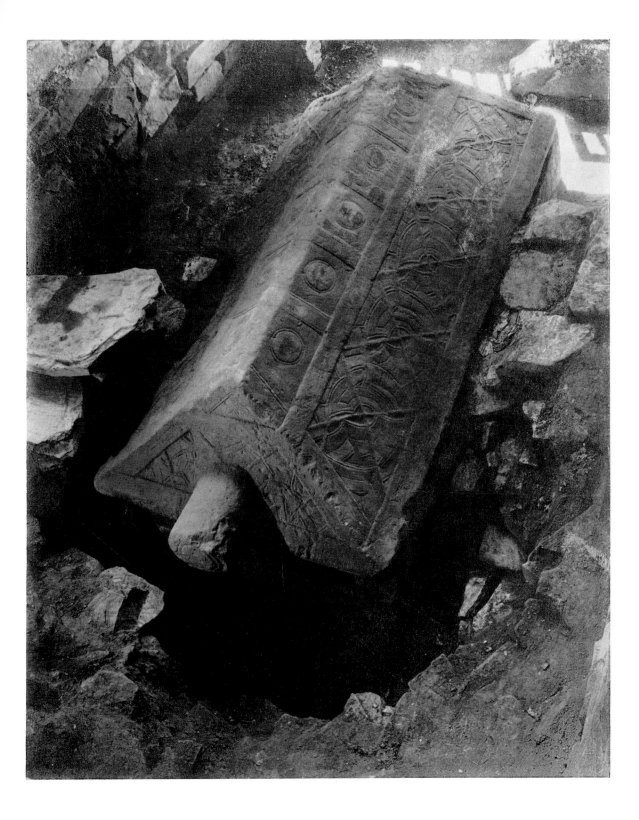

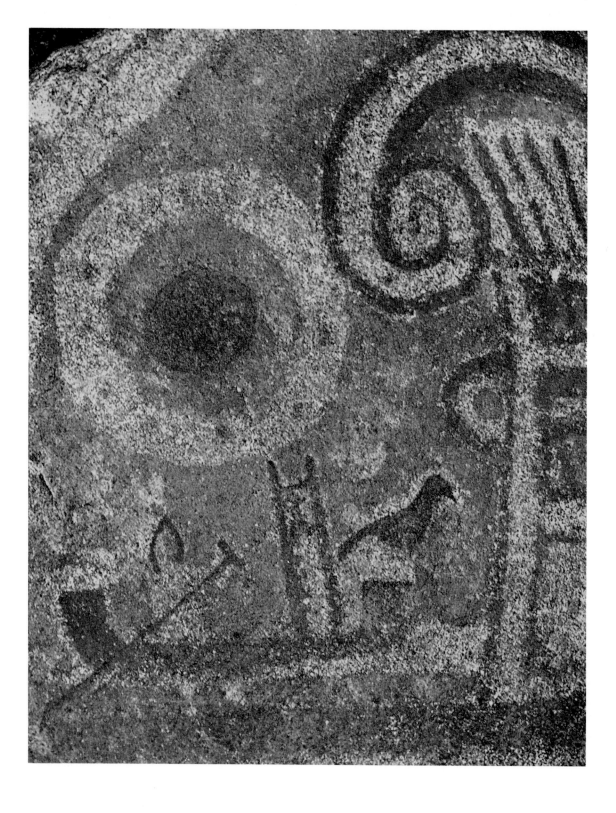

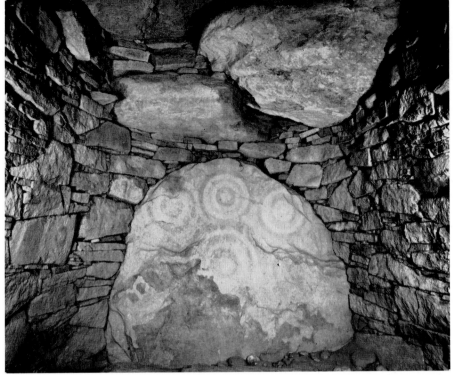

141. *Tomb with concentric circles painted on inner wall. Late Tumulus. Hino-oka Tomb, Yoshii, Fukuoka Prefecture.*

to form a barricade encircling a small hill or eminence, with apertures like sluices in them here and there. The purpose for which these *kogo-ishi* were intended has long been a subject of controversy; as the name suggests, one theory in the past was that they marked the site of religious rites, but the generally accepted theory today is that they were fortifications. Remains of hill fortresses of similar construction are found at many Koguryo sites, and these *kogo-ishi* can be seen as yet further evidence of the transmission of the culture of the peoples of Puyo and Koguryo to northern Kyu-

shu and its penetration to the southwestern limits of Honshu and the Setouchi district. Their date is still far from clear, but they probably belong to the same period as the decorated tombs, that is, the later half of the Tumulus period.

Still more clearly of continental origin than even the decorated tombs and *kogo-ishi* are the stone men (Figs. 115, 142, 143) and stone horses, but these are distributed over a smaller area, being restricted almost entirely to Yame county in Fukuoka Prefecture. They consist of figures of men in armor and horses with military accouterments carved out of

◁ 140. *Detail of painting depicting boat carrying a bird: on a large rock from tomb. Late Tumulus. Height of rock, 1 m. Mezurashi-zuka Tomb, Yoshii, Fukuoka Prefecture.*

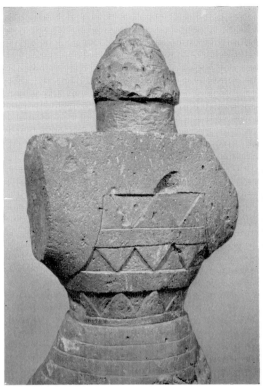

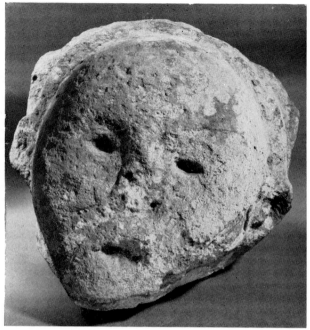

142. *Carved-tuff man wearing armor. Late Tumulus. Height, 110 cm. Ishigamiyama Tomb, Takada, Fukuoka Prefecture.*

143. *Human head carved from tuff. Late Tumulus. Height, 36 cm. Iwatoyama Tomb, Yame, Fukuoka Prefecture.*

rock. They were placed around tombs and unquestionably, in both Japan and Korea, these stone men and horses derive from the stone figures of men and beasts that were produced in China from the Han dynasty on into Ming and Ch'ing times.

To sum up, it seems that northern Kyushu in the later half of the Tumulus period must be considered—ethnologically and culturally, as well as politically and militarily—in conjunction with the continent and in particular with Korea and the northeastern districts of China. Only by doing so can one understand what lay behind the creation of the many objects of artistic interest—the tomb paintings; works of sculpture such as the stone men and stone horses; and "architectural" manifes-

tations such as the *kogo-ishi*—that characterized northern Kyushu at this time.

Finally, I must mention the Okinoshima site, where a collection of articles resembling buried treasure (including a ring of pure gold; Fig. 144) was unearthed. The site lies in the shelter of large rocks in the grounds of the Okitsumiya sub-shrine of the Munakata Shrine on Okinoshima Island in Fukuoka Prefecture. It is not clear why such a treasure should have been buried on Okinoshima, but the fact that it was found within the precincts of a shrine almost certainly means that it was presented to the shrine. Indeed, the great rock itself may well represent the shrine's most primitive form, one prototype of the Shinto shrine in Japan,

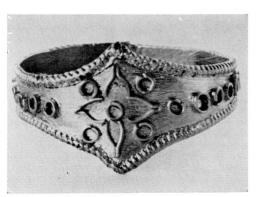

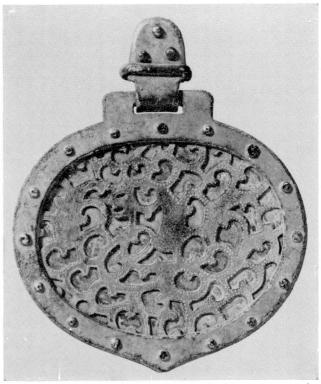

144. *Gold ring. Late Tumulus. Diameter, 2.2 cm. Okinoshima site, Oshima, Fukuoka Prefecture. Munakata Shrine.*

145. *Bronze harness ornament with arabesque bird design in openwork. Late Tumulus. Width, 9.6 cm. Okinoshima site, Oshima, Fukuoka Prefecture. Munakata Shrine.*

where it was common from ancient times to worship hills and rocks as the abodes of the gods.

The Munakata Shrine was founded in accordance with a tradition that when the imperial ancestors descended to earth the Sun Goddess, Amaterasu Omikami, sent her three daughters down to the islands in the Genkai Sea to assist Ninigi-no-mikoto, her grandson and the first ruler of Japan, who passed by the islands during his descent from heaven. Thus three shrines came into being, the Okitsumiya on Okinoshima being the farthest of the three from the main island of Kyushu. It is extremely significant that such a large number of relics with a pronounced continental flavor were discovered at a shrine associated with

such a tradition—and from beneath a rock that probably represents the shrine's original form. A considerable number of these articles would seem to have come from the continent—the finely worked gold ring, as well as the fragments of a cut-glass bowl, the fine equine trappings, the beads, and so on. The discovery of such highly decorative and costly treasure with marked continental features is unusual in the tombs of the Kinai district, but in northern Kyushu somewhat similar examples have been found at the Eta-funayama Tomb and elsewhere. This respect for continental treasure, besides showing the character and tastes of those who held power in northern Kyushu, points up the especially close relationship that they had with the continent.

CHAPTER EIGHT

The Advent of Powerful Clans: The Kinai and Setouchi Area

THE CENTER OF YAYOI CULTURE The foundations of the dominance exerted for so long in Japan in the area extending from the Kinai district to the regions around the shores of the Inland Sea (the Setouchi district) were in a sense laid during the Yayoi period. Since the end of World War II, however, a large number of sites dating from the Primeval Jomon era and on into the Archaic and Early Jomon eras have been found in this district, thus confirming that its importance dates from a still earlier age. The Archaic Jomon sites have yielded pottery of the incised and impressed-pattern types, while artistic Early Jomon vessels (Fig. 146) have been unearthed at the Kitashirakawa site in Kyoto and at an increasing number of other Early Jomon sites.

With the Late Jomon era, sites of large-scale dwellings and shell mounds increase in number around Ise Bay and along the shores of the Inland Sea, but there are few works of artistic excellence. It was only toward the end of Late Jomon and in the Terminal Jomon era that objects of sculptural interest such as the animal figurines from the Kashihara site were produced, together with all kinds of ornaments in semiprecious stone such as jadeite.

Being mountainous, with few plains apart from one in the north, and constantly visited by typhoons and other threats to rice crops, Kyushu is far from ideal for the expansion of an agricultural population. It is probable that these factors prompted the men of the wet-rice culture to move from northern Kyushu to the Inland Sea and Kinai districts at a comparatively early date. The area stretching from the shores of the Inland Sea to the Kinai district offered an ideal climate and natural setting, together with inhabitants who had already achieved a comparatively advanced level of development, and created an environment capable of assimilating the newly arrived Yayoi culture and its bearers. As a result, the Yayoi culture that came into the Inland Sea and Kinai districts underwent such rapid development that by the middle of the Yayoi period, and especially in the later part of the period, this area seems to have been the center of Yayoi culture as a whole.

A society based on the cultivation of rice, depending as it does on operations carried out by the entire community, usually imposes simple ways of life, and life is given continuity by the round of annual observances associated with agriculture. The Yayoi culture in Japan was no exception: apart from agricultural implements, vessels for eating and drinking, and other objects of daily use, almost the only noteworthy cultural relics to be found are, as we have seen, special social products

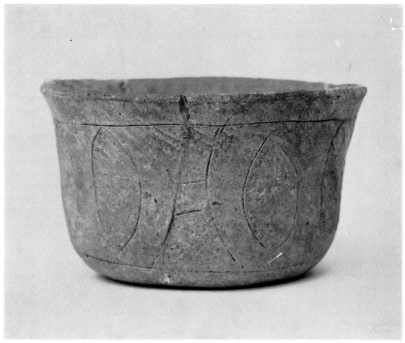

146. Red-painted earthenware bowl with incised design. Early Jomon. Height, 6.5 cm. Kitashirakawa site, Kyoto. Kyoto University.

such as the objects used in the community's rites and festivals and articles symbolizing authority. Even here, the list is surprisingly short.

Nevertheless, the Kinai and Setouchi districts produced a large number of outstandingly fine pieces in these two fields, and their culture as a whole is undeniably at a higher level than that of other districts. The objects of daily use include some with considerable grace of form, such as the ewer shown in Figure 71, the lidded vessel with a raised foot in Figure 73, and the pot with a stand in Figure 26. A few rare pieces even have incised designs of men, deer, and so on (Figs. 149, 150). Some of the cups and bowls have sophisticated designs—variations of fretwork (Fig. 148), the flowing-water pattern, and other patterns in relief —or have been painted in red and white (Figs. 23, 27, 147). These not only give some idea of the high

level and richness of the lives of the Yayoi men in the Kinai and Inland Sea districts but also hint at that culture's ultimate origins far away on the continent. It is also worth noting that the shapes of a number of the vessels seem to derive from the Black Ware of China.

Elements of bronze culture in this period include both mirrors and *dotaku* for ritual and magical purposes. The bronze mirrors include some that have two or three hook-knobs for string and are decorated on the back with saw-tooth, or triangle, patterns (Fig. 183). This special type of mirror was probably imported from Korea or it may have been made in Japan in imitation of a type of mirror that originated somewhere in northern Korea. However, it is doubtful whether this type with many hook-knobs was actually used as a mirror. I suspect that in Korea it was a kind of equine accouterment,

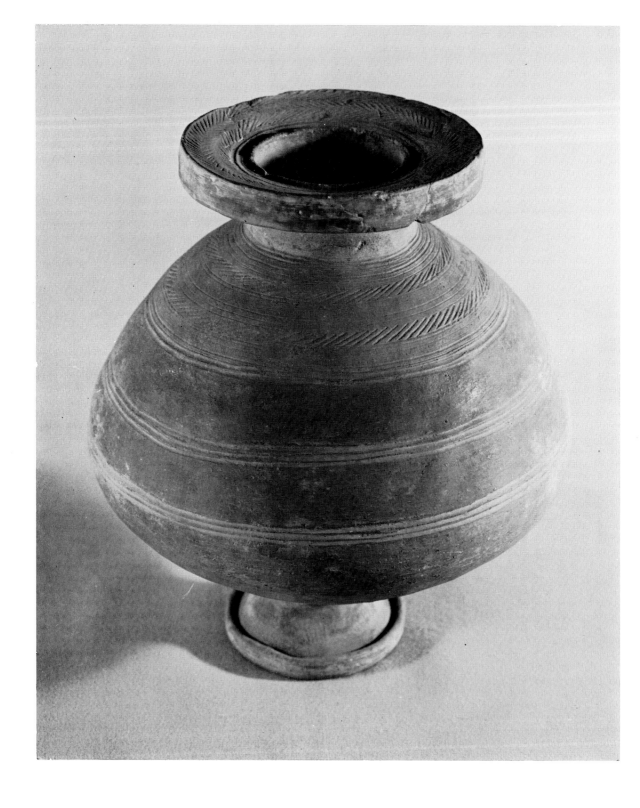

147. Footed earthenware jar decorated with cinnabar and incised patterns. Middle Yayoi. Height, 24.3 cm. Takakura site, Nagoya, Aichi Prefecture. Tokyo National Museum.

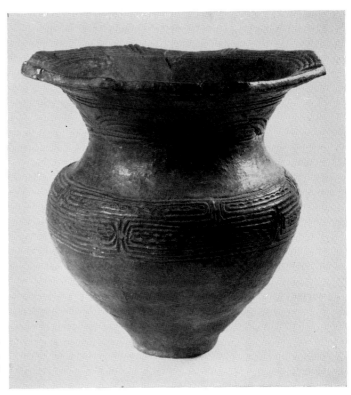

148. Wide-mouthed earthenware jar with fretwork decoration. Middle Yayoi. Height, 17 cm. Daichi site, Iwakura, Aichi Prefecture. Collection of Yasutaka Yamada.

hung over a horse's forehead as a charm to ward off evil but that in Japan it was used as a shamanistic device.

THE DOTAKU IN YAYOI CULTURE

At the time, from the middle of the Yayoi period and especially in the later part of the period, the bronze ceremonial bells known as *dotaku* made their appearance in the Kinai, Setouchi, San'in, and Hokuriku districts and in Shikoku and spread east as far as the Tokai district. Here again, just as with the bronze swords and spears of Kyushu, bronze objects from the continent provided the impetus for something new with an entirely different significance. However, with the *dotaku* the transformation of shape was far more marked than in the previous cases, and almost no direct prototypes are to be found on the continent.

The most archaic type of *dotaku* is small and close to a musical instrument in shape. Its surface is divided into a number of horizontal bands of pattern and frequently bears designs like faces with large eyes, or a corruption of the *t'ao-t'ieh* pattern. Since this type of *dotaku* has been discovered in considerable numbers in the San'in district, it seems likely that the Chinese musical instrument known as the *taku* (the same character as the *taku* of *dotaku;* the *do* means bronze) traveled via Korea (a small *dotaku* has been unearthed near Kyonju in southern Korea) to the San'in district, where it was taken over and transformed into the *dotaku,* as a ritual or ceremonial object for the community.

In the next period, *dotaku* with flowing-water patterns and patterns resembling ribbons crossing at right angles cast on their surface were made in large numbers in the Kinai and Setouchi districts.

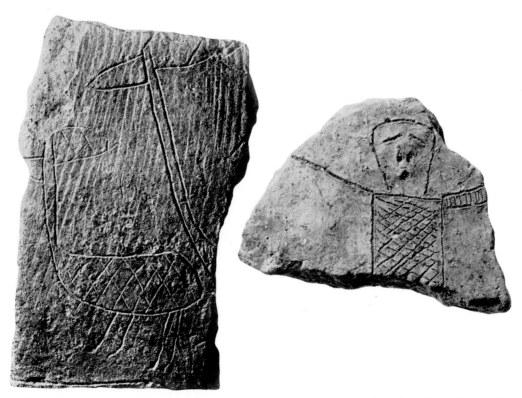

149. *Earthenware shards with incised designs of deer, left, and a human being, right. Late Yayoi. Karako site, Tawaramotomachi, Nara Prefecture. Kyoto University.*

They are large, and the casting is thin and relatively elaborate, so that the immediate impression is not so much of musical instruments as of treasure objects. The specimens with flowing-water patterns (Fig. 24), which are comparatively squat and heavy, still retain some of the appearance of a musical instrument, but those with the ribbon-type patterns (Figs. 25, 151) have a beauty that immediately suggests a purely ornamental purpose, with fin-shaped flanges at the sides to give the shape added dignity.

Further development produced the type of *dotaku* with patterns cast in line relief (Figs. 78, 152, 153), and on the ribbon type and line-relief type of *dotaku* one frequently finds, within the sectors into which the surface has been divided, pictorial or figurative designs (Figs. 21, 29, 76, 151, 152) that give them great artistic and historical interest. They are cast in a relief that suggests line drawings, and the subjects or themes seem to have been more or less fixed. They include birds and beasts such as turtles, snakes, dragonflies, and waterfowl; and scenes of deer and wild-boar hunting, of pounding grain in a mortar, and of men dancing with what appear to be spades in their hands. All of these suggest yearly observances or a feeling of the seasons in the mainly agricultural life of the Yayoi period. To me, placing fixed subjects each within its own division suggests a kind of agricultural calendar. Thus the turtles and snakes could symbolize early spring, when those creatures come to life after their hibernation; the spade dance could

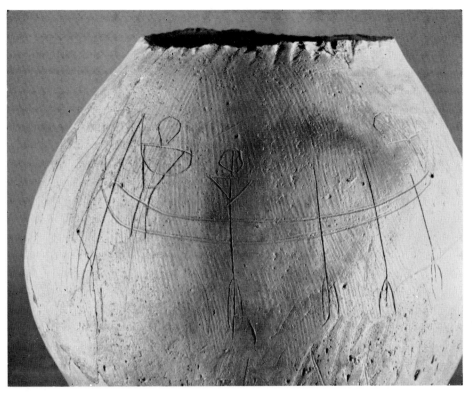

150. Earthenware pot with incised men and boat. Late Yayoi. Karako site, Tawaramotomachi, Nara Prefecture. Kyoto University.

represent some celebration prior to embarking on the cultivation of the paddy fields; the mortars could suggest the autumn harvest and rites celebrating the new rice; the dragonflies and water birds could represent, respectively, early autumn and late autumn, when birds of passage arrive in Japan; and the hunting scenes could symbolize winter. If one accepts this interpretation, then the *dotaku* may well have been used in connection with the seasons and seasonal observances.

It seems certain that by the time the ribbon-type *dotaku* were made there were already priests who specialized in ritual and craftsmen who specialized in the making of *dotaku*. It also seems likely that a fixed unit of linear measure was already in use— possibly the Later Han "foot" of China (roughly

equivalent to the modern English foot). It is said that the material for *dotaku* was obtained by melting down bronze mirrors and weapons imported from China, Korea, and their neighboring countries. It seems safe to assume that by the time it started producing *dotaku* Yayoi society in the Kinai and Inland Sea areas could already boast of members with specialists' knowledge, techniques, and skills, and that it had attained a relatively high level of development for a society based on agriculture.

Moreover, one is surely justified in inferring that the society that produced the ribbon-type and later *dotaku* was no longer a classless community but one that had already given rise to a priestly class that enjoyed leadership and authority powerful enough to exert influence outside the community. It was

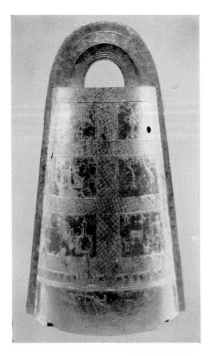

151. *Ribbon-type* dotaku *with line-relief drawings. Left, entire* dotaku; *below left, detail of water animals; below right, detail of hunter and dwelling. Late Yayoi. Height, 42.5 cm. Kagawa Prefecture. Collection of Hachiro Ohashi. (See also Figures 21, 29, 76.)*

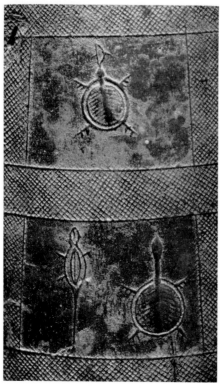

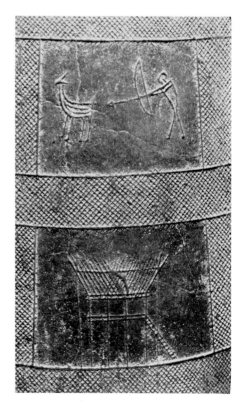

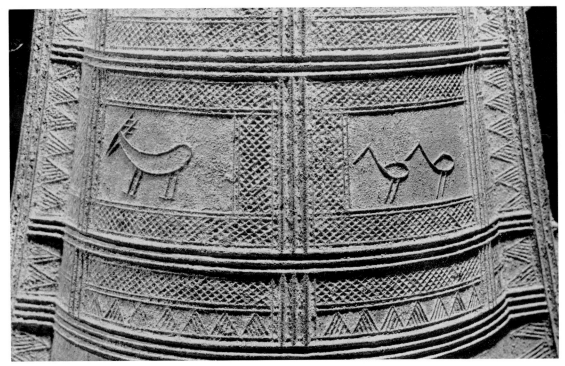

152. Large dotaku *with line-relief drawings. Above, detail of deer and* birds; *below, entire* dotaku. *Late Yayoi. Height, 64 cm. Akugatani site, Hosoe, Shizuoka Prefecture. Tokyo National Museum.*

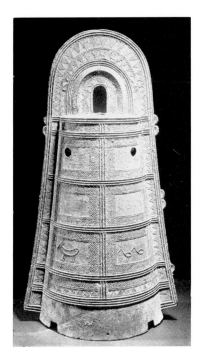

probably a kind of protostate embracing a number of agricultural communities.

In practice, however, the *dotaku* that symbolized this society suddenly vanished from the face of the earth, which makes it seem probable that around the time of transition from the Yayoi period to the Tumulus period there occurred, in and around the Kinai and Inland Sea areas, a major social and cultural change. This change involved an increase in the power of individuals and families, which tended to dismember the society based on the agricultural community and replace it with a territorial state dominated by powerful clans or aristocratic families (the latter presumably of priestly origin). More concretely, it meant the beginning of the age typified by the early tumuli.

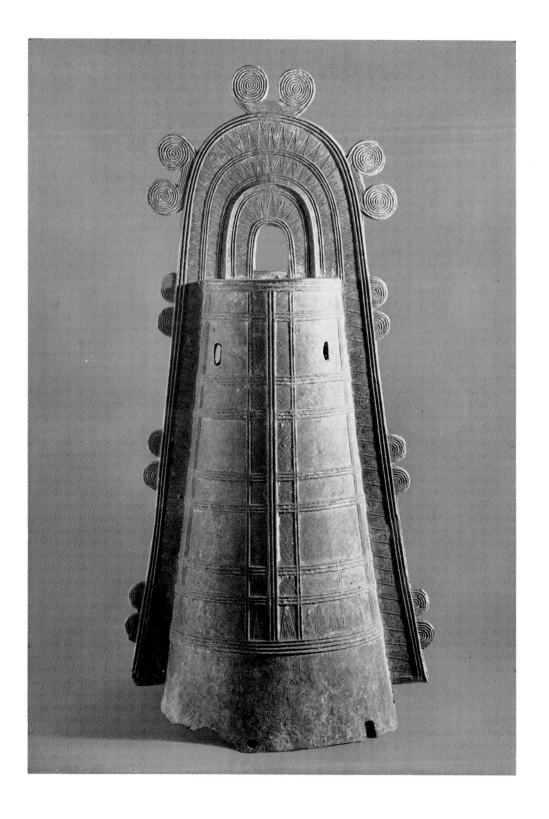

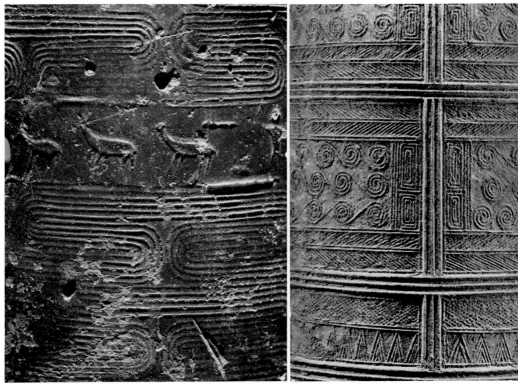

154. Detail of dotaku *decorated with flowing-water pattern and deer, both in relief. Late Yayoi. Provenance unknown. Collection of Etsuzo Tatsuma.*

155. Detail of dotaku *decorated with whorl, saw-tooth, and fretwork patterns in line-relief. Late Yayoi. Marune site, Nagoya, Aichi Prefecture. Collection of Etsuzo Tatsuma.*

THE CLANS AND EARLY TUMULUS CULTURE

The culture associated with the early tumuli—that is, the culture of what is known as the Early Tumulus era —still, as we have seen, strongly preserved the traditions of Yayoi culture. The fact that the largest of the early tumuli are concentrated in Yamato (present-day Nara Prefecture) implies that the Kinai district, and Yamato in particular, was the main source of power during this era. Its authority seems to have extended from the southern Tohoku district in the east as far as Kyushu in the west, as is presumed from the wide distribution of mirrors that seem to have been cast from the same mold. This authority, however, was probably more symbolic than actual.

The myths and traditions recorded in the *Kojiki* (Record of Ancient Matters; 712) and *Nihon Shoki*, or *Nihongi* (Chronicles of Japan; 720), Japan's two oldest national histories, speak of gods, such as

◁ 153. Dotaku *with decorative ears of whirlpool design. Late Yayoi. Height, 78.7 cm. Mukoyama site, Hitaka, Wakayama Prefecture. Tokyo National Museum. (See also Figure 78.)*

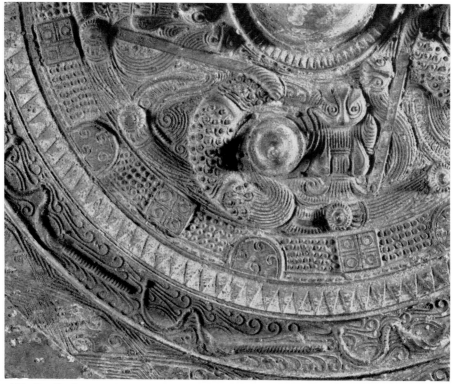

156. Detail of saw-tooth pattern and fantastic animal design in relief on bronze mirror. Early Tumulus. Chausuyama Tomb, Yanai, Yamaguchi Prefecture. Tokyo National Museum.

Okuninushi-no-mikoto (Great Land-Ruler Deity) in Izumo and Omononushi-no-kami (Great Manpower-Ruler Deity) in Yamato, whose behavior, despite the very abstract and symbolic names they are given, shows many very human qualities, and who are spoken of as the founders or representatives of local authority. Moreover, they are treated as divinities worthy of worship, which suggests that the regional authorities mentioned were a body in the form of a territorial state with a sacerdotal authority figure at the head of the ruling system. Thus the age symbolized by Okuninushi-no-mikoto and Omononushi-no-kami probably corresponds to the period when priestly clans or aristocratic families established their local authority. This was a stage on the way to the establishment of a political system approaching that of a nation based on territorial control.

During this period, objects such as mirrors, swords, and beads served as the symbols of local authority. It seems that particular importance was attached to mirrors. The fact that they were buried with members of the aristocracy or powerful local families as the personal property of their owners clearly shows that the authority was attributed to the individual. This period corresponds with the Early Tumulus era, and tombs of this period have yielded many imported Chinese bronze mirrors from the Later Han period (A.D. 25–220; Fig. 185) and from the Three Kingdoms period (A.D. 220–

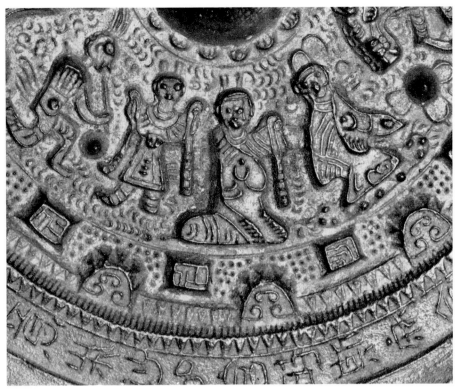

157. Detail of bronze mirror decorated with relief drawings of people. Late Tumulus. Wakayama Prefecture. Sumida Hachiman Shrine.

280), as well as Japanese imitations and original designs (Figs. 32, 111, 156, 186). The taste for erecting tumuli at this time was probably in itself another sign of the establishment of the individual authority of members of the aristocracy or powerful clans.

The burial mounds include, besides round mounds, a peculiarly Japanese type that is square at the front and round at the back, so that its plan looks rather like a keyhole; large numbers of these keyhole mounds (Fig. 160) were erected centered in the Kinai district. It is not clear just where this arrangement originated, though the possibility cannot be denied—when one considers how society of this age used mirrors imported from China as symbols of authority and erected tombs modeled

on the burial mounds of the continent—that it represents some Japanese adaptation of the Chinese ideas of yin and yang.

It appears that the significance of mound building on the continent was imperfectly understood in Japan. The Japanese, it seems, were merely impressed with the size of the mound tombs and realized their potential as symbols of authority. The Japanese mound was erected first, then a vertical pit was dug into the top of the mound to house the coffin, just as with Yayoi-period tombs. Thus the coffin was naturally situated at a point comparatively near the top of the mound.

As this adaptation suggests, in the Kinai and other districts of central Japan the continental

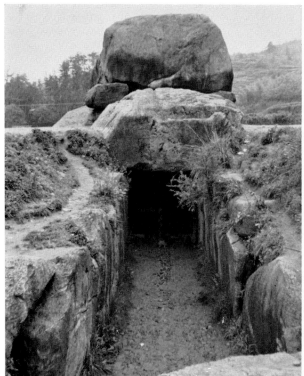

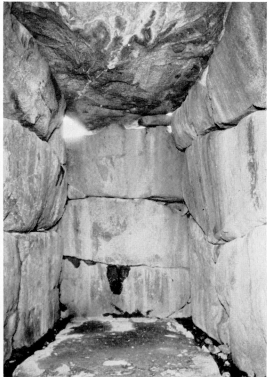

culture was not being taken over in its original form or meaning but was drastically altered to conform with the traditional culture that had been in existence since the Yayoi period. That the builders of the early tumuli in the first half of the fourth century should have adopted this approach is probably due to the fact that unlike northern Kyushu, for example, the area where they lived was removed from direct contact with the inflowing stream of culture from China and other continental areas.

THE YAMATO COURT AND LATE TUMULUS CULTURE

At the end of the fourth century this situation changed rapidly, and the horse riders from northeastern Asia, bearing the culture of the northern equestrian tribes, came into Japan via northern Kyushu and advanced along the Inland Sea to the Kinai district. They transferred their center of power to this area, and established what is known as the Yamato court, which succeeded in unifying most of Japan, with the exception of the lands of the Ezo in northern Honshu and Hokkaido. As all conquering dynasties of northern equestrians did, they curried favor with the powerful indigenous clans and aristocracy while browbeating the natives with displays of military might.

This epoch-making upheaval, so important to Japanese history politically, militarily, and socially, found its most concrete expression in the mausoleums of the emperors Ojin and Nintoku (Figs. 53, 161), which are on a scale outstripping that of the Pyramids themselves. Although they follow the keyhole plan of the Early Tumulus era, they show a better balance between the front and rear sections and are surrounded by three moats. It is note-

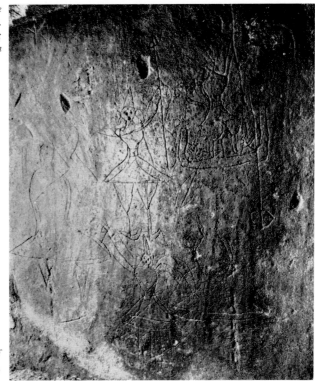

158 (opposite page). Left, approach to corridor-type tomb; right, inner chamber of tomb. Late Tumulus. Length of corridor, 11 m.; length of chamber 7.7 m.; height of chamber, 4.8 m. Ishibutai Tomb, Asuka, Nara Prefecture.

159. Detail of human figures incised on inner wall of tomb. Late Tumulus. Takaida hillside tomb, Kashihara, Osaka Prefecture.

worthy that these imperial mausoleums of the beginning of the Late Tumulus era are found not in the Yamato basin in Nara Prefecture, where the great tombs of the previous era had been concentrated, but on the Kawachi plain in Osaka Prefecture near the Inland Sea.

Of the Late Tumulus tombs, those that are of a relatively early date and massive scale are found, for the most part, in the areas of level ground around the eastern Inland Sea, on the Kawachi plain, in the area around Okayama City, and close to Wakayama City. This suggests that the earlier horse riders from northeast Asia advanced from Kyushu, through the Inland Sea area, and on into the Kinai district, setting up bases as they went—which agrees with the tradition concerning Jimmu (the legendary first emperor of Japan), his trip from Kyushu, and his eventual conquest of central Japan.

From the sixth century A.D. onward, the court established itself more or less permanently in the Yamato basin, and most of the imperial mausoleums were built there. Around the later half of the sixth century, and in the first half of the seventh century in particular, corridor-type tombs were built, in which the burial chamber and the passage leading to it were stoutly constructed with huge blocks and great slabs of stone, creating a kind of megalithic tomb. The two chief examples—the Ishibutai Tomb (Fig. 158) and the Tsukaanayama Tomb (Fig. 102)—are both situated in the Yamato basin. These corridor-type tombs were of course based on the continental models, and especially the Chinese version. However, in most cases, on the continent this type of tomb has a rectangular mound, and in Japan, too, rectangular tumuli came to be constructed along with the keyhole type.

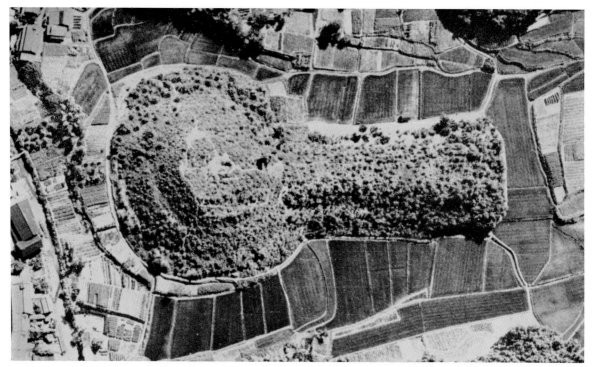

160. *Keyhole-style Chausuyama Tomb. Early Tumulus. Overall length, 207 m.; diameter of back, 110 m.; width of front, 61 m. Sakurai, Nara Prefecture.*

Occasionally, an unusual type of tomb that was round at the base and square above was built. In scale, however, none of these could rival those that were built at the beginning of the Late Tumulus era.

The introduction of Buddhism around the middle of the sixth century and the Taika reform of the mid-seventh century led to a decline in the power of the great clans and greatly influenced the burial system, so that the tumuli became progressively smaller. With the spread of the practice of cremation and the enforcement of the funeral sumptuary law, they disappeared almost entirely from the Kinai and Setouchi districts by the beginning of the eighth century.

The culture of the Late Tumulus era was essentially different from the agricultural cultures of the Yayoi period or the Early Tumulus era. In all parts of the world, the equestrian peoples tended to be enterprising, realistic, and nonexclusive. They concentrated on military and political matters; they showed a positive interest in absorbing foreign peoples and cultures; and they were fond of regal and aristocratic splendor.

The horse riders who invaded western Japan and established the Yamato court were no exception,

161. *Tomb of Emperor Nintoku. Late Tumulus. Overall length, including moats, 1000 m. Sakai, Osaka Prefecture. (See also ▷ Figure 53.)*

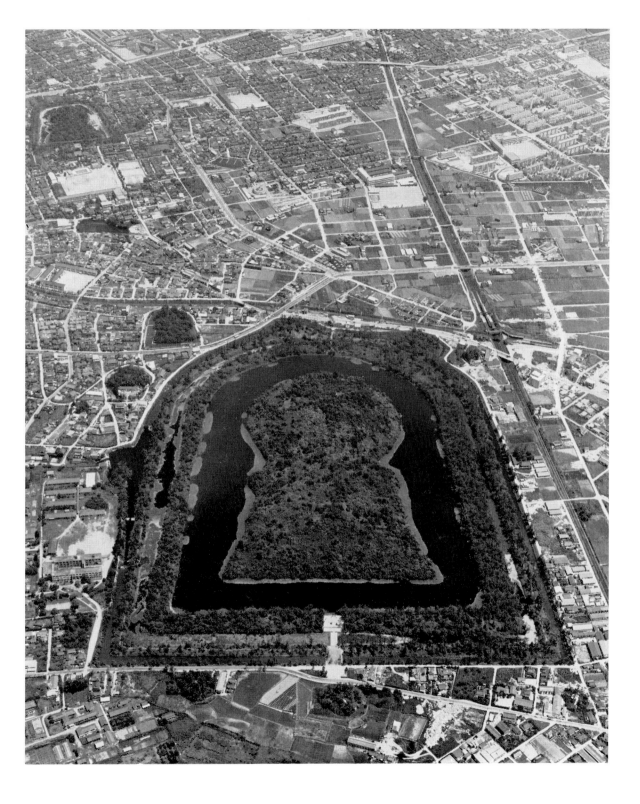

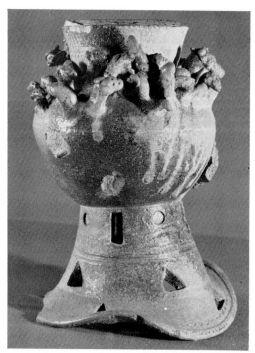

162. *High-footed* sueki *jar with figurines on shoulder. Late Tumulus. Height, 31.7 cm. Osafune site, Okayama Prefecture. Tokyo National Museum.*

tivity concentrated on such objects of decorative art and that its roots are traceable to the cultures of the northern Asian tribes and of China during the Northern and Southern dynasties (317–589).

The extraordinary enthusiasm of the Yamato court in bringing craftsmen over from the mainland and the Korean Peninsula is shown by traditions recorded in the *Kojiki* and *Nihon Shoki*. Most of these foreign craftsmen gathered in the Kinai district, and accordingly, it is this district that has yielded the finest specimens of metalwork and ceramics from the Late Tumulus era. The objects found in the Otani Tomb in Wakayama City (Figs. 113, 114, 193) are alone enough to make this abundantly clear; and there is no doubt that solely Japanese art at this period—and especially the art of the Kinai district—belonged to the same tradition as the art of northern Asian tribes and Chinese art of the Northern and Southern dynasties. Furthermore, as is shown by, for example, the glass bowl (Fig. 34), which is said to have been found in the mausoleum of the emperor Ankan (r. 531–35), the flow of art from the continent occasionally brought with it objects deriving from as far away as Persia.

However, it is with the art of the Three Kingdoms of southern Korea that Japanese art of the Late Tumulus era is most closely related—a relationship to be inferred from the existence of exact parallels in the openwork designs of *kanto-no-tachi* (Fig. 56) and buckles (Fig. 58), or, in the field of ceramics, from the relationship between *sueki* of the Late Tumulus era and Silla ware of the Three Kingdoms period. Such a relationship was probably only natural in view of the special racial, cultural, and political connections between Japan and southern Korea. A similar close link between the two is to be seen in the art of the Asuka (552–646) and Nara (646–794) periods as well, and for this reason it is important to understand the role of Late Tumulus culture in laying the groundwork for those later achievements.

Although the art of the Late Tumulus era unquestionably derived from the continent and in many cases was actually produced by craftsmen from southern Korea and elsewhere, there was at

and their character and tastes are clearly manifest in Late Tumulus culture. They regarded the world after death as similar to the present life and buried the deceased's personal possessions with him; or occasionally they made stone or *haniwa* replicas of the actual objects and placed them in the tomb in lieu of the real thing. Thus their tomb culture is incomparably more useful than the cultural relics of the Yayoi period or Early Tumulus era in helping us to imagine their actual everyday lives. The objects found in their tombs also give us a fairly clear idea of their artistic creativity and activities. They devoted particular attention to beautifying the weapons and equestrian trappings that play such a large part in the lives of a horse-riding people, and also to articles of personal adornment. Perhaps it was a natural outcome of their origins and international position that their artistic crea-

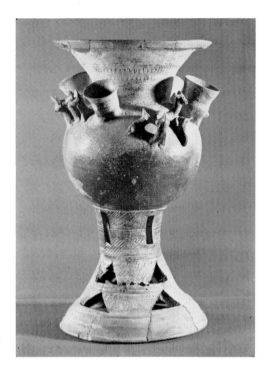

163. *High-footed* sueki *jar with multiple spouts and ornamented with figurines of people and deer. Right, entire vessel; below, detail of human figurines. Late Tumulus. Height, 37.5 cm. Nishinomiyayama Tomb, Tatsuno, Hyogo Prefecture. Kyoto National Museum. (See also Figure 107.)*

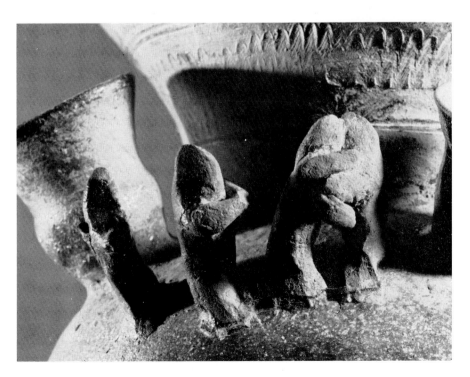

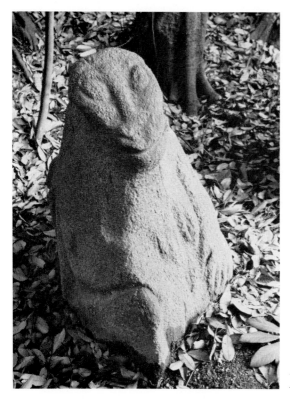

164. *Granite monkey stone. First half of seventh century. Height, 90 cm. Kibitsuhime-o Tomb, Asuka, Nara Prefecture. Imperial Household Agency.*

the same time considerable creativity among Japanese of the day. Outstanding in this respect are the *haniwa,* which, even admitting a hint from the *ming ch'i* of China, are completely original in their artistic creativity. Generally speaking, *haniwa*—which probably had their origins in the Kinai district, just as the traditions say—can be classified into two types, cylindrical *haniwa* and figurative *haniwa.* Many tombs in the Kinai district have several rows of the cylindrical type encircling the mound.

Works of a pictorial nature, as opposed to the sculptural *haniwa,* are rare in the Kinai district of this period. However, the pictures of human figures incised in the walls of the Takaida tomb in Osaka Prefecture (Fig. 159), which show soldiers wearing the same type of baggy trousers as the *haniwa* warriors, are interesting not only from the view-

point of art history but also from that of cultural history. Furthermore, they clearly show that the major artistic preoccupation of the men of the Late Tumulus culture was to give concrete expression to the things that concerned them most in the practical present world. This preoccupation, which is equally evidenced in the pictures of the decorated tombs and the sculptural forms of *haniwa,* obviously has its roots in the realism and practicality common to all equestrian peoples.

Mention should also be made of the clay figures of men, horses, deer, and so forth that decorate the shoulders of some *sueki* vessels (Figs. 33, 107, 162, 163). Similar figurative decoration is to be found on Silla ware; whatever their relationship, both are designs equally typical of an equestrian people.

Artistically, the culture of the Late Tumulus era was utterly different from that of the Yayoi period

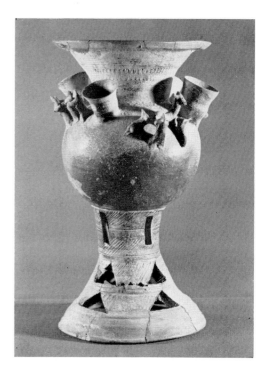

163. High-footed sueki *jar with multiple spouts and ornamented with figurines of people and deer. Right, entire vessel; below, detail of human figurines. Late Tumulus. Height, 37.5 cm. Nishinomiyayama Tomb, Tatsuno, Hyogo Prefecture. Kyoto National Museum. (See also Figure 107.)*

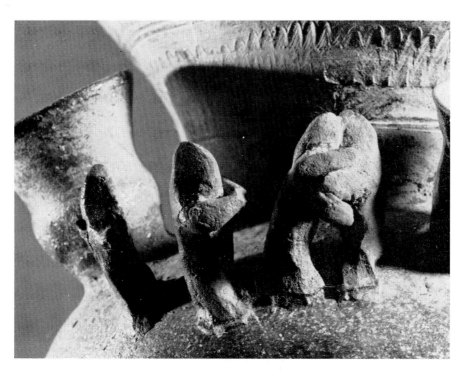

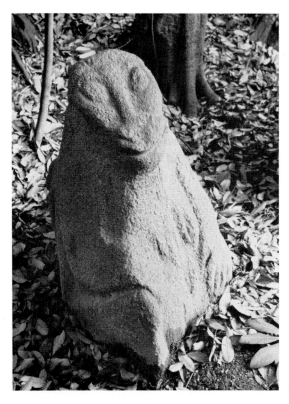

164. *Granite monkey stone. First half of seventh century. Height, 90 cm. Kibitsuhime-o Tomb, Asuka, Nara Prefecture. Imperial Household Agency.*

the same time considerable creativity among Japanese of the day. Outstanding in this respect are the *haniwa*, which, even admitting a hint from the *ming ch'i* of China, are completely original in their artistic creativity. Generally speaking, *haniwa*—which probably had their origins in the Kinai district, just as the traditions say—can be classified into two types, cylindrical *haniwa* and figurative *haniwa*. Many tombs in the Kinai district have several rows of the cylindrical type encircling the mound.

Works of a pictorial nature, as opposed to the sculptural *haniwa*, are rare in the Kinai district of this period. However, the pictures of human figures incised in the walls of the Takaida tomb in Osaka Prefecture (Fig. 159), which show soldiers wearing the same type of baggy trousers as the *haniwa* warriors, are interesting not only from the view-

point of art history but also from that of cultural history. Furthermore, they clearly show that the major artistic preoccupation of the men of the Late Tumulus culture was to give concrete expression to the things that concerned them most in the practical present world. This preoccupation, which is equally evidenced in the pictures of the decorated tombs and the sculptural forms of *haniwa*, obviously has its roots in the realism and practicality common to all equestrian peoples.

Mention should also be made of the clay figures of men, horses, deer, and so forth that decorate the shoulders of some *sueki* vessels (Figs. 33, 107, 162, 163). Similar figurative decoration is to be found on Silla ware; whatever their relationship, both are designs equally typical of an equestrian people.

Artistically, the culture of the Late Tumulus era was utterly different from that of the Yayoi period

or the Early Tumulus era, and the religious and symbolic qualities that marked the latter are mostly conspicuous by their absence. The one exception is mirrors, which, in accordance with the traditions of the Early Tumulus era, were revered as temporary abodes of the soul or as symbols of the soul itself. A number of bronze imitations of continental bronze mirrors have been found in mausoleums of the early part of the Late Tumulus era (Fig. 157). Their purpose is undeniably religious rather than practical, but around the middle of the Late Tumulus era it seems that even these bronze mirrors began to lose their symbolic nature, and both the manufacture of imitations and the import of mirrors from China declined steadily.

At the same time, traditions recorded in the *Kojiki* and the *Nihon Shoki* suggest that sometime around the reign of Emperor Kimmei (r. 539–71) a new religion, Buddhism, and a new system of ideas, Taoism, began to find followers in Yamato and its neighboring districts. It is not very clear in what manner they affected artistic expression, but it is interesting to note that around this time there appeared objects that seem to have at least some connection with religious art in China. The monkey stones (Figs. 117, 164), stone carvings, with extremely grotesque features, that stand by the Kibitsuhime-o Tomb near the tomb of Emperor Kimmei, may well have had the same significance as the grave guardians of China. It was the custom in China during the Han dynasty (206 B.C.–A.D. 222) and the period of the Six Dynasties (222–589), as well as in Koguryo, to make figures of grotesque beasts and demons in stone or metal, or to paint pictures of them on inside walls, to serve as guardians of the tombs. It is quite possible that this type of religious manifestation came into Japan from the continent along with the new Buddhist and Taoist ideas.

The proficiency acquired in the plastic and figurative arts combined with the influence of new religious and philosophical trends during the Late Tumulus era to gradually lay the foundations, principally in the Yamato district, for the brilliant artistic achievements of the ensuing Asuka and Nara periods.

Art Before the Tumulus Period

by Teruya Esaka

Professor of Archaeology, Keio University, Tokyo

THE DEVELOPMENT OF JOMON POTTERY Figures 9 and 37 show works from the peak of Middle Jomon pottery, which underwent a special degree of development in eastern Japan and produced a large number of works outstanding among primitive art. Figures 10 and 36 show works from the later half of the Middle Jomon era in which the bold, vigorous, untrammeled designs of the first half of the period are being tamed, preparing the way for the culture of the following era. The vessel in Figure 165 is of the kind popularly known as flame type, since the design of the ears around its rim resembles leaping fire; there are four ears symmetrically arranged.

The Katsusaka-type pottery found in the west of the Kanto district and on into the Koshin district (present-day Yamanashi and Nagano prefectures) shows no examples with four symmetrically arranged ears. The ears with faces (Figs. 91, 93) found in vessels of this type have the face on the inner side of a single large ear (Fig. 91). It is common for Katsusaka-type vessels to have one large ear projecting from the rim. However, the cylindrical upper-layer type vessels that are found in the Oshima Peninsula in Hokkaido and the northern half of the Tohoku district have four ears (Fig. 65), shaped like inverted fans, spaced sym-metrically around the rim of a cylindrical-type urn while the Daigi 7a- and 7b-type vessels found in the southern half of the Tohoku district and the Atamadai-type vessels found in the area around the shores of Kasumi-ga-ura Lake in the eastern Kanto district also include many urns that have four fan-shaped ears. The flame-type (Umataka-type) vessels that underwent special development in the basin of the Shinano River in Niigata Pre-fecture also seem to have come into being under the influence of the Daigi 7b-type vessels that were distributed as far as the northern half of Niigata Prefecture.

In the same sphere that saw production o these types of vessels with four fan-shaped ears, slab-type clay figurines (Fig. 167) have been excavated. The motifs of the pottery and clay figurines have features in common, which suggests that these districts formed part of one large cultural sphere. In the Katsusaka-type cultural sphere, on the other hand, three-dimensional figurines were produced.

The vessel in Figure 9 is the finest specimen of a type of vessel known as Sori 1. One of the seven restorable vessels excavated from the No. 4 pit-dwelling at the Sori site in Nagano Prefecture, it represents the transitional period between the high point of the Middle Jomon era and the increasing

organization and simplification of Late Jomon The leaping, unrestrained whorl designs seen around the mouth are in fact done in such a way that the powerful whorl patterns fit into a number of evenly spaced sections into which the rim is divided. The characteristic whorl designs found on the rims of vessels of the later half of the Middle Jomon era in the west Kanto and Koshin districts are carried on in this form from the pottery of the first half of the era, and a gradual process of ordering and simplification is evident.

Figure 37 represents a somewhat earlier period than Figure 9, and shows a work of the type known as Tonai 1 from the first half of the Middle Jomon era. It was discovered at the Fudazawa site at the southern foot of Mount Yatsugatake, close to the Sori site, and is a bowl—rare in Middle Jomon pottery—with handle decorations. Its decoration consists chiefly of odd sculpturesque shapes fashioned of clay and reminiscent of slugs, three of them resting on top of the handle and one each where the ring-shaped ornaments join the body of the pot. Some scholars see this as a variant of the snake ornaments common at this time in the Middle era, while others see it as a lizard. The circular ornaments suggestive of the face of an owl seen on the right at the base of the handle were almost certainly suggested, in fact, by owls. Half of the back of the pot is missing. A spatula or scraper shaped like a bamboo tube split in half was used to create the wave-type relief pattern that is found running along the middle of the two handles, in the center of the ring-shaped decorations, and on the back of the slug-shaped ornaments. This is one of the patterns that characterize vessels of the first half of the Middle era in the cultural sphere distinguished by the Katsusaka-type pottery.

The pot shown in Figure 36, excavated at the same Umataka site as the flame-type vessel (Fig. 165), is a work of the beginning of the later half of the Middle Jomon era that carries on from the vessel shown in Figure 9. It resembles the latter in the large ears with whorl designs that rise up from opposite sides of the rim, but the ears are symmetrical, whereas in the earlier vessel one is larger than the other.

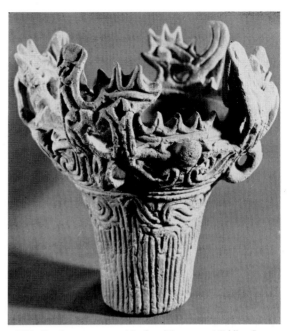

165. Earthenware pot with flamelike ears. Middle Jomon. Height, 32 cm. Umataka site, Nagaoka, Niigata Prefecture. Nagaoka Municipal Natural Science Museum.

The vessels in Figures 10 and 168 were excavated at the Tateichi site in Iwate Prefecture. They are urn-type vessels completely typical of the Daigi 8b phase of the later half of the Middle era. The whorl-design band that encircles the neck of the vessel shown in Figure 36 has given way to a design of three parallel lines in relief, and in Figure 10 the whorl pattern projects and forms a large circular ear. The band of pattern around the rim has been compressed, and the decorative pattern further simplified compared with the vessels in Figures 9 and 36. Although the vessel in Figure 10 still has whorl patterns and a pattern of vertical relief lines on the body, in later vessels of the Middle Jomon era even these give way to incised patterns, till finally there appear pots with simple patterns of a few parallel, vertically incised lines spaced at regular intervals around the body.

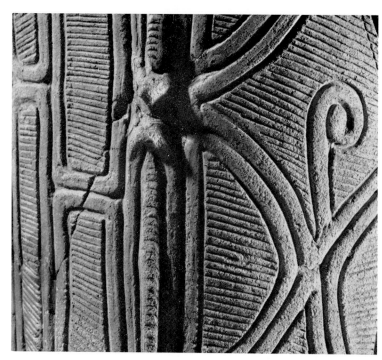

166. Detail of deep earthenware pot with bracken design. Middle Jomon. Tonai site, Fujimi, Nagano Prefecture. Idojiri Archaeological Museum, Fujimi.

In eastern Japan, pottery from the end of the Late era on into the Terminal Jomon era includes more small works than that of the Middle era. Some have the surface polished to produce an attractive dark gloss (Figs. 4, 39, 173). Moreover, whereas almost all vessels until the Middle Jomon era had been made for boiling, from the later part of the Middle era distinctions begin to be made among dishes for serving food, jars and other containers for storing food, and containers for liquids (spouted vessels). From the Late Jomon era on, this classification becomes still more marked.

The red-colored vessel in the shape of a seashell shown in Figure 38, which was excavated at the Ueyama site in the northernmost part of Niigata Prefecture, is almost perfectly preserved except for part of the tip. It is believed to be an imitation of a type of conch, known as the helmet conch, that lives in the deep seas off the Pacific coast of central Honshu.

The discovery at the same site of one small fragment of another red-colored vessel in the shape of a seashell shows that the vessel illustrated was not a solitary specimen, but cases of this kind of realistic representation of shellfish are extremely rare. About the only other example is a vessel in the shape of an abalone shell known to have been discovered long ago at the Shiizuka shell mound in Ibaraki Prefecture. This shell-shaped vessel uses carefully selected clay and the firing is good, and the comparative thinness of the body shows workmanship of a high level. The small protuberances on the body and the fine lines and other pattern characteristics show it to be a work of the end of the Late Jomon era. It is believed to be more or less contemporary with vessels of the types known as Shinchi type and Kongoji type that are found in the south of the Tohoku district. It seems unlikely that these red-painted vessels in the form of seashells were used for practical purposes, but if they were, their actual purpose is not clear.

The red-colored narrow-mouthed jar shown in

167. *Fragment of flat earthenware figurine. Middle Jomon. Height, 10.5 cm. Hataino site, Morioka, Iwate Prefecture. Morioka Municipal Board of Education.*

168. *Deep earthenware urn with whorl pattern in relief. Middle Jomon. Height, 45.4 cm. Tateichi site, Tsunagi, Morioka, Iwate Prefecture. Tsunagi Junior High School.*

Figure 39 is a large vessel, 41.3 centimeters in height, unearthed at the Kawahara site in the basin of the Goto River in Aomori Prefecture. It appears that originally the whole vessel was colored red. Traces of bright vermilion coloring still survive in the incised design on the lower half of the body, but it has not yet been determined whether this mineral pigment has a ferrous base or a mercurial base. Both types were in use in the Tohoku district during the Terminal Jomon era, and recently in Hokkaido a red dry-lacquer comb using lead coloring was discovered. The pattern on this jar is typical of the Ohora (formerly called Obora) B-type of the early part of the Terminal Jomon era. The outline of the pattern was made with incised lines, then it was filled in with an attractive rope or cord pattern, the slanting rope pattern on the remaining areas being erased with some instrument like a spatula, and finally these areas were polished to produce an attractive gloss.

The wide-mouthed jar with a colored design in red lacquer on a black lacquer ground shown in Figure 44 was excavated during the Meiji era (1868–1912) at the Kamegaoka peat-layer site in Aomori Prefecture. It is small, the height being only 9.3 centimeters and the maximum diameter 8.9 centimeters, but it is the only good specimen of a pot with a design in colored lacquer. One other similar piece discovered at the Kamegaoka site, with part of its upper half missing, is presently in the possession of Keio University. In 1956 it was designated an important cultural property by Aomori Prefecture. Vessels with patterns in red lacquer on a black base have been found only at the Kamegaoka peat-layer site and have not been found at other peat-layer sites such as those at Korekawa or Yawatazaki in Aomori Prefecture.

The only known lacquerware over a plaited bamboo base is, similarly, a specimen with red lacquer on a black base discovered at the Kamegaoka peat-layer site. At the Korekawa and Yawatazaki sites, only specimens with bright red lacquer

Ohora A-type. The lacquered vessels with plaited bamboo bases discovered at the Sanno site in the cultural layer corresponding to the Ohora A-type have patterns identical with this vessel, and thus it seems safe to consider that this pot was also excavated from an Ohora A-type cultural level. The Kamegaoka peat-layer site has yielded artifacts from the Ohora BC, C_1, C_2, and A periods.

This suggests that the technique of covering the whole vessel with black lacquer and then adding a design in red lacquer was employed around the time of the Ohora A-type, at the end of the Terminal Jomon era, and cannot date back any further than the Ohora C_2-type at the earliest.

169. Pulley-shaped earthenware earring. Late Jomon. Diameter, 6.3 cm. Ohana site, Fujimi, Nagano Prefecture. Idojiri Archaeological Museum, Fujimi.

JOMON FIGURINES AND OTHER ARTIFACTS

The clay figurine shown in Figure 48 is one of the finest relics of the period from the end of Middle Jomon to the beginning of Late Jomon. It is astonishing that in prehistoric Japan there should have lived men with the technical skill needed to produce work of this level. Fragments of other works with heart-shaped faces similar to this have been found in other places, notably the basin of the Agano River in Fukushima and Niigata prefectures in the northern Kanto district.

This figurine was discovered accidentally by laborers working on a new road at Agatsuma in the basin of the Agatsuma River in Gumma Prefecture. Records show that it was situated within a rectangular stone enclosure, which also contained large fragments of a Kasori E-type urn of the late Middle Jomon era. The pattern on the body of the figure is of the kind found on Horinouchi-type vessels of the Late Jomon era, but the pattern on the figurine is believed to predate that on the pots. Fragments of the head, upper arm, and leg of a figurine closely resembling this one have also been discovered, along with Kasori E-type vessels, at the Dobara site in Tochigi Prefecture.

The figurine in Figure 47, unearthed at the Kamioka site near Iizaka in Fukushima Prefecture, has a strange posture with knees drawn up, arms folded, and cheek resting on hand that may simply indicate a position of rest or may portray some rite;

covering the whole vessel have been found. At a marshy site at Sanno, in Miyagi Prefecture, which was recently excavated by a Tohoku University team, more than ten lacquer vessels with plaited bamboo bases and red patterns on a black background were discovered. These plaited bamboo vessels were apparently discovered in the same layer as the Ohora A-type pottery of the end of the Terminal Jomon era. The Korekawa and Yawatazaki sites are peat-layer sites that principally yield artifacts of the first half of the Terminal era such as the Ohora B- and BC-type vessels; at Yawatazaki even the uppermost layer yielded C_1-type vessels, but no C_2. This broad, wide-mouthed vessel would seem from its shape and pattern to date from the Ohora C_2 period, but if one sees this type of pattern as a vertical elongation of the pattern found on Ohora A-type vessels, then this too could be an

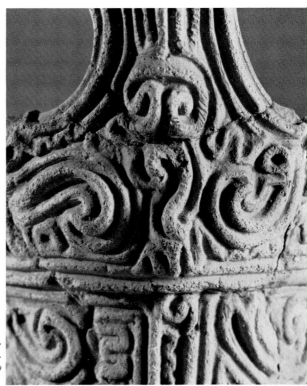

170. Detail of high-relief design on deep earthenware pot. Middle Jomon. Umataka site, Nagaoka, Niigata Prefecture. Nagaoka Municipal Natural Science Museum. (See also Figure 87.)

either way, it involved a great deal of work. It belongs to much the same period as the vessel in the shape of a seashell—the end of the Late Jomon era —shown in Figure 38. Clay figures in various seated postures with the knees drawn up were produced, though not in large numbers, in the Tohoku district from the end of the Late Jomon era on into the first half of the Terminal era.

"Owl" figurines of the type shown in Figure 49 have been found principally in areas such as the southeast of Saitama Prefecture, the south of Ibaraki Prefecture, and the north of Chiba Prefecture, where the Angyo 2-type vessels flourished. The most characteristic specimens, such as that shown in Figure 49, are found along with Angyo 2-type vessels, but a predecessor of this kind of figurine has been found along with Angyo 1-type vessels also. The head of a single figurine of this

type has been found at the Togaitsu site in the north of Toyohashi in Aichi Prefecture, possibly indicating that a certain influence from the Angyo 2-type pottery culture of the southern Kanto district was felt as far afield as here.

The saw-tooth incisions found on the hips of the figurine in Figure 49 and the figurine in Figure 47 represent a pattern universal among figurines of the later half of the Late Jomon era in eastern Japan, and may represent something such as a belt used to hold the clothes in place.

The figures in Figures 8, 50, and 174 are of the type generally referred to as snow-goggle figurines, though it seems likely that the characteristic feature in question is simply a deliberate exaggeration of the eyes.

Small specimens of this type of figure, about 12 centimeters in height and solid inside, are found

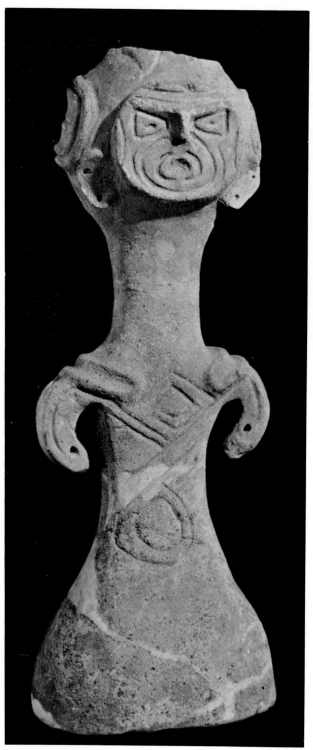

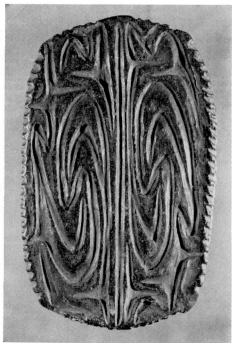

172. *Earthenware plaque with incised design. Terminal Jomon. Length, 11.9 cm. Aso site, Futatsui, Akita Prefecture. Tohoku University, Sendai.*

171. *Hollow long-necked earthenware figurine used as bone container. Terminal Jomon. Height, 36.5 cm. Koshigoe site, Maruko, Nagano Prefecture. Tokyo National Museum.*

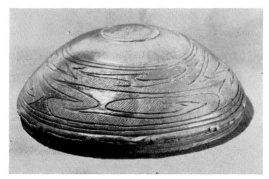

173. *Earthenware bowl decorated with erased cord-impression pattern. Terminal Jomon. Diameter of mouth, 21.2 cm. Nagawa, Aomori Prefecture. Collection of Saburo Akihama.*

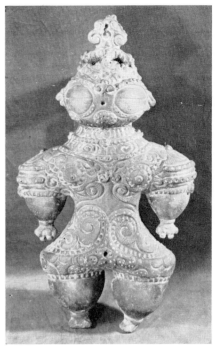

174. *Earthenware figurine with snow-goggle eyes and elaborate costume. Terminal Jomon. Height, 36 cm. Ebisudakakoi site, Tajiri, Miyagi Prefecture. Tohoku University, Sendai.*

dating from the Terminal Jomon era, roughly contemporary with Ohora B vessels, but during the period of the BC type and the first half of the period of the C$_1$ type, larger specimens that are hollow inside put in an appearance. The large figurines more than 30 centimeters in height (Figs. 8, 174) date from this time. With the later period of the C$_1$ type, the size is again reduced, to around 20 centimeters. The example shown in Figure 50 dates from this period. Almost perfect specimens of figurines are very rare, and include only two of this snow-goggle type. Although most specimens of this kind of figurine have been found in the northern half of the Kanto district, a few similar works with some local features have been unearthed in the area of the Ohora BC- and C$_1$-type pottery.

The hollow figurines (Figs. 11, 171) were made to contain human remains and contained the bones of newly born infants. A number of these figurines have been found in Yamanashi and Nagano

prefectures also, all of them from sites that yield pottery of the transitional period from Terminal Jomon to Yayoi. The faces have weird incised patterns that would seem to represent tattooing. The legs are omitted from this type of figurine, and the lower half of the trunk is enlarged so as to form a receptacle for the remains, the base forming an oval in section. There are traces of red on the figurine in Figure 11, which suggests that it was once colored.

The hollow clay plaque with a human face seen in Figure 51 was discovered at the Tokoshinai site in Hirosaki, Aomori Prefecture, in 1906, and dates from the Late Jomon era. If one puts one's lips to the hole corresponding to the mouth and blows through it, it produces a sound resembling that of a bamboo flute, which probably means that it was, in fact, a clay flute. A clay plaque in the form of a turtle, more or less the same shape as this one and also with a hollow interior, which is now in the

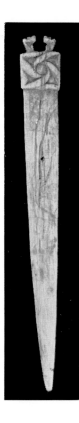

175 (left). *Carved wooden spatula (?). Terminal Jomon. Length, 52 cm. Nakai site, Hachinohe, Aomori Prefecture. Hachinohe Municipal Board of Education. (See also Figure 46.)*

176 (below). *Carved deerhorn ornament. Terminal Jomon. Length, 12.5 cm. Kamegaoka site, Kizukuri, Aomori Prefecture. Tokyo National Museum.*

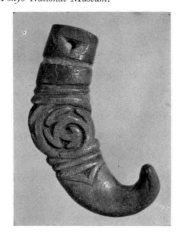

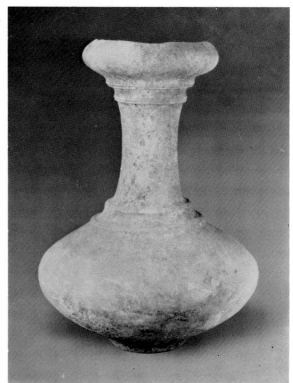

possession of Meiji University, also seems to have been used as a flute. These too are found in company with Kasori B-type vessels of the Late Jomon era, and it seems likely that clay flutes of this type—though not in great numbers—were produced for some specific purpose during the later half of Late Jomon culture in eastern Japan. The eyes of the face are close to those of the snow-goggle figurines, and beneath the face there is a three-forked design. This Tokoshinai specimen (Fig. 51) is conjectured to have been made at the very end of the Late Jomon era. The protuberance, now missing, that has left a scar in the center of the lower half of the body was most probably a representation of the navel.

The clay masks of the Late Jomon era are made to be worn over the face, with eyeholes, mouth holes, and two small holes at either side level with the eyes for attaching the string with which the

mask was secured. However, in the Terminal era—for example, the mask shown in Figure 41—the mask as a whole becomes smaller, and though there are still small holes for strings above the eyes, the eyes and mouth have become purely a part of the design, with no holes. It may well be that the mask had become a mere token worn on the forehead instead of over the whole face. Quite a large number of wooden and clay masks seem to have been made in Japan during the later half of the Jomon period, possibly for use in religious rites of some kind. Figure 40, a clay mask excavated long ago at Hata in Nagano Prefecture, cannot be dated, since it is not known what pottery, if any, was found with it, but it was probably made late in the Middle Jomon era or in the Late Jomon era. It has no holes for strings.

The mask in Figure 41 is a work corresponding with the Ohora BC or early C_1 type, that is, the

178. *Stones with incised pictures of women. Primeval Jomon. Length: left stone, 6 cm.; right stone, 4.5 cm. Kamikuroiwa site, Mikawa, Ehime Prefecture.*

middle of the Terminal era, and has large eyes similar to those of the figurine in Figure 50 and the hollow clay plaque with a face in Figure 51. This is interesting, since it shows that the exaggerated eyes that are a feature of the first half of the Terminal era are common to all artifacts that include representations of the human face.

The stone figure in Figure 45, made from grayish-yellow lava, was discovered, along with cylindrical lower-layer d_1-type pottery of the Early Jomon era, at the Mujinazawa site on the upper reaches of the Yoneshiro River in Akita Prefecture. It was believed that stone figurines and stone plaques first appeared in the Terminal Jomon era, but recently stone figurines have been discovered even at sites of the early part of the Archaic Jomon era, and similar finds from the Early era are increasing steadily. Thus it seems that it is a mistake to see the stone figurines as deriving from the clay figurines; it seems likely that the two existed side by side throughout the long Jomon period. The stone figurines of the Early Jomon era have sculpted bands that seem to represent hair on the top and both sides of the head, and beneath these are two strips that seem to represent arms bent at the elbows with the palms of the hands placed on the chest. The trunk is long and there are no legs. Similar figurines have been dug up along with cylindrical lower-layer d_1-type pottery at the Ishigami site in Morita, Aomori Prefecture. It seems possible that production of these figurines was restricted to the cultural sphere characterized by the cylindrical pottery vessels, extending from the northern half of the Tohoku district to the Oshima Peninsula in the southwest of Hokkaido.

Figure 42 shows an ornamental comb, believed to be of whalebone and to have been intended for wear in the forelock, that was excavated together with cylindrical lower-layer d_1-type pottery of the late Early Jomon era at the Enokibayashi shell mound in Aomori Prefecture. A number of combs of this shape have been unearthed at sites of the Early and Middle Jomon eras in eastern Japan. Figure 43 shows a hair ornament of deerhorn carved in the shape of a human figure that was excavated from the Numazu shell mound in Miyagi Prefecture at a shell level that also yielded Late Jomon artifacts. The resemblance might equally well be to a monkey. A single figurine of deerhorn, smaller than this ornament, was found with it. These two artifacts were reportedly found in a closely packed heap of pebbles within the shell layer, almost as though wrapped in the pebbles. A number of other deerhorn articles of personal adornment have also been found at sites of the same period.

Figures 46 and 175 show a spatula-shaped wooden object dug from the Korekawa peat layer in Hachinohe, Aomori Prefecture. More than ten

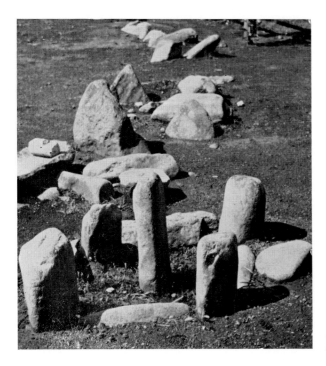

179. *Small stone circle within the Nonakado stone circle. Late Jomon. Oyu site, Towada, Akita Prefecture.*

specimens have been found at the Korekawa site, but the one shown in the photographs has the finest head carving. They are all made of Japanese cedar, and many are more than 50 centimeters in length. There are several shallow grooves at the tip, and a small hole in the center of the spatula in which some kind of rod was possibly fixed. It seems likely that these objects were some kind of stringed musical instrument resembling the modern Japanese koto. The technique that could produce this kind of carving with flaked stone implements is astonishing, and the possible existence of stringed instruments as early as the Terminal Jomon era is also highly interesting.

YAYOI POTTERY AND FIGURINES Figure 71 shows a handled ewer, rather resembling a milk pitcher, discovered at the Niizawa site in Nara Prefecture. Jug-shaped vessels have been found in western Kyushu also, but none have the mouth on one side as this vessel

does, or its beauty. This ewer and the well-proportioned, lidded and footed shallow bowl shown in Figure 73 date from roughly the same period. Clay lids are found occasionally in works from the Late Jomon era onward, but in the Yayoi period they become general.

Figure 72 shows a jar made around the time when Yayoi culture first permeated the south of the Tohoku district. Showing the typical characteristics of Yayoi culture, it shares the same shape as some of the narrow-mouthed jars of the Kanto district. As pottery of the Yayoi period moved gradually from west to east, it came to show less sign of the new techniques from the continent and stronger traces of Jomon traditions, a fact that is obvious if one compares the vessels shown in Figures 71 and 73, discovered in the Kinai district, with those shown in Figures 72 and 75, which were discovered in eastern Japan.

Figure 75 shows a pot of the early part of the late Yayoi period that was discovered at the Kugahara

180. *Whalebone shard with incised deer. Satsumon Culture. Length, 10 cm. Tokotan shell mound, Atsukeshi, Hokkaido. Kushiro Municipal Museum.*

181. *Salmon incised on rockface. Yamaino site, Okachi, Akita Prefecture. Collection of Eikichi Oshikiri.*

site in Tokyo. Kugahara, today a completely built-up residential area, still has buried beneath it the sites of more than one hundred early pit-type dwellings of the late Yayoi period. When the land began to be built on in 1930–31, approximately half the sites were investigated by archaeologists, and a large number of vessels were gathered, but it seems likely that a still greater number lie untouched beneath the houses. It is interesting that the site of a large Yayoi-period settlement should now be occupied by a typical modern housing estate.

The head of a clay figurine of the middle Yayoi period unearthed at the Osakata site in Ibaraki Prefecture (Fig. 77) dates from the period following that of the figurine unearthed at the Nakayashiki site (Fig. 11). Yayoi culture in western Japan produced slab-type clay figurines in the Setouchi district and elsewhere, but no three-dimensional ones. Even in eastern Japan clay figurines after the beginning of the Yayoi period include only a few

specimens apart from the one illustrated (Fig. 20). Possibly these figurines represent a tradition from Jomon times.

It is possible that the vessels bearing faces as part of their design (Figs. 12, 74, 121) were made to hold human remains in the same way as the figurine in Figure 11. An increasing number of mid-Yayoi-period graveyards have recently been discovered in the Kanto district and in neighboring districts. Several jars are buried together in small, roughly circular pits one to two meters in diameter and about 50 centimeters deep. It seems that each group of jars together held the remains of one human being. The vessel shown in Figure 74, which was excavated from a small pit at the Osakata site, was probably used to hold human remains in this way. The vessel in Figure 12 was discovered by chance, and no details concerning it are known, but it is believed to be connected with a tomb. Vessels with faces have also been unearthed from the group of pit-type tombs of the middle Yayoi

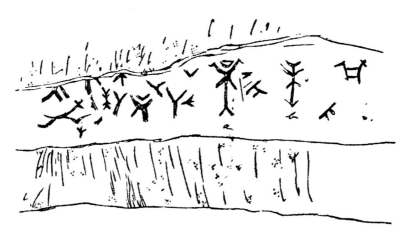

182. Drawing of incised pictures on rockface. Post-Jomon. Temiya site, Otaru, Hokkaido.

period found at the Izurugahara site recently excavated and investigated by a Meiji University team. The "face" jars are not found in all the small pit-type tombs, but on an average of one to each site, which gives interesting grounds for further study concerning the type of person whose remains they contained. Unlike the figurine in Figure 11, these jars contained the remains of adults. The jar shown in Figure 12 has two faces, placed symmetrically at the front and the back, but that in Figure 74 has only one.

THE STONE CIRCLES AND ROCKFACE CARVINGS

Figure 35 shows one of a group of stones known to local inhabitants as "sundials." It is located between the outer and inner circles of the Nonakado stone circle, one of the two stone circles at Oyu in Akita Prefecture that have been designated by the Japanese government as special historical sites. This stone circle was buried beneath a layer of volcanic ash at the time of the Towada Nakanoumi eruption (roughly two thousand years ago). Before excavation, the head of the central upright stone was projecting above the layer of

ash, and almost reached the surface of the layer of black soil, approximately 20 centimeters thick, that had accumulated on top of the ash layer. This group of stones has long, narrow stones arranged in a circle radiating outward from a central upright of green quartz porphyry, and large, roughly spherical stones are placed around the outside to the east, west, north, and south, which suggests that man already had knowledge of the points of the compass at this time. However, the name "sundial" derived from a theory that it was used to tell not the time but the seasons—to tell, by means of the shadow of the upright stone falling on a certain stone, that it was time, for example, to sow the seeds.

It was known from an early date that there were pictures incised in the wall of a cave at Temiya in Otaru, Hokkaido (Fig. 182), but at one stage doubt was cast on their authenticity. However, excavations at the Fugoppe cave in Yoichi have shown that this cave too has pictures (Fig. 82) that are similar to those carved in the face of the rock at Temiya. At the Fugoppe cave, excavations have proceeded as far as the layer containing the Ebetsu-type pottery, but a number of other cultural layers

still remain lying on top of one another beneath this point. Moreover, the parts of the rock face that were buried also have incised pictures, so that by now there is a very strong suspicion among archaeologists that the men who created the pictures were those responsible for the very lowest cultural layer, and that they lived in the age preceding the Jomon culture. It is also interesting to note that these pictures are similar to carved pictures of the late Paleolithic era on the continent. Assuming that they date from the age of Jomon culture in Hokkaido, or from the age of the Ebetsu-type pottery that was a continuation of it, then one might surely expect to find incised pictures executed with similar techniques on pieces of stone or pottery unearthed at other sites where artifacts of these ages are unearthed. In the Jomon period, sculpture is represented by the clay figurines and clay objects in the form of animals, which undergo rapid development from the Middle era onward, but pictorial art is, with one or two exceptions, entirely absent.

With the large stones incised with fish shapes (referred to by local scholars as salmon stones; Figs. 81, 181) discovered in the neighborhood of Yashima in Akita Prefecture, there is a similar doubt as to whether they really date from the Middle or Late Jomon era as has been claimed. Some of them were excavated at spots devoid of any shards or other artifacts of the Jomon period, while some were found near but somewhat separated from excavation sites. Moreover, the flake bearing marks of human processing found in the neighborhood of a salmon stone discovered at Oyachi in Yashima could well be a Paleolithic flake tool. Thus, there would seem to be a strong possibility that these rocks carved with fish shapes are also the products of an age earlier than the Jomon pottery. The fact that incised pictures of women (Fig. 178) have recently been discovered, along with artifacts of the age that saw the origin of pottery culture, at the Kamikuroiwa site in Mikawa, Ehime Prefecture, and also in the Fukui cave in Nagasaki Prefecture, would suggest that the Hokkaido and Akita Prefecture specimens just mentioned were produced near the end of the Paleolithic era.

On the other hand, the engraved picture of the face of a deer (Fig. 83) from the Hasezawa site in Kuroishi, Aomori Prefecture, would seem to be a work of the Jomon period or later. Almost all Paleolithic pictures of deer show the face in profile, not from the front. The frontal representation of a deer's face engraved on a piece of whale rib (Fig. 180) was excavated at the Tokotan shell mound at Atsukeshi in Hokkaido, which has also apparently yielded combed-pattern pottery and Okhotsk-type pottery that is later than the Jomon period. This would suggest that although no definite date can be ascribed to the deer-face carving found at Kuroishi, there is a strong possibility that it is later than the Jomon period.

CHAPTER TEN

Aspects of Yayoi and Tumulus Art

by Ken Amakasu

Lecturer in Archaeology, Tokyo Women's Christian College

YAYOI METAL CULTURE The epoch-making significance of Yayoi culture in the history of the Japanese people lay in the beginning of rice cultivation and the creation of a metal culture. The use of iron implements seems already to have begun early in this period in the form of the tools (spear-type scrapers and the like) used in fashioning wooden agricultural implements, and this seems to have acted as a spur to the rapid development of early agriculture. Then, late in the period, a switch from stone to iron in all kinds of productive implements takes place over the whole area.

From the middle of the period, bronze objects, primarily swords, spears, and mirrors, are imported from the continent and used as symbols of wealth and authority. We also find bronze swords, spears, and ritual objects such as *dotaku* produced in Japan.

The imported bronze culture combined in two streams—the mirrors and other products of the Han culture in China, and narrow bronze swords and other objects deriving from northeastern Asia and believed to have been made mostly in Korea. The bronze vessel shown in Figure 130, which was discovered at the Kubiru site on Tsushima Island, along with Han-type woven-cord-impression pottery, late Yayoi pottery, and Japanese-made spears, reveals the spread of objects derived from Chinese culture. Many Chinese mirrors of the early and middle Han period (Fig. 184) have also been discovered in some burial urns unearthed in northern Kyushu.

On the other hand, only four specimens of the special type of bronze mirror, with more than one knob and a saw-tooth pattern on the back, that derived from northern Asia have been found. These were scattered over a wide area of western Japan, in Fukuoka, Yamaguchi, Osaka, and Nara prefectures. They were found in various locations—inside a burial urn, inside a cist, in isolation, and accompanied by a *dotaku*. The largest of them, with the finest workmanship, is the mirror (Fig. 183) unearthed at Oagata in Osaka Prefecture, which was found in isolation near the top of a hill.

The *dotaku* are believed to have flourished mostly during the middle and late Yayoi period, but the fact that the flowing-water pattern on the

183. Bronze mirror with saw-tooth pattern. Middle Yayoi. Diameter, 21.7 cm. Oagata site, Kashiwabara, Osaka Prefecture. Tokyo National Museum.

dotaku shown in Figure 24 is identical with the combed flowing-water pattern characteristic of Yayoi pottery early in the middle period in the Kinai district suggests that the earliest of them date back to early Yayoi. The *dotaku* are believed to have derived from a musical instrument that was suspended from a projection at the top and struck to produce a note, and this *dotaku*, found at Onchi, is unusual in having a ring for suspending a clapper inside, thus showing that it still retained its musical function. With the change from bells intended to produce a musical note to objects intended simply to be looked at, a type appeared that had its surface divided by ribbonlike bands into a number of sections decorated with pictures (Figs. 21, 29, 76, 151). The body becomes larger, and the projection at the top ceases to serve any function in suspending the bell, becoming progressively larger

and flatter. The most advanced example of this process is the *dotaku* (Figs. 78, 153) found at Mukoyama in Wakayama Prefecture, in which the decorative ears with whorl patterns seen on the *dotaku* (Fig. 25) found at Uzumori in Hyogo Prefecture are greatly enlarged and the projection on the top greatly elongated vertically, probably to give the *dotaku* extra height. The body, once flat, has swelled out to an almost round section, either to give the work a great sense of solidity or possibly because it was intended to be viewed from the sides and not merely from the front. The craftsmen who produced these oddly shaped bronze objects were probably inspired by the desire of Yayoi man to make his ritual objects as visually powerful and imposing as possible, as symbols of the solidarity of his community.

The cultural sphere represented by *dotaku* ex-

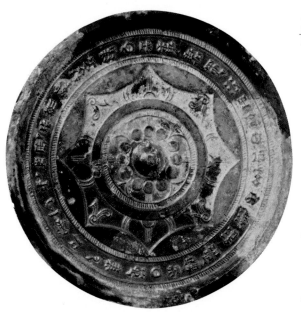

184. Bronze mirror with naiko *flower design. Middle Yayoi. Diameter, 16.4 cm. Mikumo site, Maebaru, Fukuoka Prefecture. Shofuku-ji, Fukuoka.*

185 (opposite page, left). Imported bronze mirror with god ▷ *and animal designs. Early Tumulus. Diameter, 23 cm. Akatsuka Tomb, Usa, Oita Prefecture.*

186 (opposite page, right). Domestic bronze mirror with ▷ *god and animal designs. Early Tumulus. Diameter, 21 cm. Choshizuka Tomb, Nijo, Fukuoka Prefecture.*

tended outward from the Kinai district to the Setouchi district and Shikoku in the west, and as far as Shizuoka and Nagano prefectures in the east. Nearly three hundred *dotaku* have already been discovered, and their number is increasing steadily. There is nothing on the ground surface to indicate the spots where they lie buried, and all have been discovered by accident, which gives some idea of the vast number that must have been produced originally.

The Japanese-made bronze swords, spears, and daggerlike axes that are distributed widely over northern Kyushu and other districts of western Japan, coinciding in part with the distribution of the *dotaku,* have also lost their original function, becoming larger and flatter, with increasing emphasis on visual impressiveness (Figs. 129, 131, 132). This, together with the fact that many of them have been discovered in isolation in places other than settlements and graveyards, makes it likely that they served a ritual purpose similar to that of the *dotaku,* but they do not display the same vigorous sense of form as the latter. One important difference

between the bronze cultures of the two areas represented respectively by the *dotaku* and the swords, spears, and daggerlike axes is that in northern Kyushu—the focal point of the latter area—and nowhere else a very large number of Han-type mirrors have been found in burial urns, along with other imported treasures.

Unlike the domestically produced bronze articles, which were essentially ritual objects for the community, these mirrors were obviously used as objects for burial with particular tribal chiefs, and thus served as symbols of personal or hierarchal authority. Moreover, whereas the appearance of the domestically produced bronze objects can be seen as an influence in the broad sense from the bronze culture of northeastern Asia, the transmission to Japan of the Han-type mirrors may very possibly have occurred—as is suggested by the arrival in the first century of a gold seal from the Later Han court, and by the records concerning the Wei bestowal of an official honor and bronze mirrors on Himiko, queen of Yamatai—as an indirect result of contacts between the chieftains of

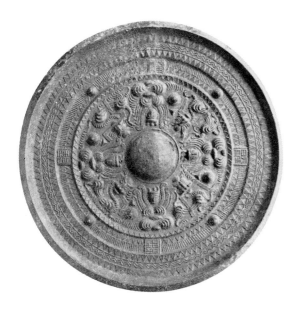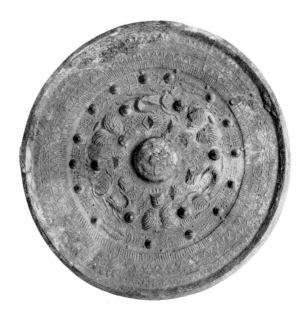

protostates in Japan and the Chinese court. If so, this would seem to indicate that these mirrors were highly valued objects that acquired their authority from the political authority of the Chinese court.

EARLY TUMULUS GRAVE GOODS The distribution of tombs of the Early Tumulus era indicates that Tumulus culture first developed in the Kinai district and the areas around the Inland Sea, then established itself over an area embracing northern Kyushu and roughly the sphere of the *dotaku*. A noticeable feature of Early Tumulus culture is the importance it attached, as burial objects, to Chinese-made mirrors and jasper bracelet-type objects in hoe (Figs. 31, 103), wheel (Fig. 30), and ring (Fig. 187) shapes. Most of the mirrors are believed to have been made in China in the Wei or the Chin dynasty, though there are also some mirrors of the middle or late Han period that are believed to have been imported in the Yayoi period and handed down in powerful families. In the process of transition from the Yayoi period to the Tumulus period, Yayoi bronze objects

such as *dotaku* and swords that are believed to have been community ritual objects disappeared completely. However, the custom of burying Chinese mirrors with the dead, as precious objects showing the personal authority of the clan chief—a custom that flourished in the Yayoi culture of northern Kyushu—was taken over into the Early Tumulus era. This fact is most interesting in considering the nature of Tumulus culture as a whole. It indicates that the rites of individual communities symbolized by the *dotaku* were absorbed and nullified by tomb rites celebrating the chieftains who brought about regional unions of those communities.

The stone bracelets made of jasper are imitative of the shell bracelets that have been discovered in the burial-urn tombs of the Yayoi period in northern Kyushu, and are believed to have possessed a strongly magical significance. Since the shell bracelets were unsuited for wear while engaging in labor, it seems likely that they were a symbol of the leisured class and served to mark some special social status such as that of the clan chieftain. The hoe-shaped stone bracelets are imitations of the

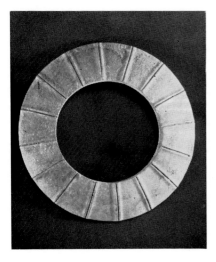

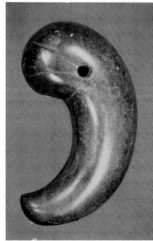

187 (far left). Jasper bracelet. Early Tumulus. Diameter, 15 cm. Choshizuka Tomb, Nakamichi, Yamanashi Prefecture. Tokyo National Museum.

188 (left). Jasper magatama. Early Tumulus. Length, 7 cm. Ino-oka Tomb, Tanabe, Kyoto Prefecture. Tokyo National Museum.

189. Circular, lidded box of jasper. Early ▷ Tumulus. Height, 8.7 cm. Maruyama Tomb, Nara.

bracelets made by cutting vertically through the shell of a conch known as *tengunishi*.

Other burial objects of the Early Tumulus era include beads such as the *magatama* (comma-shaped jewels; Fig. 188) and pipe-shaped beads, iron weapons such as swords and arrowheads, and iron agricultural and manufacturing implements. Sets of these objects found in the tombs give a good idea of the strongly magical and religious nature attributed to the chieftains who controlled military matters and agricultural production.

Tombs of the Early Tumulus era have also yielded large numbers of mirrors with beveled edges and designs showing gods and fabulous creatures (Fig. 185). They include some that are believed to have been cast from the same mold, and their distribution has suggested to scholars that they were imported in large quantities during the Wei period and kept until later, when they were distributed to different local chieftains by a chieftain, or chieftains, of the Kinai district. In time, mirrors were produced in Japan in order to meet the demand from this chieftain class. The first stage yielded mostly faithful copies of the beveled-edge mirror with gods and fabulous creatures (Fig. 186), which indicates that the mirrors imported from Wei were considered to be invested with authority in themselves.

Before long the imitations became freer, and in time some mirrors appeared that made use of completely original motifs. The Japanese craftsmen did not understand the Chinese Taoist ideas that found expression in the gods-and-fabulous-beast mirrors, nor the meaning of their inscriptions. They created one type of their own, for example, simply by omitting the gods from the design and developing the motif of fantastic creatures. The mirror of this type (Fig. 156) found in the Chausuyama Tomb at Yanai in Yamaguchi Prefecture measures more than 44 centimeters in diameter, approximately twice the size of the standard imported mirror, thus showing that the attempts of the craftsmen of the day to be original were taking them in the direction of larger mirrors, too. The design of the *chokkomon* mirror shown in Figure 32 is a fine composition that combines the motifs of both the Han flower design (Fig. 184) and the *chokkomon* design that is peculiar to Japan.

Examples of mirrors that depart entirely from the rules governing the patterns on Chinese mirrors and achieve a free pictorial expression include the mirror with a design of houses (Fig. 111) found in the Takarazuka Tomb at Samita in Nara Prefecture, and the mirror with a hunting design (Fig. 112) unearthed at Yawatabara in Gumma Prefecture. The house seen in Figure 111 is a raised-floor

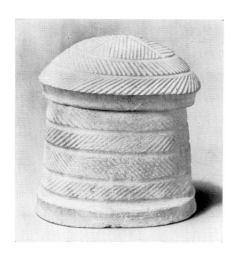

dwelling reached by a staircase with a handrail and has a platform over which is shown a shade of the type held over high-ranking personages. Besides this skillful representation of a nobleman's dwelling, three other buildings are shown around the knob in the center—a low-floored dwelling, a pit dwelling, and a raised-floor structure that seems to be a storehouse—thus providing invaluable information concerning the social structure of the day. These fine specimens of domestically produced mirrors are believed to be the work of craftsmen organized in the service of chieftains at the center of the Kinai district, and it seems likely that they inherited the traditional techniques of the groups of craftsmen who produced the *dotaku*.

From the fifth century onward, the importance of mirrors among burial objects declined sharply, and the quality of domestically produced mirrors went down, the mirrors being smaller and of poor workmanship. Even in this period, however, there are some fine specimens, such as the mirror (Fig. 157) in the Sumida Hachiman Shrine in Wakayama Prefecture, that show that the techniques of mirror making of earlier days were still maintained in some areas. The design is a faithful copy of a Chinese type. However, an epochal difference in comparison with the simple imitations of the early period, which copied the inscription without under-

standing its meaning, is that this mirror has its own inscription in Chinese telling how it came to be made. Concerning its date, the most likely interpretation of the inscription would place it at 503, in the life of Emperor Keitai (r. 507–31), but another interpretation sets it at 443, in the reign of Emperor Ingyo (r. 412–53).

The processing of semiprecious stones that had been a traditional craft since the Yayoi period underwent special development in the Tumulus period. Hard jasper was skillfully fashioned—turned on a wheel and carved with iron tools—into various types of bracelets, as well as articles of a strongly symbolic nature such as the object with a *tomoe* (comma) design shown in Figure 191, the object in the shape of a koto bridge (Fig. 192), and stone staffs. There are also occasional containers such as the circular box shown in Figure 189 and the legged dish in Figure 104. Somewhat later, there is a trend toward production in quantity; besides jasper, easily workable tuff was used, and in the late fourth and early fifth centuries the still softer soapstone also came into general use. Variety developed, and replicas of manufacturing and agricultural implements were made in large quantities, while widely varied types of kitchen and eating utensils also appeared. The coloring of the articles of personal adornment found in early tombs is predominantly blue or dark green—objects such as *magatama* in nephrite, pipe beads in jasper, and cobalt-blue glass balls. There is almost no agate or crystal, which makes it seem possible that the shift from jasper to soapstone represented both a loss of the original magical significance of the stone objects and a process of gradual formalization. This would also imply a great change in the concept of tomb ritual.

THE GREAT TOMBS AND CONTINENTAL-STYLE GRAVE GOODS

From the very outset, the keyhole-shaped tomb was predominant among the ancient tombs of Japan. The typical tomb of the Early Tumulus era was made by shaping a small hill overlooking a plain, then building up earth so as to form a tumulus with a square front

and round back (the characteristic keyhole shape) that sometimes measured more than 100 meters in diameter (Fig. 160). The slopes were covered with stones to prevent erosion, or the tumulus was encircled with rows of cylindrical *haniwa*. Thus from the outset the ancient tombs constituted a strictly defined sacred zone of an imposing appearance calculated to impress people with the authority of the chieftain.

In the keyhole tombs of the first half of the fifth century, as represented by the mausoleums of the emperors Ojin and Nintoku, the vaunting of authority by means of giant tumuli reached a kind of peak. The Habikino hills, at the confluence of the Yamatogawa and Ishikawa rivers in Osaka Prefecture, harbor the Furuichi and Konda groups of tumuli, which comprise a large number of great keyhole tombs—including those of Ojin, Ingyo, Nakatsuhime, and Chuai—built in the period from the fifth century through the sixth century. A diluvial tableland on the outskirts of Sakai, overlooking Osaka Bay, is the home of the Mozu group (Fig. 53), built mainly in the fifth century, and includes the tombs of Nintoku, Richu, and Hanzei.

The characteristic of these keyhole tombs of the fifth century is that they follow a remarkably strict and well-ordered geometrical design both in their plan and in their elevation. The length of the tumulus of the Ojin Tomb is 419 meters, the height 35.8 meters. When the moats are included, the total length is some 500 meters, and if one adds the area around the outer moat where the ground was leveled and cleared, the whole sanctuary attains the astonishing measurements of approximately 700 meters from north to south and 620 meters from east to west. The tomb precincts straddle both the hills and the diluvial area, part of the hills being swallowed up completely within the tumulus. With the Nintoku Tomb (Fig. 161), the builders used a spacious diluvial tableland that offered no topographical restrictions whatsoever, and constructed a tomb of unprecedented size, of which the tumulus itself measures 486 meters in length, and the whole area, including the surrounding precincts, measures an estimated 1,000 meters.

The construction of the keyhole tombs was

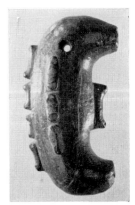

190. *Soapstone* magatama *ornamented with small* magatama. *Late Tumulus. Length, 10.5 cm. Sakuragawa, Ibaraki Prefecture.*

carried out in a planned manner, using fixed units of measure. The principles involved are only now becoming clear, but the techniques were obviously backed up by the development of engineering techniques that had successfully brought the Yamato and Kawachi plains under cultivation through the use of ponds and ditches and large-scale riparian works. These great keyhole tombs are in themselves an imposing achievement of ancient architecture, and it seems likely that the experience gained in constructing them was a technological precondition for the later adoption of the temple architecture and walled-city system of the continent.

Assuming that the changes in Tumulus culture that seem to have taken place in the course of the fourth and fifth centuries were due to the establishment of a new dynasty by an equestrian people deriving from northern Asia, those changes could be taken as a historic turning point in Tumulus culture and the Tumulus period could be divided accordingly into an Early era and a Late era lying on either side of them. This approach lays stress on the sudden, unheralded aspects of the changes of the fourth and fifth centuries. However, when one examines the developments of the period in their more continuous aspects, one finds that a number of different phenomena, among them an increase in the number of iron objects being buried in the tombs, the appearance of objects made of soapstone (Fig. 190), the appearance of *haniwa* representing

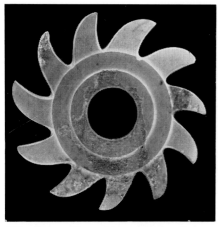

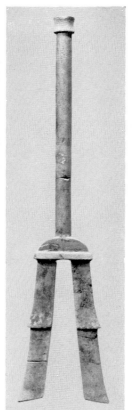

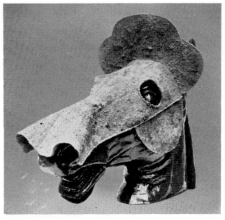

191. *Jasper object with* tomoe-*shaped decorations. Early Tumulus. Diameter, 22 cm. Higashino Otsuka Tomb, Hashihara, Osaka Prefecture. Fujita Art Museum, Osaka.*

193. *Iron horse mask. Late Tumulus. Length, 52.6 cm. Otani Tomb, Wakayama City, Wakayama Prefecture. Kyoto University.*

192. *Jasper koto-bridge-shaped object. Early Tumulus. Length, 18 cm. Ishiyama Tomb, Ueno, Mie Prefecture. Kyoto University.*

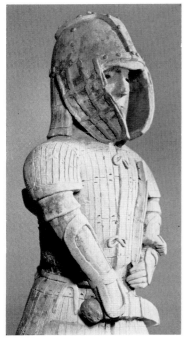

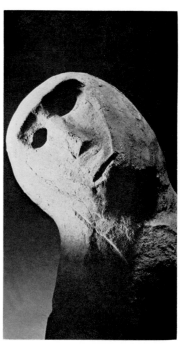

194 *(left).* Haniwa *warrior wearing armor. Late Tumulus. Height, 133 cm. Kugo site, Ota, Gumma Prefecture. Tokyo National Museum.*

195 *(right).* Haniwa *monkey. Late Tumulus. Height, 27.3 cm. Okisu site, Tamatsukuri, Ibaraki Prefecture. Collection of Tatsuo Nakazawa.*

articles of everyday use, such as sunshades (Fig. 196) and shields, the development of surrounding moats filled with water, and an increase in the size of the tombs, are observable in Yamato and the surrounding area as early as the later part of the fourth century, before the time of the Ojin Tomb. Thus one could, by equating these trends with a reinforcement and development of the authority of the Yamato court, see the stage represented by the Ojin Tomb as no more than the pinnacle of such a process of inner development. The methods of dividing the period adopted in the past have been based on the view that the changes in Tumulus culture represented basically a process of inner development; thus there was a three-era view, according to which the fifth century is seen as forming the pinnacle of Tumulus culture and thus treated as its Middle era, the eras before and after it constituting the Early and Late eras respectively. A two-era view saw the period from the end of the fifth century into the sixth, during which corridor-type stone chambers became common and groups of small-scale tumuli appeared, as representing a change and degeneration in Tumulus culture, and took the end of the fifth century as the dividing line between the Early era and the Late era.

Around the end of the fourth and beginning of the fifth century—the period that produced the tombs of Ojin and Nintoku—a major change occurred in the nature of Tumulus culture. Showy continental products, such as horse trappings and gilt-bronze articles of personal adornment, appeared among grave goods buried with the dead, and the importance of the mirrors that had hitherto been so highly valued declined. At the same time, stone objects changed from jasper articles to replicas of various objects made of soapstone, which were produced in great quantities, but even these disappear eventually. On the other hand, weapons and military accouterments such as swords, arrowheads, and armor, as well as agricultural and manufacturing implements, were placed in tombs in large quantities. The wooden coffins favored so far were replaced by massive boxlike stone coffins, and eventually house-shaped coffins come into fashion. This is also the period of the

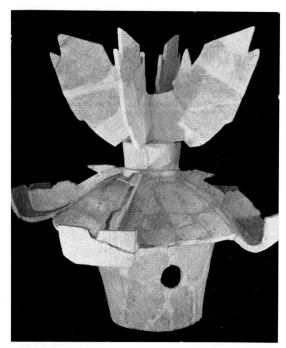

196. Haniwa *ceremonial sunshade. Late Tumulus. Height, 95.5 cm. Anderayama Tomb, Uji, Kyoto Prefecture. Kyoto University.*

first *haniwa* representing human figures, horses, waterfowl, and the like. Viewed as a whole, these changes show a trend away from the strongly magical and religious flavor of the agricultural society that first developed in the Yayoi period, and toward a culture dominated, in continental fashion, by king and nobles.

The Otani Tomb, which yielded the equine trappings shown in Figures 113 and 114, is a keyhole tomb located at the lower reaches of the Kinokawa River in Wakayama City. It housed an old-style house-type coffin (Fig. 54) made by assembling slabs of rock, and its abundance of such trappings as horse masks (Fig. 193), horse armor, and other riding accouterments made on the continent speaks

197. Detail of quiver carved in relief on tomb entrance. Late Tumulus. Kyogamine hillside tomb, Nishiki, Kumamoto Prefecture.

strongly of the presence of a horse-riding people. It is probably the tomb of a clan that took part in an expedition to Korea.

The *gyoyo* (a decoration hung from a horse's martingale or crupper) shown in Figure 114 is a fine specimen made of gilt bronze, with a palmate arabesque design in low relief and, originally, seven small spherical bells attached to its edge. The *uzu* (an ornamental version of the metal fitting attached to the crupper where the straps come together) seen in Figure 113 is also in gilt bronze, with two symmetrical arabesque dragons in openwork on the body and palmate leaf patterns on the eight projecting legs that joined the leathers of the crupper. The *gyoyo* in Figure 145 has an elaborate and eccentric

design incorporating the profile of the human face of a fantastic bird, which is hidden in proliferating arabesques. This *gyoyo* was discovered at the Okitsumiya sub-shrine on Okinoshima, an isolated island off Kyushu in the Genkai Sea, as was the gold ring shown in Figure 144. Since ancient times, Okitsumiya has been venerated as a sub-shrine of the Munakata Shrine, and the discovery of a large amount of treasure of the Tumulus period there has suggested that it may mark the site of some national rite to pray for a safe crossing during an expedition to Korea. The cup stirrups in Figure 55 were discovered in a huge corridor-type stone chamber in the Miyajidake Tomb in Fukuoka Prefecture. They are fine specimens, typical of the end of the Tumulus period, with palmette designs on the upper surface of the body.

The gilt-bronze articles of continental origin discovered in Late Tumulus tombs include—besides equine trappings—articles of personal adornment, such as belt ornaments, earrings, and crowns, all making lavish use of showy pendants, and weapons and military accessories such as armor and sword decorations. They show the desire of members of the powerful families of the fifth and sixth centuries to clothe themselves in the glittering finery popular on the continent. The belt ornament shown in Figure 58 is elaborately made, consisting of a rectangular plaque to be fastened to the belt and an attached heart-shaped pendant with three small spherical bells attached to it; the plaque and pendant have dragon designs in openwork and relief, respectively. The crown decorated with horses (Figs. 15, 126) was discovered in a keyhole tomb of the first half of the sixth century in the Kanto district, and is similar to one found at a Scythian site in southern Russia. The taste it represents is utterly typical of an equestrian people, but a slight clumsiness in the cutwork technique suggests that it was made by Japanese craftsmen. The *kanto-no-tachi* pommel (Fig. 56) unearthed at the Kinreizuka Tomb is later, dating from the seventh century. It has a design showing two dragons struggling for a jewel, but the design is noticeably simplified and almost certainly represents the naturalization of gilt-bronze manufacturing techniques.

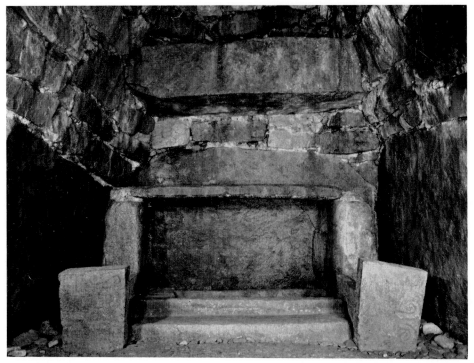

198. *Sarcophagus in chamber-type tomb. Late Tumulus. Ozuka Tomb, Keisen, Fukuoka Prefecture.*

DECORATED TOMBS AND HANIWA

In the sixth century, during the later half of the Late Tumulus era, another major change occurred in the appearance of Tumulus culture. Under the influence of the continental burial system, the corridor-type stone chambers that first appeared in northern Kyushu spread over the whole country, and at the same time the *sueki* vessels for eating and drinking became an indispensable feature among burial objects. There is a sharp increase in the number of small tumuli, while the keyhole tombs show a steady decrease in size, and in the later half of the sixth century their building ceases completely in the Kinai district. In the seventh century, there is a nationwide decline in the building of groups of small tombs as well, marking the end of the Tumulus period and the approach of the Asuka and Nara periods.

The change from burial within a pit-type stone chamber or clay enclosure to the type of burial that furnished the deceased with a fixed and stoutly protected space of his own and used *sueki* vessels to provide him with food and drink probably represented not simply an imitation of imported forms but a maturing of the ideas of the Japanese themselves concerning the next world. As a result of this concentration on enlarging and strengthening the corridor-type chamber that was the abode of the dead, the stone chambers developed steadily, from chambers made simply by splitting rock and piling the pieces on top of each other on their sides—an influence from the techniques of the pit-type chamber—to structures of huge rocks stood on edge that by the later half of the sixth century included such giant structures as the Ishibutai Tomb (Fig. 158) at Asuka in Nara Prefecture (where the inner

chamber is 4.8 meters high and the weight of the single slab of rock forming the ceiling is 77 tons), and the Tsukaanayama Tomb (Fig. 102) in Tenri. On the other hand, the tumulus as such ceased being impressive in sheer size, and became simply a covering of earth for the stone chamber within.

Another case of concern with the provisions made inside for the dead rather than the need to make a superficial impression outside is seen in the decorated tombs that developed in the Kyushu area. The custom of decorating stone coffins with engraved patterns of concentric circles or *chokkomon* patterns had been known in the Kinai and various other districts ever since the later half of the Early Tumulus era, and the decoration on the house-shaped stone coffin (Fig. 139) in the Sekijinyama Tomb, which is engraved with *chokkomon* patterns and is said to be the forerunner of the decorated tombs of Kyushu, derives from this tradition. However, the Sekijinyama stone coffin is of the "horizontal hole" type that has a hole for the deceased to enter and leave by at the end, thus already showing an influence from the corridor-type stone chamber that characterizes it as belonging to northern Kyushu.

Even during the period when, under the influence of the continental tombs with murals, decoration began to be applied to the interior of the corridor-type stone-chamber tombs of Kyushu, the first themes used were symbolic geometrical patterns, such as *chokkomon*, concentric circles, continuous triangles, and diamonds, that had already existed in the Early Tumulus era. It is another characteristic of this period that decoration is applied to the stone coffins and the stone screen that runs around the chamber against the wall— for example, the Idera Tomb (Fig. 137), the Segonko Tomb (Fig. 14), and the Chibusan Tomb (Fig. 109). It is only in the period around the second half of the sixth century that pictorial decoration worthy of the name of murals is applied to the walls; diagrams of articles of everyday use of the kind represented in *haniwa*—among them shields, quivers, and what appear to be the large circular fans held above the heads of noble persons—appear at a comparatively early date.

Other favorite themes are human figures, horses, and boats, and some tomb decorations appear— for instance, in the Takehara and Mezurashizuka tombs—that seem to tell a story. The fact that decoration is also often found in hillside tombs shows that the tomb culture was no longer a monopoly of the powerful families but had been taken over at lower levels of society as well—for example, the Nabeta hillside tomb (Fig. 138) and the Kyogamine hillside tomb (Fig. 197). The decorated tombs that are found dotted about Honshu, such as the Takaida hillside tomb in Osaka Prefecture (Fig. 159) and tombs found in Shimane, Ibaraki, and other prefectures, also belong to this tradition.

The development of these decorated tombs, while partly a result of increased skill among the artists of the day, also indicates a gradual shift away from the type of tomb rites that characterized the Early Tumulus era, which had a strongly magical element and were designed to pay homage to the spirit of the chieftain and enhance his prestige. A similar conclusion can also be drawn from the fact that the vogue for stone men and stone horses placed around the tomb to give it added dignity corresponds for the most part to the first period of the decorated tombs, and disappears by the time they reached their heyday. Insofar as they both represent a desire to embellish the tombs with everyday themes, the decorated *sueki* vessels that developed mainly in the Kinai district and the *haniwa* of the Kanto district share, despite the difference in their materials, a common spirit of the age. The relief work on the earthenware coffin (Fig. 116) in the Hirafuku Tomb, Okayama Prefecture, is doubtless another manifestation of the same trend.

The human *haniwa* discovered in the Kanto district, though artistically immature, are often found in batches displaying a variety of different poses. It is believed that these were made as part of a single group, and in some cases were stood in front of a tomb where they composed some pictorial or narrative scene. Human and animal *haniwa* appear early in the Late Tumulus era along with the great keyhole tombs, such as that of Emperor Nintoku. At first, they were probably intended to

add prestige to an imperial mausoleum in the same way as the stone men and horses of the royal mausoleums of China. The warrior in full panoply standing perfectly erect (Fig. 194), the well-dressed woman with a solemn expression (Fig. 123), and the horse with fine trappings (Fig. 124) would all fit in with such a function. However, *haniwa* were very soon abandoned in the Kinai district, possibly because the limitations of the *haniwa* as material for sculptural creation deprived it of its appeal for the powerful families that were gradually emerging as leaders of an ancient state.

Among the *haniwa* of the Kanto district, works frequently occur with a pastoral nature that is markedly different from the solemnity that seems to have been required in earlier *haniwa*. This may be related to the fact that the *haniwa* were provided not only for the royal family, aristocracy, and local chieftains, but also for the class that was buried in the groups of small tombs. The fact that there are said to be some 400 keyhole tombs in Gumma Prefecture suggests that the significance of the keyhole tombs and *haniwa*, which had been symbols of the authority of the great families in the Kinai district, had changed considerably in the Kanto district.

In the later half of the sixth century, when in the Kanto district keyhole tombs and *haniwa* were still being made in large numbers, the last keyhole tomb built as an imperial mausoleum was made for Emperor Kimmei. The energies of the ancient state hitherto directed to the erection of tumuli were before long redirected to the building of Buddhist temples and castle towns. When one compares the monkey stones dug up near the Kimmei mausoleum (Figs. 117, 164) with a *haniwa* of the same period (Fig. 195), the impression that the Tumulus period was already over is inescapable.

TITLES IN THE SERIES

Although the individual books in the series are designed as self-contained units, so that readers may choose subjects according to their personal interests, the series itself constitutes a full survey of Japanese art and is therefore a reference work of great value. The titles are listed below in the same order, roughly chronological, as those of the original Japanese versions, with the addition of the index volume.

The "weathermark" identifies this book as having been planned, designed, and produced at the Tokyo offices of John Weatherhill, Inc., 7-6-13 Roppongi, Minato-ku, Tokyo 106. Book design and typography by Meredith Weatherby and Ronald V. Bell. Layout of photographs by Rebecca Davis and Ronald V. Bell. Composition by General Printing Co., Yokohama. Color and gravure plates engraved and printed by Nissha Printing Co., Kyoto, and Mitsumura Printing Co., Tokyo. Monochrome letterpress platemaking and printing and text printing by Toyo Printing Co., Tokyo. Bound at the Makoto Binderies, Tokyo. Text is set in 10-pt. Monotype Baskerville with hand-set Optima for display.